W9-DDI-218

E.T.S.U. AT TEXARKANA LIBRARY

Art & Commerce: American Prints of the Nineteenth Century

Art & Commerce:

American Prints of the Nineteenth Century

Proceedings of a Conference held in Boston

May 8-10, 1975

Museum of Fine Arts, Boston, Massachusetts

Distributed by the

University Press of Virginia

Charlottesville, Virginia

52066

Copyright © 1978 by the Museum of Fine Arts, Boston, Massachusetts
Library of Congress Catalogue No. 78–13848

ISBN 0–87846–130–2

Type set by The Stinehour Press, Lunenburg, Vermont

Color printing by Eastern Press, New Haven, Connecticut
Monochrome printing by The Meriden Gravure Company, Meriden, Connecticut

Designed by Carl Zahn

This project is supported by a grant from
the National Endowment for the Arts,
a federal agency.

Contents

52066

Foreword

American prints, printmakers, and painter-printmakers of the nineteenth century were the focus of the American Prints Conference that was held in Boston from May 8 to 10, 1975. Eight talks and four special exhibitions relating to this conference theme offered new insights into a field not previously well studied. This report makes public record of the conference findings and contributes substantial information and new ideas on nineteenth-century American art and culture.

Boston is a rich resource for the study of nineteenth-century America. Many of the leading artists, designers, and writers who helped to form the nation's taste lived in or near Boston, or were involved in the city's institutions. At the Museum of Fine Arts, the first curator of prints, Sylvester R. Koehler (1837–1900), was vigorously acquiring prints by outstanding American painter-etchers of the 1870s and 1880s at just the moment when the Aesthetic Movement was at its height in this country. It is therefore no accident that the MFA print collection is especially strong in artistic prints of this period by painter-etchers and by creative lithographers such as William Rimmer and William Morris Hunt. Other important institutions in the region also have outstanding nineteenth-century print collections—the Boston Public Library (Wiggins Collection), the Boston Athenaeum, the Massachusetts Historical Society, and the American Antiquarian Society, Worcester.

The staffs in each of these institutions were consulted by conference planners Clifford S. Ackley, Associate Curator of Prints, and Sue W. Reed, Curatorial Assistant at the MFA. The talks they arranged and the plan that the conference followed address one of the fundamental problems with which nineteenth-century American artists wrestled and which still concerns art collectors today. The problem was that of the mechanization of production and its artistic consequences. Early in the nineteenth century it was the desire of most artisans and printmakers to develop machines that would reduce hand labor and therefore increase production, in addition to reducing unit costs. Besides the obvious profit motive, this mass production was inspired by a sense of democratic obligation to make art available to every American. But by the last quarter of the century, many critics and artists were appalled with the results of machine production. For them, the "art" element had vanished, and a need for reform was strongly felt both here and abroad to revive hand workmanship and to control the number of issued print editions. The limited-edition print, with its direct connection between artist and printmaker, respected the intimate link between inspiration and execution that has always appealed to connoisseurs.

The conference plan thoughtfully balanced lectures, exhibitions, and events to devote equal attention to those prints made for the masses versus "artistic" prints

of limited production. Half of the talks dealt with the development and flowering of lithography, chromolithography, and popular print production spanning the years from 1830 to 1900; the remainder addressed the subject of limited-edition or studio prints by American painter-printmakers of the third quarter of the century. The American Antiquarian Society, Worcester, through its print curator, Georgia Bumgardner, kindly provided the conference with a film made by Elizabeth Gilmore Holt and Wheaton Galentine, "Pictures to Serve the People— American Lithography, 1830–1855." Four exhibitions mounted especially for the conference and open to the public were designed to complement all the conference talks:

"American Prints 1813 to 1913" at the Museum of Fine Arts (assembled by Clifford Ackley)

"The Lithographs of Rembrandt Peale, Alexander Jackson Davis, and Fitz Hugh Lane" at the Boston Athenaeum (assembled by Georgia Bumgardner, Sinclair Hitchings, and Bettina Norton)

"The Accomplished Lithographer: William Sharp" at the Massachusetts Historical Society (assembled by Bettina Norton)

"'Fine Art Lithography' in Boston: Craftsmanship in Color, 1840–1900" at the Boston Public Library (assembled by Sinclair Hitchings).

Receptions for one hundred conference registrants were given by the Massachusetts Historical Society, hosted by Stephen Riley, director, and Malcolm Freiberg, librarian; and by the Boston Athenaeum, hosted by Rodney Armstrong, director. A special party for conferees was hosted by Carl Crossman and Roger Howlett of Childs Gallery.

Of the nine annual American Print Conferences held since the first in 1970, this is the fifth to be published and the second to meet in Boston—a fact that speaks well for the strong collections and interests in American prints here. Especially to be commended are the dedication and energy of the planners of the conference, Sue Reed and Clifford S. Ackley, and of all those persons who lent them support. This publication would not have been possible without the encouragement of Jan Fontein, director of the Museum of Fine Arts; the editorial and design assistance of Judy Spear and Carl Zahn of the Office of Publications; and support by a grant from the National Endowment for the Arts, Washington, D.C., a federal agency.

<div align="right">Jonathan Fairbanks</div>

Other published conference reports in the American Prints series:

Prints in and of America to 1850. Edited by John D. Morse. Published for the Henry Francis du Pont Winterthur Museum, Winterthur, Delaware, by the University Press of Virginia, Charlottesville, 1970.

Boston Prints and Printmakers: 1670–1775. Edited by Walter Muir Whitehill. Published by the Colonial Society of Massachusetts, Boston, and distributed by the University Press of Virginia, Charlottesville, 1973.

Philadelphia Printmaking: American Prints before 1860. Edited by Robert F. Looney. Published by the Tinicum Press, West Chester, Pennsylvania, 1974.

American Printmaking before 1876: Fact, Fiction, and Fantasy. Published by the Library of Congress, Washington, 1975.

D.C. Johnston's Satiric Views of Art in Boston, 1825-1850

DAVID TATHAM

Chairman, Department of Fine Arts, Syracuse University

For the history of printmaking in Boston, the arrival of D. C. Johnston in 1825 marks the beginning of a new era. The work of the artisan engravers who dominated Boston printmaking for a century before 1825 may show us a good deal about their skills but it tells us little of their minds. With a few notable exceptions (for example John Singleton Copley's Stamp Act cartoon *The Deplorable State of America* [1765] and Henry Pelham's depiction of the Boston Massacre, *The Fruits of Arbitrary Power* [1770]) eighteenth- and early nineteenth-century Boston engravers tended to keep their personalities out of their work. To find the first significant body of Boston-made prints expressing a personal vision, and having some of the other qualities that distinguish art from craft, we must turn to Johnston.

David Claypoole Johnston was born in Philadelphia in 1798 and named for his father's employer, David Claypoole, the noted Philadelphia printer. In 1815 young David was apprenticed to Francis Kearney to learn the trade of metal-plate engraving; so far as we know, that was his only formal training. In 1819 he began his own business as a printmaker, showing an early talent for comic art but finding little profitable outlet for it. At this early point in his career he began his invariable practice of using only the initials of his first two names. He became an actor in his spare time and in 1825 he moved to Boston, where he joined the Boston Theatre Company and also set up as an engraver. After a single season on the Boston stage, he abandoned professional acting, though his love for the theater and for Shakespeare in particular never waned and still enlivens the details of many of his prints. For four decades, until his death in 1865, he was a leading printmaker in Boston and one of uncommon versatility. He was expert in all the intaglio processes, he designed wood engravings and doubtless cut a few blocks himself, and he shares with Rembrandt Peale the distinction of being one of the first American masters of the new medium of lithography.[1]

But to couple Peale and Johnston on any basis other than technical mastery of the medium would be laughable, for Peale, whose exceptional talents had been shaped by the best teaching of Europe and America, was ever the academic artist and justly ranks high among those tastemakers who urged on Americans a reverence for high art along with a disdain for any other kind. Johnston, on the other hand, whose eyes were not set on a career in the loftier realms of art, saw more than a little that was inept, tired, and pretentious in the fine arts of his age, and, from the safety of his shop, fired away at the bastions of genteel taste and some of its more shallow-brained defenders.

Johnston was a social satirist of broad scope. There can be little doubt that he viewed himself as the chief American representative of the British tradition of comic art that begins with Hogarth. For Johnston, that tradition had culminated

in the work of his slightly older British contemporary George Cruikshank, whose prints he admired and to some extent emulated. Yet, despite some Cruikshankian touches, Johnston's comic work is unmistakably American in both its subject matter and in the broadness of its humor.[2]

Consider a pair of lithographs drawn by Johnston late in 1827 and printed by John and William Pendleton in Boston. The first of these is a political cartoon, *A Late Student* (fig. 1), in which Johnston shows Duff Green, editor of a Washington newspaper, the *United States Telegraph*, trying to teach the devil to be a better liar. Green encourages his struggling student to take heart, saying that in order to facilitate his learning he [Green] has engaged an able assistant. Though neither named nor shown, this assistant would have been understood at the time to be the Boston journalist Russell Jarvis, whom Green had just taken on as coeditor of the *Telegraph*. Their newspaper strongly advocated the election of Andrew Jackson as president in 1828, a disagreeable notion to Johnston, whose anti-Jackson prejudices ran strong. *A Late Student* seems to be just what Johnston's lively imagination would fashion from these circumstances, but in fact the idea is not his. From the beginnings of the history of cartooning, comic artists have welcomed and used suggestions from any source and Johnston was no exception. Both the concept and the general pictorial design, along with a fee to execute it, were supplied to Johnston by an aide to Massachusetts senator Daniel Webster. Nevertheless, most of the details, particularly the rogues' gallery of portrait busts at the upper left, which includes a villainous caricature of Jackson, are probably original contributions by Johnston, and no other comic artist then active in America could have executed the idea so well.[3]

The history of *A Late Student* is worth reviewing. Russell Jarvis, the Boston journalist who is the real subject of the cartoon, discovered that the print was in the works. He went to Johnston's shop, where he learned that the lithographic stone with its completed drawing had already been delivered to the Pendletons for printing. Jarvis rushed there, grasped the stone, and flung it to the floor, breaking it. After the brawl that ensued, Jarvis was bodily heaved out of the shop. The Pendletons pieced the stone together, Johnston lettered a new caption on it, "The Crack'd Joke," and it was printed, recording in each impression the fracture lines and stone loss that document Jarvis's call. Johnston then drew a companion piece, *Xenophon's Retreat out of the Enemy's Country. A Brief Ejectment*, in which Jarvis, still unnamed but now visible, is booted by John Pendleton out of the shop and into Graphic Court.[4] The two prints were sold as a pair.

In *Xenophon's Retreat* we see a device that Johnston used in a number of his early comic prints, the inclusion of subsidiary figures or faces to cue the viewer that everything was meant in fun and encouraging him by example to laugh at the strange events depicted. This spirit of amiability sets Johnston's work apart from the dour and occasionally malevolent cartoons of some of his contemporaries.

Another of Johnston's early lithographs, *Gymnastics* (fig. 2), drawn about 1830, pokes fun at the vogue for outdoor and indoor gymnasiums that arose in the late 1820s in Boston. The print is all farce. Rungs snap as readily as legs.

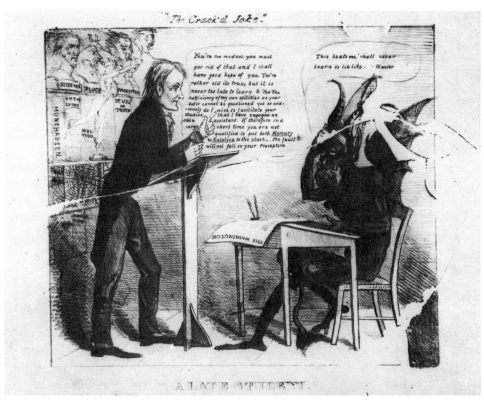

1. *A Late Student*, 1827. Lithograph, 8¼ x 9¼ in.
American Antiquarian Society, Worcester, Massachusetts

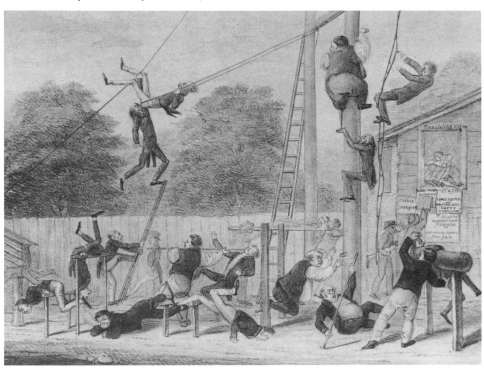

2. *Gymnastics*, ca. 1830. Lithograph, 7½ x 10½ in.
American Antiquarian Society, Worcester, Massachusetts

Collisions promise a field day for the surgeon shown in his amputating room at work with a bucksaw. Lest it all seem too grisly, the prone figure puffing on his cheroot at lower left smiles at us—as well he can, since the leg he has lost is wooden—and winks to assure us that it is all a joke.

The drawing in these early lithographs is lively, free, assured, and altogether admirable, though it serves subjects that are far from genteel and make no claim to beauty. Johnston's investment of his talent in comic art freed him from the strictures of academic practice and allowed him to respond more freely to the vitality of the new and unsophisticated democratic society in which he lived. Where the primmer souls of his age were apt to see only vulgarity, Johnston recognized the positive and sometimes comical signs of a young and growing culture and responded with good-natured satire. His art is Jacksonian, not in the narrow sense of political partisanship (for, as we have seen, Johnston had a low opinion of Jackson) but rather in its anti-elitist sentiments, in its use of humor as an important tool of expression, and in its sympathy with the changes that were reshaping American society, changes that posed difficult questions about the usefulness of older traditions and institutions.

What, for example, was to be the place of the fine arts in a democracy? Johnston delighted at opportunities for exploring this question. One of his earliest and most memorable responses appeared in a small watercolor exhibited at the Boston Athenaeum in 1828.

The Heavenly Nine (fig. 3) depicts the muses of Greek mythology, each identified by a grotesque parody of her attribute. At left, Urania, muse of astronomy, sits on her sphere, here transformed into a cannonball, while she squintingly studies the stars, as they are listed on a playbill. A loutish Terpsichore stomps out a dance to the accompaniment of her Jew's harp. Clio, who has downed one ale too many, dozes stuporously on a stack of children's histories. Behind her, Polyhymnia, a hand-cranked barrel organ on her back, declaims heavenward, while Melpomene, muse of tragic poetry, saws off her own head as she sings. She is, as Johnston says elsewhere (see note 5) in one of his awful puns, "sawing the air." Thalia, muse of comedy, is in stitches over a book by Thomas Hood, the English humorist. Above this graceless company atop Mount Parnassus sits an insane asylum.

Far more respectful treatment of the subject can be seen at the Museum of Fine Arts, Boston, for example, in Claude Lorrain's *Parnassus* of 1680. Although the painting was not in Boston during Johnston's lifetime, he may have known it through engravings, for he collected prints and had a good knowledge of the history of art. It seems unlikely that Johnston's intention in *The Heavenly Nine* was to demean Claude's picture or any other worthy treatments of the subject of the muses in the past; rather, Johnston's chief aim probably was to ridicule what he saw to be the inept and clumsy uses of classical themes in American art, architecture, and literature. His watercolor may be a burlesque of some specific painting of the muses exhibited in Boston in the late 1820s.

In 1831 Johnston etched *The Muses* (fig. 4), a variant of *The Heavenly Nine*, to serve as an illustration in the *American Comic Annual*. In this little print, which is less than five inches wide, Apollo presides, with his lyre exchanged for a

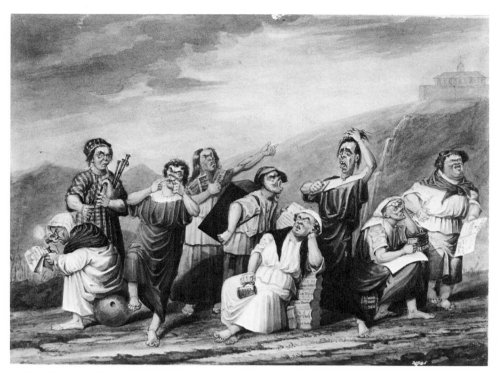

3. *The Heavenly Nine*, 1828. Watercolor, 10¼ x 13¾ in.
American Antiquarian Society, Worcester, Massachusetts

4. *The Muses*, 1831. Etching, 2¾ x 4¾ in., from Henry Finn, ed.,
American Comic Annual (Boston, 1831), facing p. 93.
American Antiquarian Society, Worcester, Massachusetts

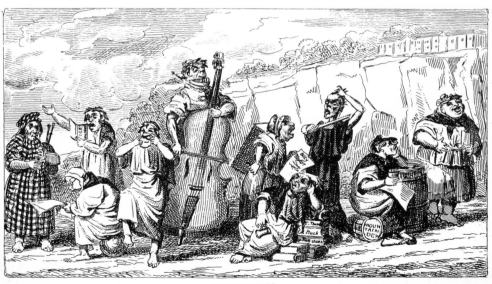

THE MUSES

bass viol. The muses are rearranged slightly to accommodate the new arrival. Euterpe's music continues to come from bagpipes, but Calliope now reads a contemporary epic, the *Boston Directory* for 1830. Erato remains seated on a keg of whiskey with a glass in her hand, incapable of moving very far. The insane asylum has become a famed resort, the Catskill Mountain House, its classical revival façade and its reputation as an American Parnassus in the wilderness both lampooned.[5]

As an etcher, Johnston liked to work in a small format. Over a period of two decades beginning in 1828 he etched, printed, and published nine numbers of *Scraps*, an annual, each of which consisted of four large pages of original etchings bound together in wrappers, every page containing eight to twelve comic vignettes.[6] In format and style, his model was a series of publications issued in London by George Cruikshank.[7] The 375 vignettes that make up the complete run of *Scraps* give us Johnston's highly personal and remarkably vivid commentary on many aspects of American culture of the second quarter of the nineteenth century. More than two dozen of the vignettes comment satirically on the world of art in America, as Johnston observed it from his vantage point in Boston.

The plight of the portrait painter in contending with misapprehended classical references is the subject of *Venus and Cupid* (1830, fig. 5). The capacious sitter, whose image on canvas is something less than a faithful likeness, complains about being painted as the Venus de' Medici (or as she understands it, "Wenus the Methodis") and asks to be shown instead as one of the muses, "Polly Meaner on Mount Pernicious," that is, as Polyhymnia on Mount Parnassus. She says that if smoking were not so vulgar, she would like to be painted as a "female shepherdess" with a pipe in her mouth. The painter speaks of his own picture of the muses. If he has in mind *The Heavenly Nine*, so much the worse for the sitter, for Johnston's Polyhymnia is scarcely a fit model. Very likely a different painting of the muses is referred to here, since the painter is not treated sympathetically and does not resemble Johnston, who never hesitated to tuck his self-portrait into *Scraps*. Indeed, we find it here in the background. It seems possible that this vignette is a second burlesque—*The Heavenly Nine* being the first—of some specific picture of the muses well known to Johnston's viewers.

The trials of portrait painters constituted a theme on which Johnston devised a number of variations. In *Comparison* . . . (1837, fig. 6) another portly sitter is being painted in the character of a classical goddess, in this case as Hebe, the eternally youthful handmaiden of the gods. The sitter conspires to aid the painter by holding a hot poker, which she expects will serve nicely as a model for the stinger of the "he-bee."

Johnston's most succinct statement on the subject of painters sorely tried by sitters exists in his drawing *The Artist at a Standstill* (in the American Antiquarian Society, Worcester, Massachusetts), which probably dates from the 1850s. He shows a sitter whose ugliness is so forbidding as to repulse any hope for a satisfactory picture. A true likeness would result in a gruesome painting while wholesale idealization, were it within the painter's powers, would result in an unidentifiable face, a figment of the artist's imagination. Johnston seems

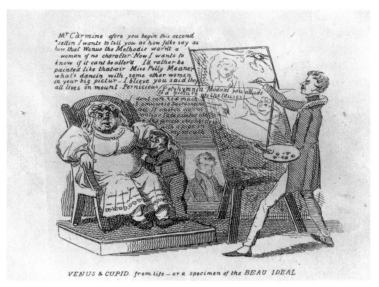

VENUS & CUPID. from life – or a specimen of the BEAU IDEAL

5. *Venus & Cupid*, 1830. Etching, 2½ x 2½ in., from plate 1
of *Scraps No. 2 for 1830*. Syracuse University Library

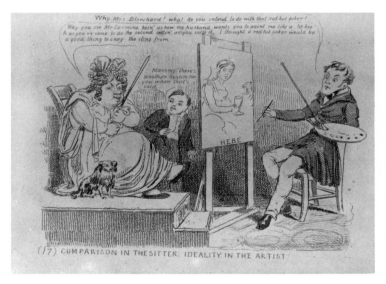

(17) COMPARISON IN THE SITTER. IDEALITY IN THE ARTIST

6. *Comparison in the Sitter*, 1837. Etching, 2¾ x 3¾ in., from plate 2
of *Phrenology Exemplified . . . being Scraps No. 7*. Collection of the author

15

never to have worked this little sketch into a print, perhaps because it is an adaptation of an etching by George Cruikshank, *Ugly Customers*, which appeared in 1835.[8] It is tempting to see the long face of Gilbert Stuart on Johnston's painter, though the physiognomy is found on Cruikshank's painter as well.

A number of *Scraps* vignettes deal with student and amateur artists. In one of 1849 (New Series No. 1), a teacher cautions his young student to "bear in mind that the face of every sitter is refulgent with intellect; therefore, observe your subject closely, for although a pumpkin on a cigar box will not find fault should you fail to express in full the vigorous mind within, this will not be the case when you come to paint the vegetable occupying its natural position between a couple of human shoulders." In another vignette on the same page, a dreadful pun springs to life: *An Officer Drawing His Sword*.

Connoisseurship, or more correctly, false connoisseurship, is a subject Johnston treated on several occasions. In *Veneration* (*Scraps* No. 7, 1837; fig. 7) a group of would-be connoisseurs burble on before a painting, separately identifying it as a Claude, a Titian, a Snyders, and a Michelangelo, in the last instance claiming it to be a prime example of the great master's flower painting. The picture that is so thoroughly admired and so variously identified proves in fact to be resting upside down. In *Connoisseurs* (*Scraps* No. 2, 1830; fig. 8) we see an exhibition of the sort that was held annually at the Boston Athenaeum. At left an unscrupulous dealer commissions his copyist to fake another Guido Reni, reminding him to paint indistinctly and to smoke the canvas. Fools and foolish remarks abound. The sole reasonable-looking person in the crowd is the tousle-haired figure right of center, a self-portrait of Johnston. In another vignette of 1835 (*Scraps* No. 6) Johnston makes fun of the prattle of art criticism by showing literally what is meant figuratively, with a result that is akin to a rebus. The legend beneath the vignette begins, "A picture remarkable for strength, depth & sharpness in the foreground," and we see brawny arms, a well, and axes. The picture is also remarkable for "harmony, playfulness, boldness of touch, an equal balance of light and shade, warmth and distance."

Some *Scraps* vignettes touch on specific works of art exhibited in Boston. One (1832, No. 3; fig. 9) deals with Horatio Greenough's sculpture *The Chanting Cherubs*, a group commissioned by James Fenimore Cooper and executed by Greenough in Florence. The figures, taken from a pair of *putti* in the foreground of Raphael's *Madonna del Baldacchino* at the Pitti Palace, were first exhibited in April of 1831 in Boston, the sculptor's native town. The public response was generally positive but not wholly so. A few visitors complained that the figures were mute. In an age of ingenious mechanical contraptions, they felt that Greenough had misled them by titling his group *The Chanting Cherubs* when the figures, in fact, did not sing.[9]

A second complaint, and the one that is twitted by Johnston here, was that the cherubs were nude. They were criticized as being indecent and shocking. Greenough had anticipated such a complaint from American viewers and had designed a set of junior-size alabaster fig leaves that could be affixed with ribbons to the figures, but he soon enough abandoned the idea as silly. The Boston exhibitors compensated for Greenough's reckless liberality, however, by dressing

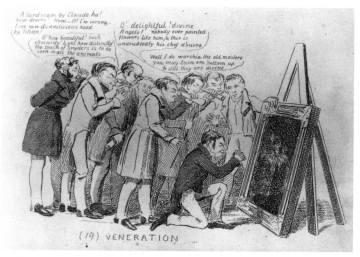

7. *Veneration*, 1837. Etching, 2¾ x 5¾ in., from plate 2 of *Phrenology Exemplified . . . being Scraps No. 7*. Collection of the author

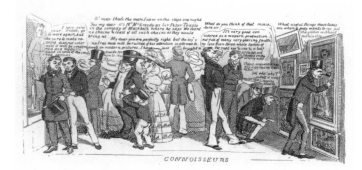

8. *Connoisseurs*, 1830. Etching, 2½ x 5¼ in., from plate 4 of *Scraps No. 2 for 1830*. Syracuse University Library

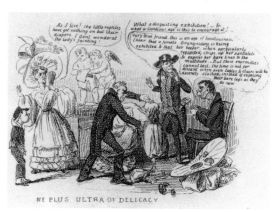

9. *Ne Plus Ultra of Delicacy*, 1832. Etching, 2½ x 3½ in., from plate 3 of *Scraps No. 3*. American Antiquarian Society, Worcester, Massachusetts

the figures in dimity aprons for a few days, to the great glee of the press in other cities. In Baltimore, one journal hoped that "this pure spirit of delicacy may be extended over Boston Common until every cow shall wear pantaletts."[10]

In his vignette, Johnston shows a lady of such delicacy that the sight of even diapered cherubs has sent her into a swoon. That she may not in truth be quite as innocent as she appears is suggested by the titles of the volumes that have tumbled from her handbag: Thomas Moore's *Letters and Journals of Lord Byron* (1830) and the Reverend John McDowall's *Magdalen Facts* (1832) were two of the more scandalous volumes of the 1830s. *Magdalen Facts* also peeps out of the pocket of a sanctimonious onlooker who remarks reprovingly on the licentiousness of the age.[11]

Johnston sent this etching to Greenough, who responded in August of 1832 with a letter from Florence in which he commented "I am happy to see by the way you have treated the exhibition of the Chaunting Cherubs that you think with me that those who would fain improve us by rendering us ignorant of our nature—who teach us to be ashamed of our glory—and make life one continued dissimulation, are the worst enemies of true virtue."[12] As an assault on prudery, Greenough's sobersided letter is less memorable and less effective than Johnston's ridicule. The statuary itself is lost; its whereabouts, if indeed it still exists, have not been recorded in this century. The only pictorial evidence of the group consists of a small rough sketch in one of Greenough's letters (see note 10) and this etching by Johnston.

In the 1840s the vogue for mammoth paintings peaked in Boston. After the successful tour of Rembrandt Peale's *Court of Death* in 1820, both the dimensions of traveling show pictures and their quotient of moral uplift grew hand in hand, season by season. Indeed, the format of mammoth paintings increased in the 1840s with the development of a hand-cranked apparatus capable of drawing a canvas of seemingly endless length, and perhaps four to twelve feet high, from one reel to another across a stage. The titles of the panoramas help explain something of their popularity; even now our curiosity is stirred by such titles as *The Moving Panorama of the Drunkard* and *A Walk in the Garden of Eden with Adam and Eve*. Most were promoted in terms of size. John Banvard's *Moving Panorama of the Mississippi River*, which was shown in Boston in 1846 and 1847, was claimed by its proprietors to be three miles long. Certainly, it was not; still, it must have *seemed* that long while its four reels of canvas took two hours to pass before its audience. Banvard's success spawned a number of other river panoramas and among these was Benjamin Champney's *Great Original Picture of the River Rhine and its Banks*, which opened at Horticultural Hall in Boston late in 1848, just as Johnston was working up what would be his last number of *Scraps*.[13] Poking fun at these protracted watery travelogues, Johnston offered the river Humbug, whose flanking hills question themselves as to which particular river panorama they are playing in at the moment. One suggests to another that the water below them resembles a serpentine stream, and we see the inspiration for his remark swimming away. It is a topical reference: in November of 1848 the press was alive with stories of a British ship sighting a sea serpent of remarkable length in the North Atlantic.[14]

Below the vignette Johnston lettered his parody of the sort of patter that accompanied panoramas. His phrase "The Largest Monster Panorama of all Creation" pertained not only to the sea serpent but also, in its mention of "creation," to two moving panoramas shown in Boston late in 1848, each dealing with the history of the world from its creation to the deluge. Of the two, the most newsworthy was *The Antediluvian World*, because it was designed by a celebrated British painter of the sublime, John Martin. Advertisements claimed that the first two hundred forty feet of Martin's panorama depicted the creation of the world.[15] Transforming the sublime to the ridiculous, Johnston gives us Raffaelle Viledaub (fig. 10), an artist who may be understood to represent all painters of panoramas, and who is seen here at work with a generous brush on *his* version of the creation of the world, the first six miles of which show the passage from Genesis, "when darkness was on the face of the deep."

Though Johnston has left us a rich source of information about two decades of Boston life in his *Scraps*, little political satire is found in it. Johnston preferred to tackle that subject on the larger scale of the broadside print. He did so on one occasion by setting his political commentary in the context of art. His etching *Exhibition of Cabinet Pictures* (fig. 11), published in 1831, is made up of twenty-three miniature political cartoons, shown as pictures hung from ceiling to floor in a cabinet (to use the old term for a small gallery). At lower left the print is signed "Snooks," one of several pseudonyms used by Johnston from time to time, though in fun rather than to hide his identity, which is made clear enough in this print by means other than a name, as we shall see. Unlike the earlier *Late Student*, this cartoon seems to be wholly original with Johnston.

The end wall is taken up by a cabinet library. Of the many books, only three titles are covered with cobwebs and evidently have never been read: *Political Economy*, *Johnson's Dictionary*, and *Murray's Grammar*, the last two serving to

10. *Raffaelle Viledaub*, 1849. Etching, 2¼ x 4¼ in., from plate 3 of *Scraps No. 1, New Series*. Syracuse University Library

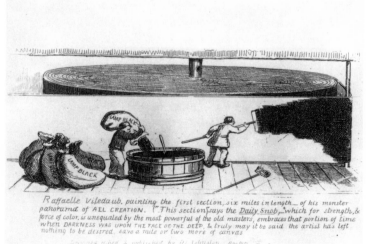

Raffaelle Viledaub, painting the first section, six miles in length — of his monster panorama of ALL CREATION. ("This section,"says the *Daily Snob*, "which for strength, & force of color, is unequaled by the most powerful of the old masters, embraces that portion of time when DARKNESS WAS UPON THE FACE OF THE DEEP, & truly may it be said the artist has left nothing to be desired, save a mile or two more of canvas.")

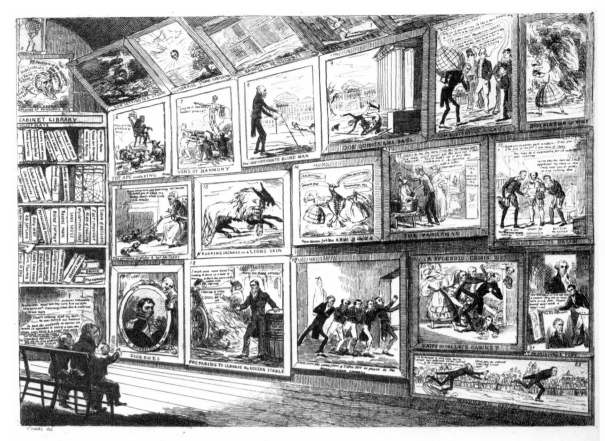

EXHIBITION OF CABINET PICTURES

11. *Exhibition of Cabinet Pictures*, 1831. Etching, 8 x 11 in.,
American Antiquarian Society, Worcester, Massachusetts

point up what Johnston saw as the comparative illiteracy of President Jackson, who is, of course, the main subject of satire in this cartoon. The titles of the other books refer to the most talked-about political crisis of 1831, the Peggy Eaton, or "petticoat," affair.[16] Two years earlier, in 1829, Jackson's friend and secretary of war, John Eaton, married the former Peggy O'Neale, once a barmaid in her father's popular Washington inn and by 1828 a young widow. Because of her background and the gossip that she and Eaton had been scandalously involved long before her first husband's death, the wives of the other cabinet officers refused to accept her socially, much to the annoyance of the president, who had known Peggy for years and who had advised his friend Eaton to marry her. The titles of the un-cobwebbed books in the cabinet library joke about it: *Innkeeper's Daughter*, *Secrets of the Tavern*, *All for Love*, *School for Husbands*, and the punning *Eaton College*. The petticoat affair worsened the already strained relations between the president and his cabinet with the result that in the spring of 1831 all but one member resigned.

At upper right we see a petticoated figure putting the torch to Troy. Painting number 14 shows a new design for the arms of the United States made of corsets, petticoats, and a booby gannet. In number 13 Jackson tries to scrub a petticoat clean. He is told by a washerwoman that he will never get the dirt out of it. On the wall behind them is a full-length picture of President Jackson with cane and hat in hand after a painting by Ralph E. W. Earl. Johnston knew that the Pendleton shop had just been commissioned to make a lithographic reproduction of this painting, with the goal of having hundreds of impressions available for the 1832 presidential election campaign. The print is parodied here in this tiny detail even before it has been drawn on stone.

In picture number 20 at lower right, Peggy joins in the fray as Jackson and his cabinet let fly at each other. Martin Van Buren looks on approvingly from a safe distance, expecting that the crisis can only aid his own aspirations. Below, in number 22, Jackson is tripped up by a petticoat in his forthcoming race against Henry Clay. Just above the figure of Clay, in number 21, is Johnston himself in a self-portrait as a painter, palette and brush in hand. On the wall behind him is Gilbert Stuart's Athenaeum portrait of Washington. Johnston holds a glum-looking likeness of Jackson captioned "The Second Washington" and remarks in mock ignorance that he sees no difference between the original and the copy.

At lower left, out of the world of the pictures, the mood and manner change. In contrast to the ludicrous satire of the rest of the print, Johnston's detail of a father and his sons contemplating a portrait of Commodore William Bainbridge is touched with irony. Bainbridge, a senior naval officer of great integrity and achievement, was well known and widely respected in Boston as a result of three tours of duty as commandant of the Boston Navy Yard. He was relieved of his command by Jackson's secretary of the navy for reasons that were political and indefensible, and the president refused to intervene. Jackson's shabby treatment of Bainbridge was to Johnston a far graver human failing than all of the non-sense surrounding the Peggy Eaton affair. Only rarely did Johnston express strong feelings pictorially without first recasting them in humorous terms, but with Bainbridge, and later with the burning of the Ursuline Convent in Charlestown by a mob, and later still with the issue of slavery, Johnston could not laugh at what he saw to be injustice and worse.[17]

It was not possible for Johnston to support himself and his family by comic art alone and so from the beginning to the end of his career he made prints of all sorts, from trade cards to calling cards, and he illustrated many books. He was also an active and popular teacher, conducting afternoon classes in drawing and painting and evening classes in mechanical drafting. As a painter he exhibited annually at the Boston Athenaeum and was consulted by the trustees of that organization about old master paintings. He was on good and close terms with most artists in Boston. He was in fact always very much a part of the world of art he so regularly parodied, and it is not always clear whether he is making fun of that world or not. Some of his paintings were intended to be comic, and are unmistakably so, but when he aimed at seriousness the result seldom seems serious enough to suit our tastes. For example, his small oil portrait of Washington Allston at the Bowdoin College Museum of Art has an element of carica-

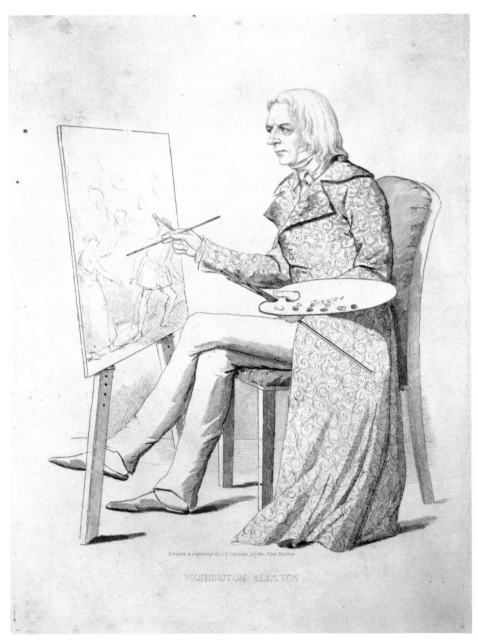

12. *Washington Allston*, 1843. Etching, 6½ x 5¼ in.,
from *The New Mirror*, vol. 2, no. 2 (October 14, 1843), facing p. 17.
Museum of Fine Arts, Boston. M3031

ture. It was perhaps with this painting in mind that the editor of the *New Mirror*, a popular magazine published in New York, asked Johnston to etch a portrait of Allston not long after his death in 1843. Johnston did so, using as a model S. V. Clevenger's bust of Allston (at the Boston Athenaeum) with a result that comes perilously close to caricature (fig. 12). Even with so respected a subject as Allston, Johnston found it hard to suppress a grin.

D. C. Johnston had no predecessors as a graphic satirist in Boston, nor any immediate successors of significance. Though he taught all of his children to be artists, he seems not to have encouraged them in comic expression. His two sons became painters, Thomas a successful portraitist, and John an animal painter and the chief assistant of William Morris Hunt in his great mural for the state capitol at Albany. Johnston's three daughters were all skillful amateurs.

In 1860 Johnston and his family moved to the suburbs, settling into a little country villa next to an orchard in Dorchester, not far from the rail line to Boston. He died there in November 1865 at age sixty-seven. In a general sense all artists live on in their work, of course, but few nineteenth-century American artists have left as vivid and interesting a record of themselves as has Johnston. His lively mind freshly engages ours each time we look at his prints and smile.

NOTES

I wish to record my gratitude to Mr. and Mrs. Edmund F. Freeman, who have generously shared with me memorabilia and lore about D. C. Johnston, Mr. Freeman's great-grandfather. My research for the present paper, and for a comprehensive study of the artist and his works, has been aided by a grant from the Council of the American Antiquarian Society, allowing me to spend the month of May 1974 as a Visiting Research Fellow at the Society's library in Worcester, Massachusetts.

1. Brief biographical sketches of Johnston include Clarence S. Brigham, "David Claypoole Johnston, 'The American Cruikshank,'" *Proceedings of the American Antiquarian Society* 50 (April 1940), pp. 98–110, and Malcolm Johnson, *David Claypool Johnston*, exhibition catalogue ([Worcester: American Antiquarian Society] 1970), pp. 5–14. Whether Johnston spelled his middle name with a final *e* is not clear; no evidence in his own hand either way has yet come to light. The artist's own humorous autobiographical sketch appears in William Dunlap, *History of the Rise and Progress of the Arts of Design in the United States*. 2 vols. (New York: published by the author, 1834), 2, pp. 327–332.

2. He must have been well acquainted with the work, and perhaps also the persons, of two older graphic satirists whose careers were closely associated with Philadelphia, William Charles (1776–1820) and James Akin (ca. 1773–1846), although his work developed in rather different directions than those seen in the prints of his older contemporaries. For the most recent studies on Charles and Akin, see Lorraine Welling Lanmon, "American Caricature in the English Tradition: The Personal and Political Satires of William Charles," *Winterthur Portfolio* 11 (Charlottesville: University Press of Virginia, 1976), pp. 1–51; and Maureen O'Brien Quimby, "The Political Art of James Akin," *Winterthur Portfolio* 7 (Charlottesville: University Press of Virginia, 1972), pp. 59–112.

3. John Sullivan, "The Case of 'A Late Student': Pictorial Satire in Jacksonian America," *Proceedings of the American Antiquarian Society* 83 (October 1973), pp. 277–286. Illustrated.

4. Ibid. Reproduced on p. 282. The present writer and others who have speculated about the meaning of this pair of cartoons are indebted to Sullivan for tracking down the history of the prints.

5. Henry J. Finn, ed., *The American Comic Annual* (Boston: Richardson, Lord, and Holbrook, 1831), plate facing p. 93. The etching illustrates the long doggerel poem "The Muses in Masquerade," pp. 93–103, which, though unsigned, is probably by Johnston in collaboration with Finn. The poem is set "upon the Catskill Mountain."

6. David Tatham, *A Note on David Claypoole Johnston with a Check List of his Book Illustrations* (Syracuse University, 1970), pp. 8–9. *Scraps* was published for each of the following years, publication occurring in the final weeks of the preceding year in each case: 1829, 1830, 1832, 1833, 1834, 1835, 1837, 1840, 1849.

7. George Cruikshank, *Phrenological Illustrations* (London: published by the author, 1826); idem, *Illustrations of Time* (London: published by the author, 1827); and idem, *Scraps and Sketches*, part 1 (London: published by the author, 1828).

8. George Cruikshank, *My Sketch Book* (London: published by the author, 1834–1836), plate 27.

9. Nathalia Wright, *Horatio Greenough* (Philadelphia: University of Pennsylvania Press, 1963), pp. 67–75.

10. *Niles Weekly Register* (Baltimore), June 18, 1831, p. 283. Greenough's sketch for the proposed fig leaves is reproduced on plate 2 of *Letters of Horatio Greenough*, ed. Nathalia Wright (Madison: University of Wisconsin Press, 1972), pp. 66–69. See also Nathalia Wright, "The Chanting Cherubs: Horatio Greenough's Marble Group for James Fenimore Cooper," *New York History* 38 (1957), pp. 177–197.

11. *Magdalen Facts* (no. 1, January 1832) was the only number published of what had been projected as a periodical devoted to the exposure and eradication of prostitution in the United States. Its compiler, the Reverend John McDowall, was mortified when his reform tract became a best-seller on account of its unintended salaciousness. Few American readers had seen anything like the candid (for the time) accounts of brothels, fallen women, and saved magdalens (to use the then-popular euphemism for harlot). There is a brief account of McDowall and his publication in David S. Pivar, *Purity Crusade* (Westport, Conn.: Greenwood Press, 1973), pp. 25–28.

12. Greenough to Johnston, August 30, 1832, Manuscript Collections, American Antiquarian Society, Worcester, Mass.

13. Broadsides and other printed ephemera concerning these panoramas are owned by the American Antiquarian Society. Banvard's panorama is discussed at length in John F. McDermott, *The Lost Panoramas of the Mississippi* (Chicago: University of Chicago Press, 1958), pp. 18–46. Champney's Rhine panorama was announced in the *Boston Transcript* for October 30, 1848, and was favorably reviewed in the *Boston Post* for December 11, 1848, by which date it had been on view for a few days.

14. *Boston Transcript*, November 11, 1848.

15. *Boston Transcript*, October 14 and 20, 1848. Though designed by John Martin, the panorama was executed in Rome by Italian painters under the supervision of Martin's son Charles, according to the *Transcript* ads.

16. See *Dictionary of American History*, rev. ed., vol. 2 (New York: Charles Scribner's Sons, 1976), p. 389; and Claude G. Bowers, *Party Battles of the Jackson Period* (Boston: Houghton-Mifflin, 1922), pp. 116–133.

17. For Johnston's response to the burning of the convent, see *Scraps (No. 6) for the Year 1835* (Boston: published by the author, 1834), plate 4. See also Georgianne McVey, "Yankee Fanatics Unmasked: Cartoon on the Burning of a Convent," *Records of the American Catholic Historical Society of America* 83 (1972), pp. 159–168. Johnston's attitudes on the issue of slavery before the outbreak of the Civil War are not clear, but his etching *The House that Jeff Built* (1863; Museum of Fine Arts, Boston, K 1357) is a strong and unhumorous anti-slavery statement.

Panoramic Views of Whaling by Benjamin Russell

ELTON W. HALL

Curator, Old Dartmouth Historical Society Whaling Museum, New Bedford

Prints depicting whaling, although not as numerous as other genres, have always been important to collectors and cultural historians for their strong nineteenth-century romantic qualities. For the historian of the whale fishery they vary in interest from priceless to useless, since few printmakers had the faintest idea of what went on aboard a whaler, how the whale was pursued, or what the boats and equipment looked like. However, some accurate representations were produced by careful draftsmen who had been whaling or were thoroughly acquainted with the subject. Perhaps the most famous of these artists was Benjamin Russell of New Bedford,who went to sea and became an artist when his family whaling business failed. Each of the eleven prints bearing his name is regarded by historians as a reliable pictorial document and among the most desirable prints of the American whale fishery.

Born in 1803 into one of the oldest New Bedford families, Benjamin Russell was brought up with every anticipation of leading the prosperous life of a whaling merchant: his family was one of the most active in the industry, having interests in thirty-eight vessels at various times, as well as large real estate holdings. Benjamin himself held shares in ten vessels between 1829 and 1833.[1] When the Marine Bank was organized in April 1832, Russell was on the first board of directors. Edmund Wood, in an address to the Old Dartmouth Historical Society in 1911, described the Russell family business:

> *In 1830 we had in New Bedford, two commercial houses which at the time overshadowed all others, on the one hand were the Rotch's carrying on both foreign commerce and whaling with long continued success, on the other hand were Seth and Charles Russell, who had recently increased the prestige of that family and were rich and powerful. Some of their foreign ventures in commerce were brilliant, they carried a large bank balance in London, they owned many merchant ships and whaleships, and they had also acquired a large amount of real estate within the town.*[2]

Thus Seth, the father, and Charles, the uncle of Benjamin Russell, were thriving, and Benjamin doubtless had no reason to believe that he would not continue in the family business. However, the Russell family was caught in a constriction of credit caused by the banking disorders of 1832 and 1833—right in the middle of what Philip Purrington described as a "splurge of material ostentatiousness" that included the building of several mansions.[3] Unable to meet the notes presented by creditors, the Russell firm failed. The family were forced to forfeit their entire property because in those days of the demand note, a debtor could be imprisoned if his creditors were not satisfied. Samuel Rodman, a merchant with

close ties to many other leading families, recorded in his diary for December 30, 1833:

> *Engaged at the bank & c'g house A.M. The difficulties incident on the failures of Chas. Russell & George Tyson [Benjamin's brother-in-law] and the assignment of Seth Russell, making the principal business, a special meeting of the directors being also held in the afternoon.*[4]

The New Bedford banks agreed to receive a note of hand signed by Joseph Ricketson, John Avery Parker, Joseph Grinnell, and William Rodman for the sum of $38,851.66 with the property of the Russells as security.[5] By the following year the Custom House records show that the Russells had no interest in any vessels, and on July 30, 1835, an auction was held for the sale of twenty parcels of land including the mansions that had belonged to the Russell family.[6]

Naturally, lacking family resources, Benjamin's services were no longer required as a director of the Marine Bank. Edmund Wood recalled that Russell had drawn a caricature of the president of the bank, Joseph Grinnell, at a directors' meeting, seated at the head of the table on a block of ice. This picture was said to be "exceedingly popular with certain disappointed applicants for discount, who had been chilled by the presidential atmosphere."[7] The drawing has not turned up but, judging by a group of cartoons Russell did later in life, he was certainly capable of such mischief.[8]

In 1841 Russell embarked on the ship *Kutusoff* of New Bedford for a voyage of three years and five months. There is no apparent reason for Russell's choice of *Kutusoff*: none of the owners had any known ties with the Russell family, nor had the master, William H. Cox, ever sailed for the Russells when they owned vessels. It was simply an available berth when Russell was ready to go. Although thirty-seven years was an advanced age to begin whaling, Russell is believed to have had the position of cooper, a job less strenuous than pulling an oar. His obituary stated that he had served an apprenticeship to a cooper[9] (coopering having been a trade practiced by Russell's ancestors), and the settlement book for the voyage lists Russell as having the hundredth lay or share of the voyage, which was approximately that of a cooper. Eight years after the failure Russell was still heavily in debt, and the settlement shows that all of his share in the proceeds of the voyage was assigned to other persons, so that Russell received nothing himself.[10]

Perhaps the principal benefit of the voyage to Russell, and certainly to us, is that his experience at sea enabled him to gain thorough knowledge of whale fishery. *Kutusoff* circumnavigated the world, engaged in both sperm and right whaling, and visited many ports commonly frequented by whalers. This experience was to serve him well in the years to come.

The *Panorama of a Whaling Voyage around the World* is the earliest known datable artistic effort by Russell.[11] It was a painting 8½ feet high and approximately 1,300 feet long, accomplished when Russell was well into his forties, and one wonders what background he had that would suggest to him his ability to make a success of it. Earlier writers have made reference to Russell's interest in making drawings along the New Bedford waterfront as a young man, but no such identified sketch is now known. Russell attended Friends Academy and,

52066

since drawing was considered a polite accomplishment, he might have had classes with a drawing master as part of his general education. There is certainly nothing about any of his pictures that suggests he ever had extensive training with an accomplished artist. The merit in his work is in the great care with which it has been executed and the meticulous attention to correct detail seen throughout.

After production of the *Panorama* and prior to 1867, the year Russell is first listed in the city directory as an artist,[12] he seems to have shifted from one job to another, living at different addresses, employed variously as a clerk or accountant. During this period, perhaps encouraged by the success of the *Panorama* and uninspired by life in the counting house, he began to support himself by ship portraiture and whaling scenes. The watercolors thought to be Russell's earliest include some that he did for his own pleasure, such as a portrait of *Kutusoff*. Later on, his ship portraits show care in including the name and correct flags as if to insure the approval of the owner or master who was probably the intended customer. It would be logical for Russell to consider lithography as a potential source of income, and in 1848 he did so.

One of Russell's handsomest lithographs is entitled *A Ship on the North-West Coast Cutting in Her Last Right Whale* (fig. 1). Removal of blubber and baleen is shown in the center; at left the same vessel is portrayed homeward bound. There are two impressions in the collection of the Old Dartmouth Historical Society, one black and white and the other hand-colored. In the latter, printed in a different typeface in the bottom margin above the title, is an additional line: "A whale's head with the bone attached." Another impression in a private collection includes a second extra line (in the same type as that indicating the

Benjamin Russell
(1803–1885)

27

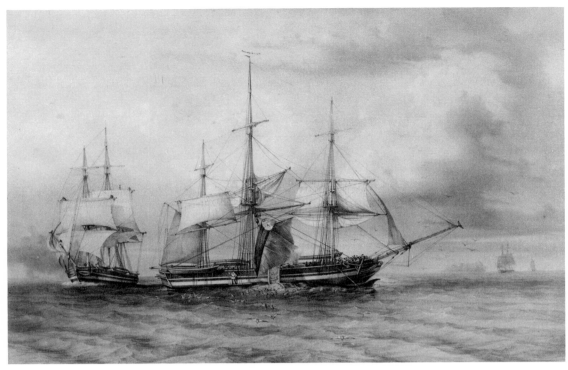

1. *A Ship on the North-West Coast Cutting in Her Last Right Whale.* 17¼ x 26½ in.
Designed by B. Russell New-Bedford / Printed by Lemercier, Paris / Lith by A. Mayer
Under vessel at left: *Same Ship Homeward Bound. Executed undre* [sic] *the Care of C. Combier,*
*Director of the American Agency, Rue Notre-Dame des Victoires, 40. Paris.**

whale's head): "Entered according to Act of Congress in the year 1848 by B. Russell in the Clerk's Office of the District Court of Massachusetts." It is the only known impression with the copyright line and provides the sole documentation for the date. The evidence suggests New Bedford as the principal place of publication, but a scan of local newspapers yields no editorial comment or advertisement for the print.

Northwest Coast scenes in the *Panorama* have much in common with this lithograph, not surprisingly, as they were contemporaneous. The vessels in both are full-rigged, a form that was superseded in the 1850s by the bark (that is, a ship with fore-and-aft sails on the mizzen or aftermost mast). They have old-fashioned single topsails instead of the later double topsails, and they are four-boat ships with no hurricane houses and only simple skids for the spare boats. Spare spars and lumber were secured on two timbers ("rooster tails") protruding from the stern. The style of the bow—with its heavy cheek knees and billet head, long curved trailboards and double hawse holes for hempen cables—the broad white band and narrower sheer-stripe along the sides, and the extensive fenestration in the stern are also indicative of the 1840s.

*All illustrations courtesy of the Old Dartmouth Historical Society, New Bedford, Massachusetts. Text quoted verbatim from the prints appears in italics.

Russell had much of a reporter's instinct for a newsworthy item that would sell. The subject he chose for his first lithograph would have had a broad appeal because so many people in New Bedford had family, friends, or financial interests on the Northwest Coast. Although most of his ship portraits give the vessel's name and show her house flag, these marks of identification are completely lacking here, an omission that seems deliberate so that a potential customer would not pass the lithograph by because it showed a vessel owned by a rival firm. It has been suggested that the ship is *Kutusoff* or *Arab*, but Russell's watercolors of these vessels are significantly different.

Production arrangements for this lithograph were different from those of Russell's subsequent prints; it is the only one he had lithographed abroad. No large-folio lithograph is known to have been published in New Bedford prior to 1848. Since he was embarking on a venture new to both himself and his city, perhaps he felt that the name of Lemercier, by then well established as the leading lithographic printer in Europe, would lend prestige to the print in addition to insuring as fine a job of printing as could be had anywhere.

The American Agency mentioned in the caption has not been identified, but from 1855 to 1865 the address rue Notre Dame des Victoires 40, Paris, was occupied by maritime agencies and commission houses. C. Combier, the director, may have been one Cyprien Combier, who in 1864 published a *Voyage au Golfe de Californie*.[13] Inclusion of his name on the print might then have appeared to be a favorable endorsement to New Bedford merchants.

This work is of distinctly higher artistic merit than any other lithograph or watercolor by Russell. The subject is well defined; the ships have a feeling of mass, perspective, and three dimensionality; the figures have weight, i.e., the crowd up in the bow seems more of a group than a row; and the surface of the water and sea birds are more convincingly rendered than in Russell's other works. These factors demonstrate a more competent hand, probably that of the lithographer, Auguste Etienne François Mayer (1805–1890). Mayer, a specialist in marine subjects who worked in Lemercier's shop, could have improved certain artistic elements and retained the correct details of the ship, thus giving the print the appearance of work by a more accomplished artist.

There are other early lithographs bearing Russell's name that were not primarily his work. They are *Sperm Whaling No. 1—The Chase* and *Sperm Whaling No. 2—The Capture* (figs. 2 and 3). The captions of both of these prints state that they were "from Drawings by A. Van Best [sic] & R. S. Gifford, corrected by Benj. Russell, Esq!"; they were lithographed by the firm of Endicott in New York and published by Charles Taber & Co. in New Bedford. The Charles Taber Company was an old New Bedford firm started as a bookstore by William C. Taber early in the nineteenth century. In due course, Taber added navigational instruments, took on a bookbinder and an instrument maker, and by the mid-1850s entered the picture business. Eventually the firm was called the Taber Art Company. In 1857, Taber published a broadside of New Bedford house flags, followed the next year by a city view called *New Bedford Fifty Years Ago* after a painting by William Allen Wall, and in 1859 they commissioned a pair of whaling scenes.

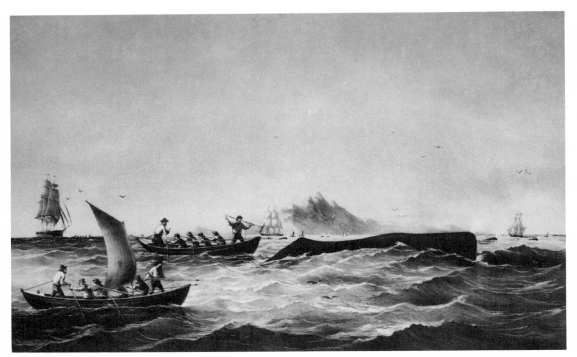

2. *Sperm Whaling, No. 1.— The Chase.* 16¾ x 26½ in. *Lith of Endicott & Co. New York /
Entered according to Act of Congress AD. 1859 by Charles Taber & Co.
in the Clerks Office of the District Court of Massachusetts.
From Drawings by A. Van Best* [sic] *& R.S. Gifford, corrected by Benj. Russell Esq.r
Published by Charles Taber & Co. No. 49 Union St. & No. 2 Purchase St. New Bedford, 1859.*

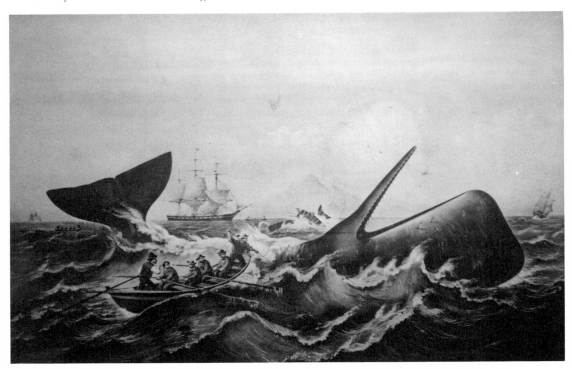

3. *Sperm Whaling, No. 2.— The Capture.* 16½ x 25¾ in. *Lith of Endicott & Co. New York /
Entered according to Act of Congress AD 1862 by Charles Taber & Co. in the Clerks Office
of the District Court of Massachusetts.
From Drawings by A. Van Best* [sic] *& R.S. Gifford corrected by Benj. Russell Esq.r*

The *Daily Evening Standard* of July 8, 1859, carried the following notice:

C. Taber & Co. have just published the first of a beautiful series of engravings illustrative of the whale fishery. It is entitled "The Chase" and represents a boat in pursuit of one of the monsters of the deep and the boatsteerer just about to plunge the harpoon into his body. Several ships and boats are in pursuit of others of the school, and a mountainous island rises in the background. The drawing is by Messrs. Van Beest and R. S. Gifford, well known and competent artists, aided by the experience of Benj. Russell, Esq., and the picture is executed in the best style of chromo-lithography. It will doubtless meet with a ready sale.

The next morning the *Mercury* also announced the print:

Sperm Whaling—The Chase—C. Taber & Co., have just issued another of their spirited representations of the Whale Fishery, from drawings by A. Van Beest and R. S. Gifford, corrected by Benj. Russell, Esq. and lithographed by Endicott, New York. The eagerness of the whalemen in close pursuit of the oleagic monster is admirably portrayed, while the flitting of the seabirds athwart the briny waves and the whaleships in the distance give a vivid effect to the picture.

The Taber firm itself placed an advertisement in the *Mercury* beginning July 10, 1859:

"GIVE IT TO HER" Sperm Whaling No. 1. The Chase—Great pains have been taken to have this picture a correct representation of whaling. The previous representations of this subject (except a few now out of the market) are caricatures rather than true pictures. We believe this to be in the main, an accurate representation. It is well got up on the best style of the art, and finely colored. Price to subscribers $5 for the pair, single copies $3.

Chas. Taber & Co.
No. 49 Union St. and 2 Purchase St.

There is a slight contradiction between the two editorial pieces quoted here. The *Standard* states that the print is the first in a series, while the *Mercury* refers to it as "another of their spirited representations . . . ," which implies that previous whaling prints had been issued by Taber. Another whaling print entitled *Sperm Whaling No. 2—The Conflict*[14] was published by Taber in 1858, the year before *The Chase*. The title, *Sperm Whaling No. 2*, implies that there ought to have been a *Sperm Whaling No. 1*, but no such print is known. *The Conflict* was obviously not intended to be a companion to *The Chase*, for the format and details of production and publication are different. An account given by Robert Doane, who had worked in Taber's store, may well explain the problem. Doane recalled seeing Van Beest bring in three sepia India ink sketches of whaling scenes about the same size as the lithographs. Taber mounted the drawings on boards with wide margins on which he invited whalemen to write criticism.[15] It appears that the remarks became so profuse and contradictory that Benjamin Russell was engaged to put the drawings in order. The three sketches referred to by Doane were probably the three that became lithographs. *The Conflict* bears

the earliest date and is the only one that Russell did not correct. We may, therefore, suppose that Russell became involved after its publication and reworked *The Chase* and *The Capture* into a pair of acceptable prints.

The backgrounds of the three artists involved in this pair of prints suggest the part that each one might have played. Albert Van Beest, born in Rotterdam in 1820, was a competent marine artist who was brought to New Bedford in 1854 by William Bradford. His principal contribution to art in New Bedford was to introduce a lively and romantic spirit not previously seen in local painting. Robert Swain Gifford, a native of Fairhaven, had shown an early interest in drawing and had been befriended by Van Beest, who noticed him drawing along the waterfront. Although only in his late teens at that time, Gifford showed sufficient promise to stimulate Van Beest's interest in him. He particularly liked drawing watercraft, and his earliest sketchbooks show that he took great pains over the work.[16] Van Beest, as the professional artist, probably received the commission for the prints and, both for assistance with details and as encouragement for his young friend, arranged for Gifford to have a part in the work. However, neither of these men knew anything about whaling, and to avoid the scornful criticism of those potential customers who did, Benjamin Russell was engaged to correct any discrepancies. The kinds of things Russell might have corrected would be the shape of the whale and the way he lay in the water, the gear in the boats and their positions as they approached the whale, and the ships in the background.

The second print of the pair, *Sperm Whaling No. 2—The Capture*, was not published until 1862. Perhaps Taber delayed its release in the hope that the stock of prints of the earlier *Sperm Whaling No. 2—The Conflict*, would be sold off, realizing that if he released the improved print, he would be stuck with the less successful one.

The composition of *The Capture* is not original, being derived from a lithograph by William J. Huggins entitled *The South Sea Whale Fishery*, published in London in 1833.[17] The Huggins print shows a sperm whale in the same position with a boat approaching. However, the New Bedford artists have improved upon the original by making it a much more lively scene. It was no doubt Van Beest who whipped up the seas and gave the boat crew more dramatic postures and determined expressions. Van Beest's drawing for the lithograph survives,[18] and it is quite close to the Huggins print. The difference between Van Beest's drawing and the finished product, which is much stiffer and less dramatic, may then represent the work of Russell and Gifford. The additions include a whaleship hove to in the background, a boat being overturned by a whale, a boat in the background going on a whale, a ship on the horizon, and a headland. The whaling scenes are certainly the work of Russell, although it is difficult to determine what Gifford may have done.

The Taber Company suffered a fire in the fall of 1862 and announced that their entire stock would be closed out immediately for cash. On November 11, 1862, they advertised in the *Mercury*: ". . . and we now offer the entire balance of editions of our series of engraving of WHALING SUBJECTS, three in number, price 50cts each plain, 75cts colored; New Bedford Fifty Years Ago, and the

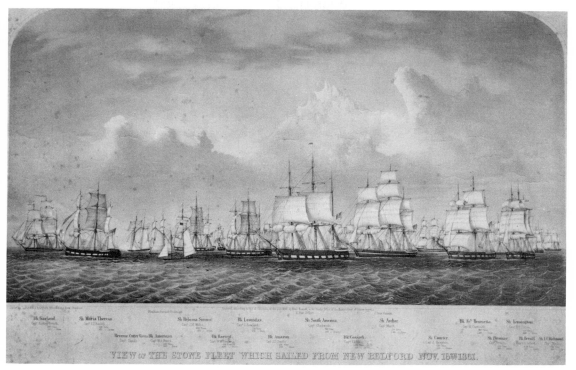

4. *View of the Stone Fleet Which Sailed From New Bedford Nov. 16th 1861.* 13 ½ x 24 ¾ in.
*Lith^d by L. Prang & C°, 34 Merchants Row, Boston / Entered, according to Act of Congress, in the year 1862
by Benj. Russell, in the Clerks Office of the District Court of Massachusetts.*
The following information is included in the lower margin from left to right: *Bk.* Garland,
Capt. Rodney French, 243 Tons, 190 Tons Stone / Sh. Maria Theresa, *Capt. T. S. Bailey,
330 Tons, 320 Tons Stone / Revenue Cutter* Varina, *Capt. Sands / Pilot Boats* Rescue *&* Richmond;
Bk. American, *Capt. W. A. Beard, 320 Tons, 300 Tons Stone / Sh.* Rebecca Simms, *Capt. J. M. Willis,
400 Tons, 425 Tons Stone / Bk.* Harvest, *Capt. W. W. Taylor, 314 Tons, 400 Tons Stone /
Bk.* Leonidas, *Capt. J. Howland, 231 Tons, 200 Tons Stone / Bk.* Amazon, *Capt. J. S. Swift,
318 Tons, 328 Tons Stone / P. Boat* Effort / *Sh.* South America, *Capt. Chadwick, 646 Tons, 550 Tons Stone /
Bk.* Cossack, *Capt. Childs, 256 Tons, 250 Tons Stone / P. Boat* Vision / *Sh.* Archer, *Capt. Worth,
321 Tons, 280 Tons Stone / Sh.* Courier, *Capt. S. Brayton, 381 Tons, 350 Tons Stone /
Bk. Fr.*⁵ Henrietta, *Capt. M. Cumiski, 407 Tons, 381 Tons Stone / Sh.* Potomac, *Capt. Brown,
356 Tons, 350 Tons Stone / Sh.* Kensington, *Capt. B. F. Tilton, 357 Tons, 350 Tons Stone /
Bk.* Herald, *Capt. A. H. Gifford, 274 Tons, 240 Tons Stone / Sh.* L. C. Richmond, *Capt. Malloy,
341 Tons, 300 Tons Stone*

Signal Sheet—price reduced to 37 ½ cents." This is the first and only known
indication of the fact that all three lithographs were in print and that they were
available plain as well as hand-colored. No uncolored impressions have turned
up. There is no record of the size of the editions of these prints or of how many
were sold.

Russell's next lithograph was the *View of the Stone Fleet Which Sailed from
New Bedford Nov. 16th 1861* (fig. 4), printed by L. Prang & Co., 34 Merchants
Row, Boston. The fact that Russell copyrighted the print in his own name sug-
gests that he intended to publish it himself. Strangely, no advertisements have
been found for it in the local newspapers. The event depicted is the departure of
a fleet of old whaleships purchased by the Navy Department to be sunk as
obstructions in the entrance to the harbors of Charleston, South Carolina, and

Savannah, Georgia. For months after the sailing of the fleet there are advertisements for gear that had been stripped from the vessels, but none for the print. Whether Russell sold them from his home or office or consigned them to a local book or art store is not known.

This is the only print for which Russell went to Louis Prang for lithography. There were two stones used in its printing, one black and the second blue. Unfortunately, the stock on which this lithograph was printed is acidic, and the use of knotty pine boards for frame backing, along with the effects of coal heating and the moist atmosphere of the waterfront, have prevented many impressions from surviving in good condition. A number of examples that have passed through the hands of dealers have been heavily cleaned and recolored, making it difficult to know exactly what one is looking at. It is helpful to examine more than one impression.

Russell showed himself to be more journalist than artist in the Stone Fleet print. Every vessel that sailed with the fleet is included in the picture, and down at the bottom is listed under each vessel its name, the name of its master, tons measurement, and tons of stone aboard. The vessels are overlapped so that many of them would hardly be noticed were it not for the caption indicating that they were there. The print portrays realistically the tremendous traffic jam that must have taken place on Buzzards Bay on November 16, 1861.

Newspapers were forbidden to make any reference to the fleet until it was well out to sea, so that it was not until November 25 that the *Mercury* carried the following account:

The fleet went off in fine style, the pilots and masters going on board at 6¼ o'clock A.M. and at 8½ every ship was outward bound. At 10¼ o'clock the pilots began to leave, and the fleet stood south. The crews consisted of 14 men each, except for the South American which carried sixteen. The cost of these ships to the Government was about $10 per ton. Some of them were worth double that sum per ton, and all would have brought more than that if they had been broken up. Here at least, the Department has got full value for the money it has expended, and in the fitment of the vessels, the Government has had the benefit of some of our most experienced shipowners.

In due time we shall hear the result of this novel expedition. It has been admirably managed in its inception, the ships are in charge of experienced navigators familiar with the Southern Coast, and the orders of the Department, whatever they are, will be executed to the letter. We have large faith in the enterprise; and as it is an exceedingly pacific mode of carrying on the war, all our citizens will join in wishing it success.

The newspapers followed the progress of the fleet whenever they received information, as it was of considerable interest to the citizens. The notion that the vessels would have brought twice the amount they did if broken up is misleading, for if all of them were offered as junk at the same time, the market for them would vanish. There were not nearly enough facilities for breaking up that many vessels at the same time in New Bedford. In addition, the vessels had been stripped, and a good deal of money could be made selling the equipment. The

firm of I. H. Bartlett was employed to purchase the ships and fit them for the voyage, and for local farmers with wagons and oxen there was money to be made hauling stone to the waterfront. Provision of that fleet was not an act of patriotic sacrifice to New Bedford, but a good business venture. As for the remark that the government received good value for its money, it was not borne out by subsequent events, since the use of the hulks to blockade Charleston harbor was a total failure.

Much has been made of the departure of the Stone Fleet as an event that delivered a serious blow to the whale fishery. However, at the time the fleet of 16 whalers sailed, of which only 14 were from the port of New Bedford, there were 287 vessels listed in New Bedford and Fairhaven.[19] The Stone Fleet represented less than 6 percent. Moreover, a check of the customs records shows that these vessels ranged in age from 20 to 58 years, averaging about 40. Most of them had long since paid for themselves and were close to, if not past, the end of useful service as whalers. In fact, the captains were cautioned by the Navy to use extreme care in making the passage south, and when the vessels arrived, Commander Missroon of the *U.S.S. Savannah* reported: "They are all laden with stone, but few good vessels among them, and all badly found in every respect. . . ."[20] Several of them arrived in sinking condition. Considering that the Navy paid a total of about $56,000 for the old hulks, the New Bedford whaling merchants lost none of their reputation for shrewd business acumen. The *Whalemen's Shipping List*, which reported all news of interest to the whaling industry, made no more mention of the event than to list the names of the vessels sold to the government and give the date of their sailing.

The departure of the fleet, whatever effect it may have had on industry, was doubtless an exciting event. The citizens of New Bedford were supporters of the Union cause. There was an active anti-slavery organization in the city, and the presence of Confederate vessels added another hazard to whaling. The sailing of any vessel was always an important occasion, and to have twenty sail at once must have presented a dramatic sight. Prior to departure the captains assembled for a group photograph taken by the Bierstadt brothers,[21] and they were regarded as heroes upon their return. Consequently, it was a likely subject for one who wished to sell lithographs.

The *Whalemen's Shipping List* announced the publication of Russell's two most important whaling prints on June 6, 1871:

Benjamin Russell's Whaling Scenes

Our citizens and many whaling captains have for years past been expressing a wish that some reliable and truthful representation of Sperm and Right Whaling could be got up that would clearly and faithfully present their views without the exaggerations that have been palmed off for years as true whaling scenes, some so grossly and imperfectly drawn, as to almost deter a man from entering upon a whaling voyage; doubtless many drawn from imperfect descriptions, or imagination by those who never witnessed any of the exciting scenes of a whaler's life, and so have been led into error of the prints intended to give the public true pictures as they really are. Mr. Russell was induced to enter into the only way whereby the scenes could be obtained from actual

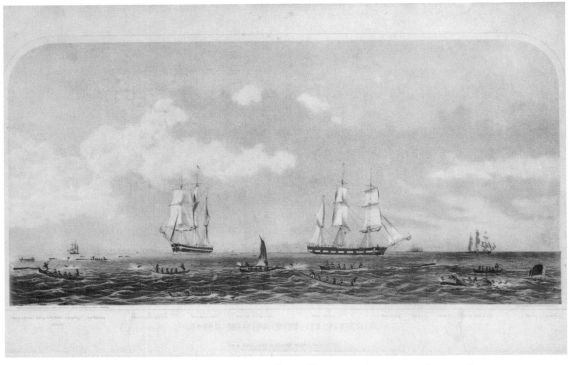

5. *Sperm Whaling With its Varieties.* 16 x 32½ in. *Entered according to act of congress in the year 1870 by Benjamin Russell in the office of the Librarian of congress at Washington / J. H. Bufford's Lith. 490 Wash.ⁿ St. Boston / Proof / From an original Drawing by BENJAMIN RUSSELL, New Bedford, Mass.*
The following scenes are identified in the lower margin from left to right: *Waiting a chance / Setting on the Whale / Ship cutting in / Just Fastening / Fast Boat / Changing Ends / Dead Whale Waif'd / Fast Boat Rolling up Sail / Whale sounding / Whale running / Trying out / Stove Boat / Towing Whale to Ship / Whale in a flurry (Dying)*

observations, and sketching most of them on the spot, and accordingly made a voyage of forty-three months in a ship with this object in view. During that long and tedious voyage, he was having sperm and right whaling adventures brought before him in all ways, to enable him to carry out the main object he had in view in leaving home for that length of time. He has succeeded in having two views—one of each, perfected in fine lithograph style, and from captains who have criticized them very closely, *they pronounce them, not only as works of art, but a clear, and truthful representation of the scenes they have long been familiar with, and fully entitled to their honest testimony, that no other views have ever been issued that will compare with Mr. Russell's labors to satisfy and gratify the community, in getting out what has long been wanted, and they have given positive evidence of their appreciation of the pictures, by taking copies of what they have experienced a pleasure and profit in, by showing their friends how they have passed many years of their lives in*

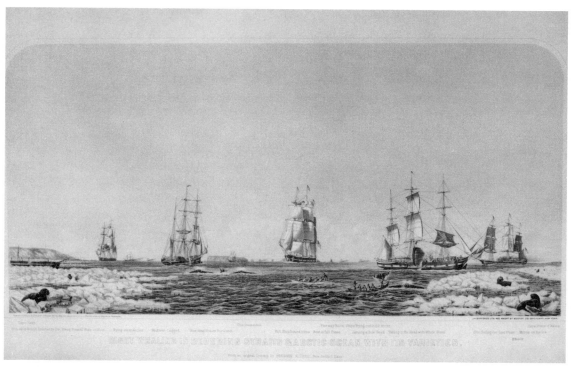

6. *Right Whaling in Behering Straits & Arctic Ocean With its Varieties.* 16 x 32¼ in.
Entered according to Act of Congress in the year 1871 by Benjamin Russell in the Office of the Librarian of Congress at Washington / J. H. Bufford's Lith. 490 Wash!! St. Boston. 201 Broadway, New York / Proof / From an original Drawing by BENJAMIN RUSSELL, New Bedford, Mass.
The following scenes are identified in the lower margin from left to right: *Cape East / Ship abandoned, Crushed by Ice / Towing Blasted Whale to Ship / Trying out at Anchor / Blubber Logged / Bow Head Whales Pursued / The Diamedes* [sic] */ Full Ship bound home / Boat in full Chase / Fairway Rock / Ships Trying out in the Arctic / Lancing a Bow Head / Taking in the Head with Whale Bone / Ship Boiling her last Whale / Walrus on the Ice / Cape Prince of Wales*

pursuit of their calling, and Mr. Russell should be entitled to great credit for his labors.

The price of these fine pictures is only $5 each, and will be sent to any part of the world postage free, on receipt of the above price.

These prints do indeed live up to the claims made for them in the newspaper account, which, it should be noted, was an editorial and not a paid advertisement. One could give a complete lecture on whaling using the two prints alone as illustrative material.

In *Sperm Whaling with its Varieties* (fig. 5) two whalers are shown in the middle ground hove to with their boats lowered. Because sperm whales were commonly, although not always, hunted on offshore grounds, there is only a broad expanse of ocean in the background. All along the foreground are boats engaged in the full range of whaling activities. To the left a boat is waiting its chance to fasten to a whale. Another boat is going on a whale, with the har-

pooner about to dart his iron. A third boat toward the center of the picture is going on a whale with its sail still set. By ancient custom, the harpooner (commonly called the boatsteerer by whalemen) pulled the bow oar. After harpooning the whale, he changed position with the boat header, an officer in charge of the boat, who steered it until the whale was struck. It became the officer's duty to kill the whale after he had been exhausted and the boat could approach him again. This is shown under the bow of the whaler at the left.

When the whale was struck, he did one of three things, all of which are depicted in the center and right foreground. Generally he ran, as shown in front of the whaler on the right. Another response was for him to sound, or dive to a great depth. In that case, the boat would hold on to him as long as the whale line lasted, but if he did not level out or return to the surface before all the line was paid out, he would have to be cut loose and whale, harpoon, and line would be lost. While that was undesirable, it was preferable to a third alternative of the whale, which was to attack the boat, as sperm whales, being somewhat more pugnacious than other species, have been known to do. The scene near the right foreground shows a boat stove by a whale, with its crew swimming around in the water. The damage resulting from such an attack could range from simply upsetting the boat to total loss of boat, gear, and crew.

Assuming all went well, the whale would eventually tire from a 3,000-pound weight and the whalemen would pull up to him, enabling the boat header to kill him with a lance, as shown at the left. If there were more whales in the area, the carcass was marked with a waif, a small flag mounted on a pole to facilitate finding it later, and the boat went off in pursuit of another. Often several boats were secured together in tandem to lighten the work of towing the dead whale to the ship. All of these activities can be seen in the lithograph, with identifying captions below.

The setting of the companion print (fig. 6) is the Bering Strait, an excellent whaling ground in June and late September, for the bowhead whales would converge there as they migrated north and south. The seascape extends across the Strait, looking north into the Arctic Ocean, from East Cape, the eastern tip of Asia, to Cape Prince of Wales, the western point of North America. The Diomede Islands and Fairway Rock are accurately shown in the middle of the Strait. In this print, Russell does not go into as much detail about pursuing the whales as in *Sperm Whaling*, although there is a chase and a lancing in the center foreground. On the left is the shattered hulk of a whaler that has been nipped in the ice. Off in the distance a blasted whale is being towed to a ship. Whales that had been killed and lost or otherwise died would eventually bloat and come to the surface. If the blubber had not become rancid it was worth saving. Such a windfall was not an unmixed blessing, however. Blasted whales were referred to as "stinkers" by whalemen, undoubtedly for good reason.

Russell shows more of the processing of whales here than in *Sperm Whaling*. The second whaler from the left is cutting in, removing the whale's blanket covering of blubber. Russell's caption under this scene is "Blubber Logged," which means that the ship is completely full of blubber above and below decks. It would be useless to catch another whale until the blubber already aboard was

rendered into oil. Far in the background can be seen ships up in the Arctic Ocean with clouds of black smoke billowing up from them, indicating that they have had a successful chase and are boiling blubber. Also in the picture are some walruses lounging about on the ice, a familiar sight in the Arctic.

The bowhead (referred to in the print caption as the right whale) is a baleen whale. It has no teeth, but baleen, plates of tough fibrous material like horn, strains plankton from the water. Baleen was an article of great commercial value used for corset stays, umbrella ribs, and buggy whips prior to the availability of spring steel and celluloid. The entire upper jaw of the whale from which the baleen hung was cut off and brought aboard ship.

More than any of the prints with which we have so far dealt, these two whaling subjects reveal Russell's panoramic vision. Even the aspect ratio of the image gives it a cinemascopic appearance. Russell included within the confines of his prints much of the activity that would normally encompass a broad expanse of ocean. The ability to do this successfully required the same organizational talent as did his *Panorama of a Whaling Voyage Around the World*.

Among several impressions of each of these two prints in the collection of the Old Dartmouth Historical Society are some printed in color and others that have been colored by hand. The fact that some were printed only in black suggests that he intended to offer them both plain and colored. However, no plain impression is known, nor do any of the advertisements indicate that there was anything other than the colored version available. Perhaps Russell originally planned to sell both, but subsequently changed his mind and colored the rest himself.

Certain impressions of both prints are marked "Proof." Apparently there were a number of artist's proofs in addition to the regular edition. In the *Whalemen's Shipping List* of September 2, 1873, the following advertisement appeared:

Russell's Whaling Views

Which are highly finished, colored and are now all out of print; *representing the only TRUE and FAITHFUL copies of whaling ever brought before the public.* —COMPRISING—

Sperm Whaling *with all its varieties 36 x 24*
Right Whaling " " " *36 x 24*
Arctic Ocean Views, *(5 in a set) giving true scenes of the abandonment of our whaleships in the ice, with views of the Walrus as they were described by Captains who were on the spot, and all classed as perfect copies of that great event.*

Those in want of the above rare prints will have their orders promptly *attended to by addressing Benjamin Russell, New Bedford, Mass.*

No charge for delivering to any part of the United States, and favorable charges for foreign orders.

The fact that this advertisement was run for over a year in the *Shipping List* indicates that the demand for the prints had been less than anticipated. It may well be that Russell had deliberately had a large part of the edition marked "Proof" as a stimulus to prospective purchasers.

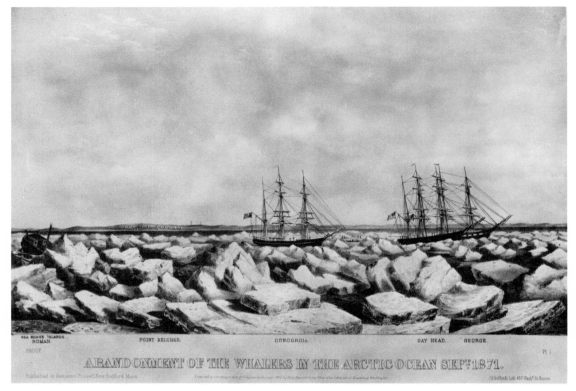

7. *Abandonment of The Whalers in the Arctic Ocean Sep! 1871 / Pl. 1. 11 x 18¼ in.
Published by Benjamin Russell, New Bedford, Mass. / Entered according to Act of Congress
in the year 1872 by Benj. Russell in the Office of the Librarian of Congress at Washington /
J. H. Buffords Lith. 490 Wash^n St. Boston. / Proof*
Initialed on stone: *J.P.N.*
Scenes, left to right: *Sea Horse Islands / Roman / Point Belcher / Concordia / Gay Head / George*

The last five prints that Russell did were a series showing the Arctic disaster of
1871 (figs. 7, 8, 10, 12, and 14). Each print bears the title *Abandonment of the
Whalers in the Arctic Ocean, Sept. 1871,* and is printed in black over a warm
gray. The event is well documented and needs only a brief description here.[22]
The whaling fleet had gone to the Arctic for the summer in pursuit of the bow-
head whale. There was no reason to believe that there was any extraordinary
danger; whalers had been going there for many years and knew what conditions
to expect. This time, however, an unusual southwesterly gale set in for four days
blowing ice floes toward shore until they grounded, trapping the fleet of thirty-
two whalers between them and the shore, between Point Belcher and Icy Cape.
On September 2 the brig *Comet* was crushed and sunk, and less than a week
later, the barks *Roman* and *Awashonks* were crushed. It was apparent that the
entire fleet might meet the same fate, or that 1,200 men and a few women faced
the possibility of a winter in the Arctic without food. The masters of the whalers
therefore decided to abandon their ships while there was still an opportunity to
escape and join other ships in clear water. On September 13, having met and
signed an agreement to leave, the captains directed their crews to sail by whale-
boat to the rescue vessels. This was accomplished without loss of life, but of the

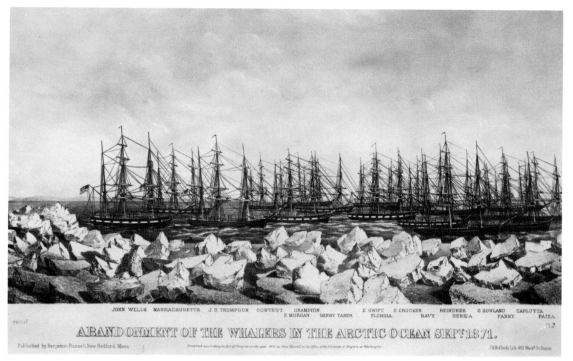

PROOF

JOHN WELLS. MASSACHUSETTS. J.D.THOMPSON. CONTEST. CHAMPION. E. SWIFT. O.CROCKER. REINDEER. G.HOWLAND. CARLOTTA.
E. MORGAN. HENRY TABER. FLORIDA. NAVY. SENECA. FANNY. PAIEA.

ABANDONMENT OF THE WHALERS IN THE ARCTIC OCEAN SEPT 1871.

Published by Benjamin Russell, New Bedford, Mass. Entered according to Act of Congress in the year 1871 by Benj. Russell in the Office of the Librarian of Congress at Washington J.H.Bufford's Lith 490 Washᵗ St Boston.

8. *Abandonment of the Whalers in the Arctic Ocean Sep!* *1871 / Pl. 2.* 11¼ x 18½ in.
In lower right corner of image: *On Stone by J. P. Newell.* Publication data same as fig. 7.
Scenes, left to right: *John Wells / Massachusetts / J. D. Thompson / Contest / E. Morgan /*
Champion / Henry Taber / E. Swift / Florida / O. Crocker / Navy / Reindeer / Seneca /
G. Howland / Fanny / Carlotta / Paiea

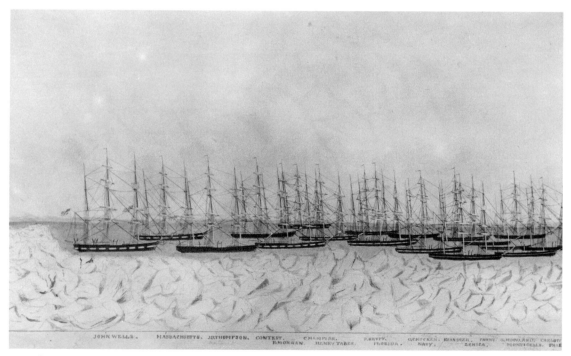

JOHN WELLS. MASSACHUSETTS. J.D.THOMPSON. CONTEST. CHAMPION. E.SWIFT. O.CROCKER. REINDEER. FANNY. G.HOWLAND. CARLOTTA.
E.MORGAN. HENRY TABER. FLORIDA. NAVY. SENECA. MONTICELLO. PAIEA.

9. Preliminary watercolor for fig. 8. 13½ x 18 in.

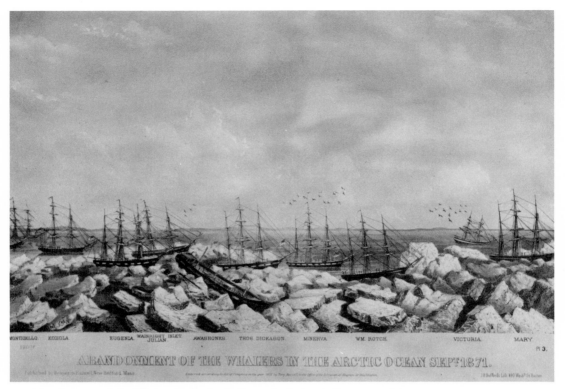

10. *Abandonment of the Whalers in the Arctic Ocean Sep.! 1871 / Pl. 3.* 11 x 18 in.
Initialed on stone: *J.P.N.* Publication data same as fig. 7.
Scenes, left to right: *Monticello / Kohola / Eugenia / Wainright Inlet / Julian / Awashonks /*
Thos. Dickason / Minerva / Wm. Rotch / Victoria / Mary

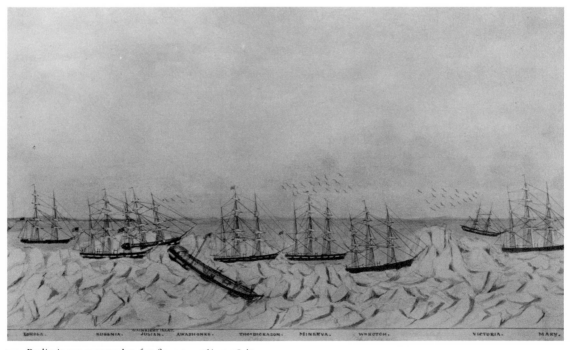

11. Preliminary watercolor for fig. 10. 13 ½ x 18 in.

thirty-two vessels abandoned, only one was recovered the following season. Ironically, four days after the ships were abandoned, the wind went northeast and the ice was blown out. The loss was the greatest disaster that ever befell the New Bedford fleet and hastened the eventual decline of the industry.

Since the citizens of New Bedford could not go to Alaska to have a look for themselves, Russell provided a visual description of what happened. He produced a series of five watercolors, subsequently reproduced as lithographs, showing the coastline of Alaska with the ships caught in the ice or between the ice and shore. Arranging the five prints from left to right, the view stretches northeast to southwest with the Seahorse Islands just north of Point Belcher at the extreme left. The ships farthest to the north were caught there. Going southward (plate 2), more of the fleet is shown caught in the ice. Plate 3 shows the fleet at anchor between the shore and the ice, and in plate 4 the officers and crew have abandoned their ships and are proceeding to a point of rendezvous at Icy Cape before transferring to the seven rescue vessels. In the final plate the survivors are shown being put aboard whaleships in open water. Together these prints include about 200 miles of the Alaskan coast.

In 1911 the Old Dartmouth Historical Society was given four of the five original watercolors (figs. 9, 11, 13, and 15). (How the first one became separated from the rest, or what has become of it, is not known.) They are of considerable interest for comparison with the prints, for they enable one to see in what ways the lithographer departed from what was given to him.

The watercolors for plates 2 through 4, when placed edge to edge, present a continuous panorama, the bows of some vessels carrying over from one drawing to the next. It is obvious that Russell conceived of this series as an entity rather than five separate pictures. The continuity between plates 2 and 3, transcribed onto stone by J. P. Newell, breaks down considerably; it is lost entirely between plates 3 and 4. The compositions have not been changed in the lithographs to make separate statements; they simply end at the edge of the stone without the continuity of detail seen in the watercolors.

In the watercolors for plates 2, 3, and 4, Russell has left the ice pack and water very sketchy, relying on the lithographer to give form and mass to the ice as well as a surface to the water. All of the watercolors have notes written along the bottom, concerning principally details of rigging and color schemes of the whaleships. These instructions have been adhered to in the lithographs.

In plate 3 bark *Monticello* appears at the left, having been transposed from the right side of watercolor number 2. Some spars and casks have been added to the ice alongside *Awashonks*. A note under *Wm. Rotch* on the watercolor instructs the lithographer to alter the rig to a bark similar to *Minerva*, which was done. Other changes were trivial, such as the flights of birds and some flags.

Plate 4 shows alterations in the ice floes both in the foreground and along the shore, and the men and boats ashore have been rendered differently. The birds in the watercolor have been omitted from the lithograph. Russell apparently left a substantial amount of the finished detail to Newell.

The fifth watercolor is by far the most finished of the set, yet there are numerous minor changes between that and the lithograph. The relative positions

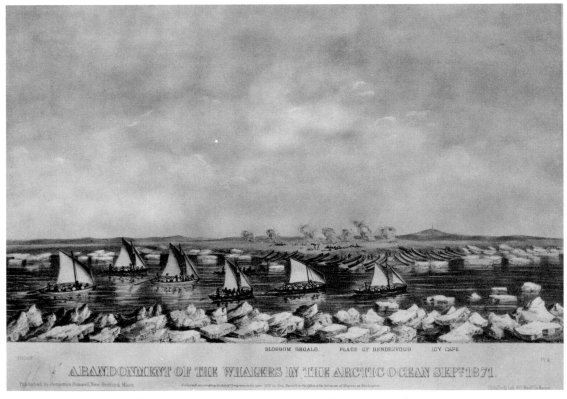

BLOSSOM SHOALS. PLACE OF RENDEZVOUS. ICY CAPE.

PROOF Pl 4.

ABANDONMENT OF THE WHALERS IN THE ARCTIC OCEAN SEPT 1871

Published by Benjamin Russell, New Bedford, Mass. Entered according to Act of Congress in the year 1872 by Benj. Russell in the Office of the Librarian of Congress at Washington Child & Co. Lith. 420 Wash'n Boston

12. *Abandonment of the Whalers in the Arctic Ocean Sep.ᵗ 1871 / Pl. 4.* 11¼ x 18 in.
Publication data same as fig. 7.
Scenes, left to right: *Blossom Shoals / Place of Rendezvous / Icy Cape*

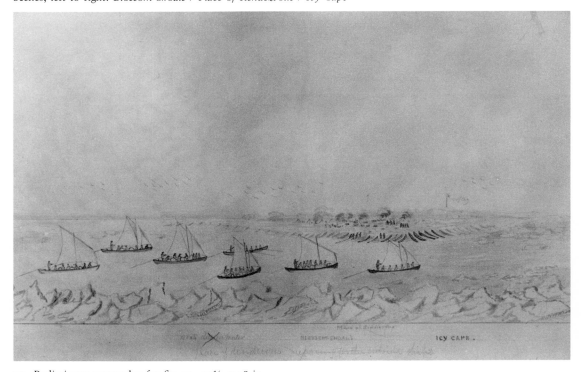

13. Preliminary watercolor for fig. 12. 13½ x 18 in.

of the whaleboats have been changed, the surface of the water is not nearly as characteristic of Russell as is the watercolor, and small details throughout have been altered.

The differences, however large or small, between the watercolors and the prints raise the question of the basic relationship between artist and lithographer. Normally one would expect that a commercial lithographer would produce a true reproduction of a drawing submitted to him. Some differences between the watercolors and lithographs, particularly in certain nautical details of plate 5, do not appear to be ones that a lithographer would undertake on his own initiative, for it is unlikely that he would have the knowledge. There are two possible explanations for these differences. One is that Newell made corrections based upon notes, supplementary sketches, or instructions furnished by Russell. It is also possible that the watercolors at the Old Dartmouth Historical Society are not the final versions that Russell sent to Bufford. Contemporary newspaper accounts indicate that Russell produced his watercolors based on information supplied him by the captains and crews of the lost vessels. Russell may have worked up this set, shown it to the whalemen for corrections, and then made a finished set incorporating the suggested revisions for Bufford to reproduce. However, such a hypothetical set of watercolors is not known to exist.

There was some delay between creation of the watercolors and their publication as lithographs. The *Whalemen's Shipping List* carried a brief note on April 2, 1872:

Russell's Arctic Pictures

The papers and the captains say they are true to life. They are in a set of five pictures, and when lithographed, will be sought for by everybody—not only as a work of art, but as a valuable record of the greatest disaster that ever befell our whaleships.

It was not until October 22, 1872, that the same newspaper made mention of publication of the lithographs:

Russell's Arctic Pictures.—To those who have not secured a set of these interesting and yet sad scenes of the whaleships abandoned in September, 1871, in the Arctic Ocean, now recently ascertained to be all destroyed by the ice and natives, except the Minerva, *we would say that an opportunity offers itself from the few proof copies left, to obtain them by early application. We flattered ourselves that many of the ships would ride out the storms of winter safely, and again reach our waters, but all hope of them is at an end. Of the fleet of this year, we are pained to add to the great loss, three more ships that shared the same fate of the others. These scenes are vouched for by many captains who were there, as giving a true representation of the ice, ships, and every particular. All orders at house or from abroad, will receive prompt attention by addressing Benjamin Russell, New Bedford, Mass.*

The matter of proof copies comes up in this notice. The advertisement of September 2, 1873 (see p. 39) ran until November 24, 1874. The fact that the supply of a "few proof copies" had not been exhausted and was still in sufficient stock to warrant advertising after two years is somewhat suspicious. Moreover,

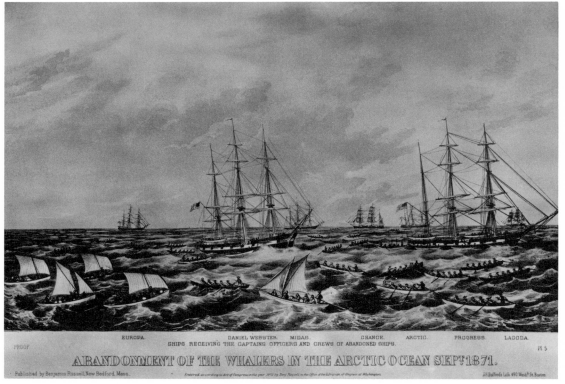

14. *Abandonment of the Whalers in the Arctic Ocean Sep! 1871 / Pl. 5.* 11¼ x 17¾ in.
Publication data same as fig. 7.
Scenes, left to right: *Europa / Ships receiving the captains, officers, and crews of abandoned ships /
Daniel Webster / Midas / Chance / Arctic / Progress / Lagoda*

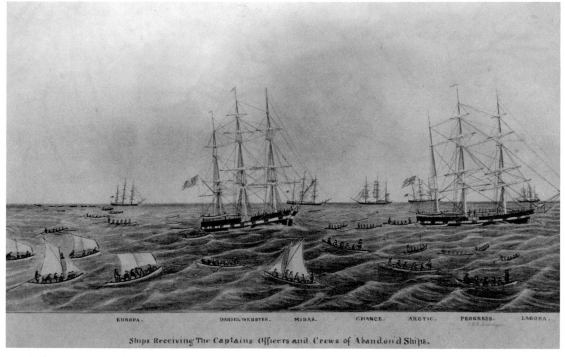

15. Preliminary watercolor for fig. 14. 13½ x 18 in.

in the case of the Arctic pictures, there are no known impressions not marked "Proof," so it may be that Russell used the proof impressions as a sales gimmick.

Two other references to Russell's lithographs have been investigated since the initial presentation of this paper. In G. Brown Goode's report of 1887 on the fishing industries of the United States, there are two drawings captioned as being after French lithographs by Benjamin Russell.[23] One of them is from the *Ship on the Northwest Coast* (fig. 1 above); the other is a scene showing the bailing of the case of a sperm whale alongside a ship. As no such lithograph has turned up, the eleven listed here constitute all of the known prints of Benjamin Russell.

In *Sou'West and by West of Cape Cod* by Llewellyn Howland, there is a story entitled "Islands".[24] It includes a description of a New Bedford counting room, where hanging on the walls

> *were many prints and paintings by "Uncle Ben" Russell and other marine artists, which by their prodigious and accurate detail defied all efforts to exhaust their interest. "The Ship Corinthian in tow of the Ship George Howland in the Arctic"—a Russell, and so far as I have been able to discover the only imprint made of this particular lithograph—was the gem of the collection. The transparent greens of the ice, the frosty sparkle of the snow, the olive tone in the water, the sharpness of every line and curve gave to this portrait of the ships and their situation and surroundings a reality and vividness beyond compare.*

The picture by Russell described here has recently been acquired by the Old Dartmouth Historical Society. It is a watercolor and was owned by Llewellyn Howland's father. Members of the Howland family have indicated that perhaps fifty years had elapsed between the time the watercolor was sold out of the family and the time the story was written. Consequently, Howland may not have remembered the medium, or, as a grandson had suggested, he may have deliberately called it a lithograph to get a rise out of his good friend Allan Forbes, the most eager and successful collector of Russell's work.

The work of Benjamin Russell is prized today for its accurate pictorial representation of the ships and scenes of the whale fishery. The newspaper articles cited above give ample testimony to contemporary regard for their verisimilitude. Further evidence is offered by a statement of expenses of a court case involving a collision between the barks *Helen Mar* and *Ontario*. Russell was paid fifty dollars to make a watercolor of the accident to be used as evidence in the hearing.[25] Another example of Russell's attention to detail is seen in the portrait of *General Scott* in the Allan Forbes collection.[26] The name board of the vessel is in the Old Dartmouth Historical Society, and comparison with the watercolor shows that Russell observed not only the style of lettering but the method of abbreviation as well. Correct delineation of his subjects is what seems to have pleased Russell most, earned him the respect of his contemporaries, and causes us to value his pictures today.

1. *Ship Registers of New Bedford Massachusetts* (Boston: The National Archives Project, 1940).

2. Edmund Wood, "Benjamin Russell," address given at the Old Dartmouth Historical Society, September 29, 1911. Published by the Society in "Historical Sketch No. 33."

3. *Bulletin*, Old Dartmouth Historical Society and Whaling Museum, Summer 1958.

4. "Diary of Samuel Rodman," vol. 7, p. 110. Manuscript in the collection of the Old Dartmouth Historical Society.

5. Zephaniah W. Pease, *The Centenary of the Merchants National Bank* (New Bedford, 1925), p. 30.

6. Broadside, "Valuable Real Estate at Auction" (New Bedford, July 30, 1835). The broadside, in the collection of the Old Dartmouth Historical Society, lists the twenty parcels of land.

7. Wood, "Benjamin Russell," p. 7.

8. Two of these cartoons are illustrated in Richard C. Kugler, ed., *New Bedford and Old Dartmouth, A Portrait of a Region's Past* (New Bedford: Old Dartmouth Historical Society, 1975), p. 195.

9. New Bedford *Evening Standard*, March 4, 1885.

10. Settlement book, Ship *Kutusoff*. Old Dartmouth Historical Society, miscellaneous accounts S33–40.

11. The New Bedford *Mercury* of December 5, 1848, carried the following announcement:

<div style="text-align:center">

The Panorama

of a

WHALING VOYAGE AROUND

THE WORLD

</div>

Messrs. Purrington & Russell respectfully give notice that their great painting of a WHALING VOYAGE AROUND THE WORLD, being now completed will be exhibited in a few days at SEAR'S HALL.

A testimonial was printed in the *Mercury* on December 7:

We upon this side of the river have been very much delighted with the exhibition of Messrs. Russell & Purrington's 'Voyage round the world,' for several evenings past, and we are not a little proud of having been allowed to witness its first exhibition. All who were present, and there were not a few who were well qualified by actual observation to judge of its merits, allow that it came fully up to the mark, in its delineation of scenes well known to our gallant whalers, and in its general features. The hall has been crowded every evening. I notice that it is to be exhibited in your city tomorrow evening, and I have no doubt that from its character and real merit, the enterprise of its spirited proprietors will meet with ample encouragement.

<div style="text-align:center">

Old Jack

Fairhaven, Dec. 6, 1848

</div>

Presumably Russell's motive for undertaking the *Panorama* was purely financial, for fifteen years after the failure he had not cleared his debts, as indicated by Samuel Rodman's diary, December 13, 1848: "The Children went to the 'Panorama of a Whaling Voyage' just finished by Ben. Russell which takes the attention of the public and will probably restore his broken fortunes and enable him to fulfill his hon'ble intentions of pay'g all his creditors." (Manuscript in the collection of the Old Dartmouth Historical Society, vol. 18, p. 182.)

It is not known exactly what part Caleb Purrington had in the *Panorama*. He was a partner in the commercial painting firm of Purrington and Taber in Fairhaven. The reference in Rodman's diary to Russell still having to pay his creditors suggests that Purrington must have put up the money for the project; it required 1,300 feet of cotton sheeting as well as the paint. The overall conception and most of the scenes were probably Russell's, with Purrington doing much of the actual work of finishing off the painting from Russell's sketches. It is hard to believe that Russell worked entirely from memory in producing the *Panorama*, particularly in the matter of views of ports and islands. However, there is no evidence of his keeping a sketchbook.

12. The 1845 and 1849 city directories list Russell as a merchant living at 81 State Street in New Bedford.

13. Information supplied by Madeleine Barbin, Conservateur, Cabinet des Estampes, Bibliothèque Nationale, Paris.

14. Illustrated in M. V. and Dorothy Brewington, *Kendall Whaling Museum Prints* (Sharon, Mass., 1969), p. 7.

15. This story was related by a New Bedford artist, Lemuel D. Eldred, in an article entitled "Recollections of Albert Van Beest—Famous Marine Artist" (New Bedford *Sunday Standard*, February 15, 1914). Eldred speculated that the lithographs were the work of Van Beest alone, but a comparison of the lithograph *The Capture* with Van Beest's drawing makes that suggestion unlikely.

16. An extensive collection of the sketchbooks of R. Swain Gifford exists in the Old Dartmouth Historical Society.

17. Illustrated in Brewington, *Kendall Whaling Museum Prints*, p. 50.

18. Illustrated in *New Bedford and Old Dartmouth*, p. 108.

19. *Whalemen's Shipping List and Merchants Transcript*, November 19, 1861.

20. *Official Records of the Union and Confederate Navies in the War of the Rebellion* (Washington: Government Printing Office, 1901), series 1, vol. 12, p. 419.

21. Illustrated in *New Bedford and Old Dartmouth*, p. 113.

22. A good account of the Arctic disaster of 1871 may be found in *One Whaling Family*, edited by Harold Williams (Boston: Houghton Mifflin, 1964), pp. 223–242.

23. George Brown Goode, *The Fisheries and Fishery Industries of the United States* (Washington: Government Printing Office, 1887), section 5, plates 207 and 208.

24. Llewellyn Howland, *Sou'West and by West of Cape Cod* (Cambridge: Harvard University Press, 1947), pp. 61–62.

25. Miscellaneous papers pertaining to bark *Helen Mar*, Old Dartmouth Historical Society.

26. Illustrated in *Whale Ships and Whaling Scenes as Portrayed by Benjamin Russell*, State Street Trust Company, Boston, Historic Monograph Series no. 39 (1955), p. 59.

1. *F. W. P. Greenwood,* 1840. Color lithograph, 20½ x 16⅜ in.
Museum of Fine Arts, Boston. Bequest of Charles Hitchcock Tyler. M33960

William Sharp: Accomplished Lithographer

BETTINA A. NORTON
Registrar, Essex Institute, Salem

When William Sharp decided to emigrate from England to America in 1839, at the age of thirty-six, he was already an accomplished lithographic artist. He settled in Boston, Massachusetts, and at his death thirty-six years later, he left a number of impressive prints which he had put on stone—views, narrative scenes, and a variety of interesting portraits. Moreover, he was almost certainly responsible for the introduction of color lithography to Boston.

Sharp received some contemporary notice. But color lithography was soon being practiced by other, larger shops in Boston. Some were using the technique to copy landscape paintings with a marvellous exactness. These prints, and similar undertakings, eclipsed the work of William Sharp; his contributions were forgotten. In the search for the origins of some of the techniques of printmaking in America, Sharp's work now resumes its well-deserved importance for its exposure of contemporary European developments and for its technical skill. Sharp was a lithographer in the forefront of his profession.

He had been in Boston for less than a year when his name was brought to the attention of the vestry of King's Chapel, a Unitarian church just beyond Tremont Row, where Sharp and his family were boarding. The artist wished to make a lithographic portrait of the rector, F. W. P. Greenwood (fig. 1). He was a good subject: rector of a prominent downtown church; a scholarly man who had written a well-received history of the church a few years before; and a handsome man who posed easily. Sharp chose him to display to the Boston market his technical abilities and competence at portraiture. The lithograph, widely known to collectors and historians of American prints, was well conceived and drawn, and it was printed in colors. Larger than most contemporary prints, it was Sharp's grand attempt to launch a lucrative and rewarding career in Boston.

The brief summary of his life and career which follows provides the background for a closer look at his work with color lithography.

The Years in England

Little has been known of Sharp's early work and contributions to lithography in England. This is understandable in a field which is less conspicuously creative, less self-conscious, and more commercial, than, for example, painting. Lithography, like present-day architecture, was often practiced by a firm which gave its name to a commission, and actually involved talents of the team that worked for the shop. The specific contributions of these men are hard to ascertain. Even among lithographers like Sharp, who soon established their own firms with their own imprints, their early careers, and possible contributions, are obscure.

Sharp was sixteen years old when he first exhibited at the Royal Academy in 1819 (fig. 2). He showed more portraits for the next two years, then not again

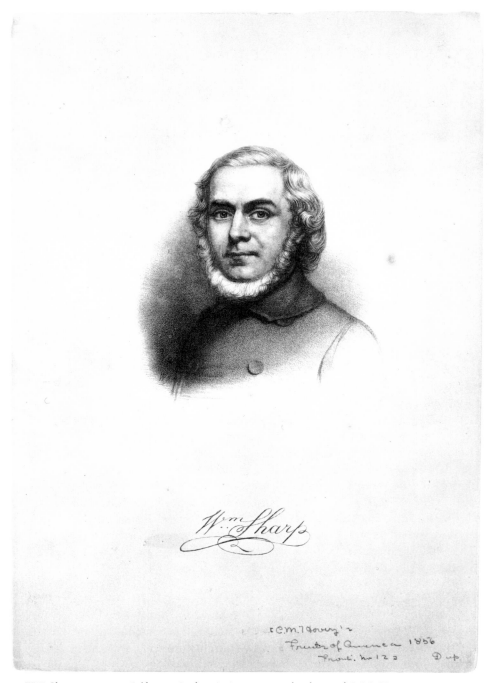

2. *W*^m *Sharp*, ca. 1856. Self-portrait, frontispiece to second volume of C. M. Hovey, *Fruits of America*, 2 vols. (Boston, 1856). Tinted lithograph, 7⅛ x 4 in., including signature. Print Department, Boston Public Library

until 1829. Where he was living and what he was doing in these intervening eight years is not known. During the decade from 1829 to 1839, Sharp was living at various addresses in London. By 1831, he was a member of the Society of British Artists, and was also an exhibitor at the Suffolk Street Artists' Society. He spent some time in business for himself after 1833, though he is listed in only the 1836 and 1838 Directories, and was living for part of the time in Soho.[1]

The Boston Public Library owns two portfolios[2] containing about 250 lithographs—proofs and published prints—done by Sharp in England. Many were printed by Hullmandel, the major English lithographic printer in the first half of the nineteenth century. Dated prints range from 1829, with ones like *The Late Mrs. Cumberbatch*, and several other portraits of women after Sir Thomas Lawrence (possibly part of a series), to a print after Morley, published in 1833, of three ponies belonging to the Princess Victoria.

Most of Sharp's lithographs were after the portraits of John Hayter (1800–1891), an artist who exhibited at the Royal Academy for over half a century (fig. 3). Hayter's sketches were most in sympathy with Sharp's sensibilities—the combination of the carefully worked rendering of the faces, and the more sketchy style used for the figure—a method which Sharp used to great effect in his portraiture. And William Sharp, father of a large family, seemed at home with idealized portraits of women and sweet little boys and girls. Two figures whose portraits Sharp did in England were later to become famous in America; when the adulation of the performers Mademoiselle Sontag and Madame Malibran came to these shores, Sharp turned to his portfolio for a "likeness" which could be put to whatever pose seemed suitable, and printed hundreds of illustrations for sheet music covers (fig. 4).

John Hayter's older brother George (1792–1871), also a portrait painter, was in Paris at the time, doing portraits of "French notabilities." Some of these were translated into prints. A proof impression of Robert N. C. Hamilton Esquire was printed by Lemercier from a painting by George Hayter (fig. 5). It was put on stone by Sharp, as was *Count Flahantt*, an aide to Napoleon, and the very limp but attractive *Countess Arthur Potoska* (fig. 6). Sharp's stay in Paris is presumed to have been short; he had done some work for Day & Haghe in London in 1830, and by May of 1831 he was back in that city.

The two portfolios in the Boston Public Library brought a revelation: Sharp had done a great deal of work for English printers before he arrived in Boston. He translated sketches and paintings, from the light pencil or crayon sketches of the Hayters to the dark tones of a Reynolds or a Guercino, copied so often by graphic draftsmen—stipple engravers as well as lithographers—in the late eighteenth and early nineteenth century. By the time he had arrived in the United States, Sharp was competent in many lithographic techniques—shading, building up tone, parallel hatching, stopping out.

In attempts to discover more about Sharp's career in England, various institutions in that country have been most helpful. Replies from them often ended, however, with an apology that so many questions were unanswerable. The portfolios therefore reveal more about Sharp's career than any other source; he himself provided the best record, the autobiography, of his English career.

THE YOUNG COMMODORE.

Drawn on Stone by W. Sharp from a Sketch by John Hayter

3. *The Young Commodore*, ca. 1830. Lithograph after a painting by John Hayter; from Sharp's portfolio II, 64, 12½ x 10⅜ in. Print Department, Boston Public Library

4. *Madame Malibran de Beriot*, ca. 1832. Lithograph proof impression after a painting by F. Y. Hurlstone; from Sharp's portfolio, 17⅝ x 17⅛ in. Print Department, Boston Public Library

5. *Robert N. C. Hamilton, Esqr.*, ca. 1831. Lithograph proof impression after a painting by George Hayter; from Sharp's portfolio II, 36, 10 x 7⅞ in. Print Department, Boston Public Library

4

5

6. *Countess Arthur Potoska*, 1831. Lithograph proof impression after a painting
by George Hayter; from Sharp's portfolio II, 2, 12 x 9½ in.
Print Department, Boston Public Library

A Long Career in Boston

William Sharp arrived in Boston with a wife and six children (there were to be nine in all). Described in the King's Chapel vestry record within six months of his arrival as an "eminent artist,"[3] he was also called or advertised at various times as a "distinguished artist," lithographer, portrait painter, drawing teacher, and, by 1857, a "lithographer and photographer," according to the Boston City Directories.

William Sharp's house on Tremont Row was conveniently next to the music publishers for whom he drew sheet music title pages for several years. In 1847 he bought a piece of property in newly surveyed Washington Village, Dorchester (now part of South Boston). He became an incorporator and backer of the Washington Village Christian Union Society in 1855. On land adjoining his and that of some other incorporators, they built a chapel for public worship and a sabbath school "free and independent of all sectarian bias or control."[4] The society was short-lived, though the building still stands, and is now a branch of the Boston Public Library. A few of the modest brick houses on Ellery Street, around the corner from where Sharp lived till the death of his wife in 1869, are still standing between garages and vacant lots of present-day Washington Village.

The first of Sharp's nine children was a daughter born in England in 1829; the last was a son, Edward Thrasher, born in Boston in 1846. At Edward's death at age seventeen, Sharp acquired a plot in Mount Auburn Cemetery. There he and his wife, Emma Georgiana, and the family of his son Philip are also buried. Sharp died at the home of one of his daughters in Milton on July 2, 1875.

William Sharp was one of the four lithographers working in Boston in the 1840s and 1850s with the surname Sharp which appeared in imprints; in addition, two other Sharps were employed in lithography shops. They have been sorted into two distantly related families:

William Sharp (1803–1875), whose son Philip (also, Philippe; 1831–1881) joined his father's business by 1852. (Another son, George Henry, worked for a short while for the lithographer F. F. Oakley, and a daughter Eliza was a watercolorist.)

James Clement Sharp (1818–1897) and his brother William Comely Sharp (1822–1897). (Their father emigrated to this country as a small boy in the 1780s.) The only one of the four whose shop remained continuously at the same address was the last, William C. Sharp, who became a lithographer some time before 1844.

Although the works of the two Sharp firms are often confused, the relatively uncomplicated and uninspired career of William C. [omely]'s firm is in sharp contrast to the interesting and varied, though sometimes restless and frustratingly opaque career of William Sharp. He had several short-lived partnerships. The first lithographs done in Boston which bear his name in conjunction with other lithographers, however, were done for Benjamin Thayer's firm. Sharp drew several portrait lithographs for the presidential campaign of 1840, in which William Henry Harrison was put forth to unseat Martin Van Buren.

The "Freemen's Quick Step" "as performed on the Glorious 10th of September" appeared under the lithographer's imprint of Sharp & Michelin. This partnership, formed in mid-1840, produced a lovely view of the Old Colony House in Hingham, Massachusetts, and a view of the First Parish Meeting-House in the same town. Both Fitz Hugh Lane and Benjamin Champney, later to become well-known artists, did work for the firm that year. Some music sheets with title pages printed by Sharp & Michelin were extremely popular; "The Lament of the Irish Emigrant," drawn on stone by Sharp, was published in two editions by William Oakes, at least six by George P. Reed, and transferred and redrawn by Sharp in 1843, to be lithographed by Bouvé & Sharp. Others are commendable pieces of lithography; Harry T. Peters, who described Sharp as a "talented craftsman who led the way into new fields," felt that the music sheet illustration for "The Wrecker's Daughter" was "of more than passing interest," and "extremely well done."[5]

Sharp & Michelin also began work on a little book of medicinal plants, called *The American Vegetable Practice*, printed with tints.[6] The partnership lasted less than a year. Sharp & James C. Sharp began business on Franklin Street in 1842 and continued the printing of *The American Vegetable Practice*.

A number of interesting portraits were produced in these years—of militia commanders and pastors of local churches (figs. 7, 8, and 9). And William Sharp changed partners again. James C. Sharp turned over his shop on Franklin Street to his younger brother, and became a surveyor in Dorchester. In 1843 William Sharp went into partnership with Ephraim W. Bouvé. Some of the stones stayed at James C.'s old shop, others went to the new partnership. "Old Dan Emmit's Original Banjo Melodies" and "Your Friend and Pastor Geo. W. Wells" were two of the melodious titles illustrated by the firm. Of enduring interest are the set of four lithographs after paintings by Philip Harry, done in 1843, called *The Streets of Boston*, for Bouvé & Sharp lithographed all but the first of this admirable series. Comparison of the prints with the original paintings confirms Sharp's ability to translate the flavor of an original to a reproductive medium.

After 1845, Sharp had his own firm. His son Philip worked with him by 1852 and thereafter. They churned out dozens of sheet music illustrations; an increasing number were in color. Sharp printed large editions; impressions of many music sheets can be found which show evidence of a tired stone. Unlike his work with Bouvé, many of the images printed by Sharp in this later period seem to have been his own compositions; some were floral bouquets, some portraiture. One of his best prints is a view of Meeting-House Hill, Dorchester, which shows the same stylized treatment for lithographing trees that Sharp used in the competently drawn view of Tremont Street looking south, for *The Streets of Boston* (figs. 10 and 11). The technique is highly suited to lithography.

In the last decade of his printmaking, from 1846 to 1856, Sharp produced two series of chromolithographed illustrations for the publications *The Fruits of America* and *Victoria Regia*. Renowned for their beautiful coloring and technical proficiency, these prints were the culmination of his career. They were the result of twenty years' experimentation with and development of the technique of color lithography.

7. *Rev. Nathaniel Thayer, D.D.*, ca. 1842. Lithograph proof impression after
a painting by Gilbert Stuart; from Sharp's portfolio I, 27, 12 x 10¼ in.
Print Department, Boston Public Library

8. *Colonel Charles A. Macomber*, from "Macomber's Grand March," by Edward L. White, 1841.
Lithograph title-page illustration for sheet music, 3¾ x 3¼ in.
Print Department, Boston Public Library

Painted by Badger Drawn on Stone by W. Sharp

Your friend and pastor
George W Wells

9. *Your Friend and Pastor, George W. Wells*, ca. 1844. Lithograph after a painting
by [Thomas?] Badger, printed by Bouvé & Sharp, Boston, 7⅝ x 7½ in.
Print Department, Boston Public Library

10. *The Streets of Boston. Tremont Street, South*, 1843. Tinted lithograph after a painting by Philip Harry, 13 ⅝ x 15 ¾ in. Boston Athenaeum

11. *Tremont Street, "Brimstone Corners"*, before 1843. Oil painting on panel by Philip Harry, 13½ x 15¼ in. Massachusetts Historical Society. Bequest of Henry L. Shattuck

Hullmandel, England's major early lithographer, for whom Sharp executed many prints in the 1830s, had been printing with one tint-stone as early as 1824, and by 1827 quite regularly. In France, Engelmann published *Manuel en Couleurs* in 1835, and two years later patented chromolithography.

Owen Jones, an ornamental designer, returned to England from his travels in Spain about that time, and was looking for a color printer for his pictures of ancient Moorish buildings of the Alhambra. The resultant early plates, lithographed by another English firm, Day & Haghe, and printed by Jones & Hull, are dated March 1, 1836. "Thus we see that the combined genius of Owen Jones and Day & Haghe hammered out the first pure printing in colours from stone in England."[7] These were printed in flat, opaque colors of bright red, blue, and gold. In 1839, Thomas Shotter Boys's pictorial chromolithographs, printed by Hullmandel, were published. They had transparent and graduated tints, in a manner more akin to the long-standing tradition of aquatint illustrations with watercolor. That particular portfolio "seems to mark the beginning of the struggle between printing in opaque and transparent colours"[8] which continued throughout the nineteenth century.

There are some examples of printed color in the portfolios of Sharp's work done in England. They are all proofs—with no indication of the printer. Some take examination under magnification to determine whether the color is applied wash or printed inks. Of the six or so that have touches of printed color, the most clear is a portrait signed and dated "W. Sharp 1837" (fig. 12).

It was Boys's and Hullmandel's approach that Sharp was purportedly developing contemporaneously. A print of the head of a dog in the American Antiquarian Society (fig. 13) has a penciled note on the mat: "First chromolithographic Specimen Made in England by Wm. Sharpe about 1835." It seems to have been done in three colors of ink—brown, pink, and blue. In barely discernible lettering, however, the print is signed on the stone in faint yellow "WSharp 1835"; this signature provided the clue that there were four, not three, colors used. The pink, blue, and yellow were probably done on one stone, and the brown on another.

The Museum of Fine Arts in Boston also has several chromolithographs, all without imprint, from the same period. They are part of the Koehler collection. Cat. No. 3277 has a margin note by Koehler: "Mr. Sharp says this was made in 1832" (underlined about six times). The note is the likely source of Peters's remark that Sharp may have begun experimenting with chromolithography as early as 1832.[9]

Sharp's experiments seem to have been quiet, or not openly received. Owen Jones was reported to have "approached various lithographers in London and told them of his wish to have his illustrations printed in colours, but he could get no one to undertake the job."[10] He may have been ignorant of Sharp, or may have turned him down for the job. Or Sharp may have been somewhere else, perhaps in Paris. A third possibility is that Sharp may not have been far enough along in his own technical development.

12. Unidentified portrait of a man, dated in pencil, 1837.
Tinted lithograph with printed color from Sharp's portfolio II, 27, 8¼ x 7⅛ in.
Print Department, Boston Public Library

65

13. [English spaniel], 1835. Chromolithograph proof impression, 7½ x 10⅝ in.
American Antiquarian Society, Worcester, Massachusetts

Sharp turned to printing with colored inks, it seems, when he was no longer working for Hullmandel. Sharp was undoubtedly aware of the stipple engraving done in England in the latter half of the eighteenth century by William Wynne Ryland and the famous Francesco Bartolozzi who printed several colors on one plate; graphic artists through Europe were familiar with the "manière anglaise." This technique used in lithography characterizes Sharp's early work with printed color in the portfolios. Colored inks were used to heighten lips and cheeks. The care involved in printing such small touches in which registration is critically important is obvious. Sharp's propensity to develop a method to reproduce delicate washes in sensitively drawn lithographic portraits is admirable; only a draftsman with technical expertise would conceive of such projects.

Introduction and Development of Color Lithography in Boston

With these experiments behind him, Sharp came to America and soon solicited the Greenwood portrait. There was no doubt that the viewing—and, it was to be hoped—buying public would know it to be the work of William Sharp; the print contains the words "Drawn from Nature and on Stone and Printed in Colours by Wᵐ Sharp"; "This Plate executed at the request of the Congregation of Kings Chapel, is respectfully dedicated to them by their obliged and Obdᵗ Servᵗ Wᵐ Sharp"; "Entered . . . by William Sharp"; and it is signed on stone "WSharp

1840." His name appears four times. Stylistically, Sharp's earliest signed work with printed color done in Boston was a natural step from the use of color seen in the portfolios. *F.W.P. Greenwood* has light suggestions of coral color on face and hands, and light blue in the background on either side of the head.

Harry T. Peters wrote that since the colors seemed to have been applied for printing on only one stone the print could be called a "lithotint." With this as precedent, an earlier print, *The Princess Victoria*, published in 1833, has also been so called.[11] "Lithotint" commonly refers to the tonal effect produced by a wash of color, however, and does not properly refer to localized areas of different colors placed on one stone. But even this is a misinterpretation of the term as used by lithographers in the 1840s. The term actually referred to a spattering technique, of increasing density, similar to aquatint. Sharp's adaptation was a clever derivation from a technique used in stipple engraving; superimposing colors for chromatic effect was a notion which probably came more slowly. Until 1843 there are no known prints done by Sharp in Boston that are similar to the chromolithographs he is believed to have done in England in the mid-1830s.

In answer to the question of whether Sharp was responsible for the first color printing by lithography in Boston, *F.W.P. Greenwood* was probably the first portrait lithograph printed in colors, but it was not the first example of printed color, for there are at least two music sheet title pages with printed color published earlier. "Gov. Morton's Grand March" used tint for a tracery frame border; "Tremont Grand March," for a wreath of delicate flowers encircling a harp. The pieces were copyrighted by Henry Prentiss, the prolific music publisher, on November 22, 1839, and January 25, 1840. The lithographer in both cases was T. Moore of Boston. The ink for the color is coral, or rusty pink.

Moore's firm was taken over very shortly after these sheets were printed by the businessman and real estate broker Benjamin W. Thayer. Sharp did some work for Thayer before forming his own partnership with Michelin. Perhaps Thayer inherited Sharp along with Benjamin Champney and Fitz Hugh Lane from the bankrupt Moore. Both the pieces mentioned above were published six months after Sharp arrived in Boston. And the coral or rusty pink color is the same as that used in the flesh tones of *F.W.P. Greenwood*. Evidence is therefore strong that Sharp was responsible for the first color lithography in Boston.

Within the year of Sharp's arrival in Boston, the shops of Thayer & Co. and Sharp & Michelin were printing music sheet illustrations with tints. Sharp had worked for the first, and was a principal of the second. The tints the shops used were either gray-green or tan-beige, two colors predominant in landscape, the subject matter to which they were generally applied. The coral ink of the flesh tones of *F.W.P. Greenwood* was seldom used. More work in color printing came with the publication in 1841 of *The American Vegetable Practice* (fig. 14). The introduction states:

> *The colored illustrations in the Materia Medica, will, I presume, meet with the entire approbation of the public. They have been procured at great expense; and they were executed by a new process, invented by Mr. Sharp, recently of London, being the first of the kind ever issued in the United States. The different tints were produced by a series of printed impressions, the brush not*

having been used in giving effect or uniformity to the coloring. Connoisseurs in the arts have spoken of them in terms of admiration, and Mr. Sharp will no doubt succeed in bringing his discovery to a still greater degree of perfection.[12]

Sharp proceeded to do so. In 1843, in partnership with Ephraim W. Bouvé, he printed a sheet music cover for "Fleurs d'Eté" (fig. 15), which, if the pansies had been omitted, would have been one of the most highly successful, subtle, and delicate pieces of chromolithography produced in this country in the first years of the medium. A curious and important chromolithographed portrait of Daniel Webster (fig. 16), after a painting by Alfred Gallatin Hoit, was printed by Sharp between 1848 and 1853. It is not well known and was probably not widely distributed, if at all; the only known impressions are proofs. Perhaps the noticeable demarcation of red tint in the background made the print less attractive to prospective buyers. But the portrait certainly stands as one of the first—if not the first—efforts at full-blown chromolithography for portraits in Boston.

By 1845, Sharp was on his own. He succumbed to printing gift books, such as "Ladies Gems" and "caskets" in red, blue, and gold, and sheet music covers equally brightly colored, in the manner akin to medieval illumination, the rival technique from England championed by Owen Jones, who went on to use chromolithography for illustrations of ornamental decoration.

Sharp had to wait eight years after he began his career in Boston to bring his interest in chromolithography to culmination. Two projects came to him, one on top of the other, through the auspices of the Massachusetts Horticultural Society. *The Fruits of America*, "containing Richly Colored Figures, and full descriptions of all the choicest Varieties cultivated in the United States," was issued in parts from 1847 to 1856, and was published in two volumes by C. M. Hovey in 1856. The frontispiece of volume 1 contains a portrait of Hovey, the author, and volume 2 of Sharp, who drew and printed the illustrations. The Massachusetts Horticultural Society, which issued the parts in its newly instituted publication of the proceedings, wrote in 1847:

After infinite trouble and disappointment, the Committee feel satisfied that the process of Chromolithing, in its present state, is not adapted for a work of the character which it is determined to stamp on the Transactions of the Massachusetts Horticultural Society, or to give even a faint idea of the beautiful drawings made by their artist, Mr. W. Sharp.

While, therefore, the Committee regrets extremely that it is obliged to issue the present number with Chromolithed plates, it has resolved not only that the plates of the future numbers shall appear in a very different style, but that, if possible, those of the first number shall be reproduced in a uniform manner.[13]

In spite of the verdict, the illustrations were produced as chromolithographs. This was the first production of its kind in Boston. Chromatic color effects were achieved by printing color separations, a process still in use today. The fruits were the choicest specimens, and the illustrations well portray their succulence (fig. 17).

Witch Hazel. Hamamelis Virginica.

14. *Witch Hazel. Hamamelis Virginica*, from Morris Mattson, *The American Vegetable Practice*
(Boston, 1841). Color lithograph (printed by W. & J. C. Sharp),
5 ⅞ x 3 ¾ in. Print Department, Boston Public Library

15. (See p. 73 in color.)

16. *Daniel Webster*, ca. 1853. Chromolithograph proof impression after a
painting by Alfred Gallatin Hoit, 9¾ x 7½ in.
Museum of Fine Arts, Boston. Gift of Sylvester R. Koehler. K3284

A much more stylized work is the *Victoria Regia*, an elephant-folio publication devoted to the giant water lily owned by a Salem, Massachusetts, amateur botanist, John Fisk Allen. Sharp began work on this while still running off pears and apples for *The Fruits of America*. The technical skill displayed in these fine, enormous plates (fig. 18)—the careful register for each color—is truly admirable. Mr. Allen credited his portfolio on the *Victoria Regia* to Sir Joseph Paxton, who "prepared an account of the growth of the plant . . . for a memoir of the Victoria Regia by Sir W. J. Hooker, and it is on this work we mainly rely for the correctness of our historical material." Later, ". . . for the botanical description . . . I am indebted to the work of Sir W. J. Hooker, in part, and to the personal inspection of the plant by Rev. J. L. Russell, Professor of Botany at the Massachusetts Horticultural Society."[14]

That is not the whole picture. The compositions, the method of execution, and the colors are almost direct copies of the *Victoria Regia, or, Illustrations of the Royal Water Lily*, by Walter Fitch, with descriptions by Sir W. J. Hooker, published in London in 1851, three years earlier. The plates in John Fisk Allen's adaptation are in different order; two were eliminated and one was added. The text was taken almost word for word, though the London edition is lengthier. Sharp's illustrations, however, do credit to their source; they are better compositions, executed with color more elegant and less garish than their English model.

Within a few years, other lithography shops in Boston began to turn out chromolithographs that were hard to differentiate from the oil paintings they were meant to simulate. With his son Philip, Sharp was involved by that time in a new enthusiasm—photography—the profession of a newly acquired son-in-law, though no such productions by Sharp are known.

In Sharp's long career in Boston, he cranked out a large number of sheet music illustrations, some using for source material portraits and figures from his scrapbook of his English prints. Fortunately for the story of American prints, so meshed with that of American history, some of these illustrations are competently executed portraits—William Henry Harrison, Major Train, and Colonel Macomber. And there are some fine landscapes, in black ink lithography.

Sharp's delicately colored large-format crayon portrait style did not take hold; no commissions similar to the *Greenwood* are known. He did achieve some notice for his believed introduction of color lithographic printing, and, if the hints by others about the expense of his work are to be believed, he derived a good income from it as well. Sharp arrived in Boston in 1839 at the exact midpoint in his life. In addition to a wife and six children, he probably had with him a large quantity of the colored lithographic inks with which he had been experimenting in England. Within a short time, he subjected his technical development to popular approval. His career took a turn upward when the widespread interest in horticulture joined with his abilities as an artist and technician.

He began his career in England under the tutelage of a major force in nineteenth-century printmaking, the firm of Hullmandel. Sharp brought his portfolio and his lithographic inks with him from England to America. He returned to English sources for his *Victoria Regia*. Yet he incorporated this preparation and source material with American subject matter, and left a varied, interesting, and

THE TUFTS APPLE

Fruits of America Plate Nᵒ . Drawn from Nature & Chromo lithᵈ by W. Sharp & Son

17. *The Tufts Apple*, from C. M. Hovey, *Fruits of America*, 2 vols. (Boston, 1856).
Chromolithograph, 8½ x 7⅛ in. Print Department, Boston Public Library

18. (See p. 74 in color.)

72

15. *Fleurs d'Eté* (by Félicien David), 1843. Chromolithograph title-page illustration
for sheet music (printed by Bouvé & Sharp, Boston), 11¾ x 8¼ in.
Boston Athenaeum

18. *Victoria Regia, Fully Open*, one of six plates from John Fisk Allen,
Victoria Regia; or The Great Water Lily of America (Boston: printed and
published for the author, 1854). Chromolithograph, 15 x 21 in.
Museum of Fine Arts, Boston. Gift of Charles D. Childs. M36480

technically competent collection of views, portraits, and chromolithographed fruits, flowers, and portraits. Some are among the finest lithographs produced in America in the nineteenth century.

NOTES

1. London Directories in the early nineteenth century listed only men in business for themselves.

2. Justin Winsor, librarian of the Boston Public Library at the time, wrote on a piece of library stationery pasted inside the front cover: "Sharp's own scrap-book of the proofs, etc. of his work. We obtained them through his son-in-law, J. W. Black, photographer, in Boston." (This was eight months after the lithographer's death in 1876.) They were recently found in the Fine Arts Department, and have now been transferred to the Print Department.

3. Vestry minutes for December 19, 1839:

> It is being represented by Mr. Eliot that Mr. W.ᵐ Sharp, an eminent artist, was desirous to take a likeness, gratuitously, of the Rev.ᵈ Mr. Greenwood for the purpose of furnishing engravings thereof, it was voted, that Mr. Eliot be a committee to request Mr. Greenwood, to accede to the wishes of Mr. Sharp, by sitting to him for his likeness.

The records of King's Chapel are on deposit at the Massachusetts Historical Society.

4. Suffolk County Registry of Deeds, L 700 f 273.

5. Harry T. Peters was the author of *America on Stone* (New York, 1931), the foremost source on American lithography in the nineteenth century. The Sharps are discussed on pages 363–365.

6. Information on this pioneer work in chromolithography and the titles of many sheet music covers by Sharp were provided through the kindness of Professor David Tatham, Department of Fine Arts, Syracuse University.

7. C. T. Courtney Lewis, *The Story of Picture Printing in England During the Nineteenth Century* (London [1928]), p. 140.

8. Ibid., p. 153.

9. Peters, *op. cit.*, p. 364; see also discussion of P. S. Duval. Koehler had appended another note questioning the date; it was unclear whether it was a "o" or a "6."

10. Lewis, *op. cit.*, p. 139.

11. *The Princess Victoria* is not a lithotint; the color is watercolor wash and not printed ink. For further clarification, see Bettina A. Norton, "Beginnings of Color Lithography in America" (forthcoming).

12. Morris Mattson, *The American Vegetable Practice* (Boston, 1841), vol. 1, p. xi.

13. *Transactions of the Massachusetts Horticultural Society*, vol. 1, no. 1, July 1847, as quoted in Peters, *America on Stone*, p. 364. Note: This disclaimer was in only a limited number of copies of volume 1, number 1, of the *Transactions*, and was evidently removed before the edition was fully printed.

14. John Fisk Allen, *Victoria Regia, or The Great Water Lily of America* (Boston, 1854). The work published in England is *Victoria Regia, or, Illustrations of the Royal Water-lily, in a series of figures chiefly made from specimens flowering at Syon and Kew*, by Walter Fitch; with descriptions by Sir W. J. Hooker, published by Reeve & Benham (London, 1851). The Massachusetts Horticultural Society has copies of both.

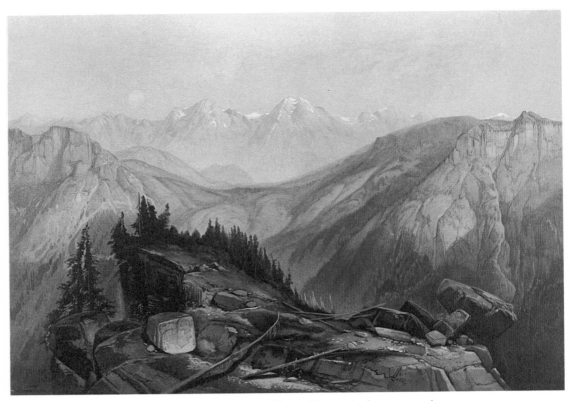

1. Louis Prang. *The Lower Yellowstone Range*, 1875. Chromolithograph after a watercolor of 1874 by Thomas Moran, 14 x 19¾ in. Included in a folio by F. V. Hayden, *The Yellowstone National Park* (Boston: L. Prang and Co., 1876).
Division of Graphic Arts, National Museum of History and Technology, Smithsonian Institution

The Democratic Art of Chromolithography in America: An Overview

PETER C. MARZIO

*Director, The Corcoran Gallery of Art; formerly Curator of Prints,
National Museum of History and Technology, Smithsonian Institution*

To Reproduce, to Imitate, Not to Create

Chromolithography, a commercial process of multicolor lithography that served advertisers and art promoters, was truly a democratic art of the second half of the nineteenth century. Chromos of cupids and cast-iron stoves and madonnas by Correggio, Raphael, Murillo, and other old masters, were made in imitation of oil paintings, watercolors, and chalk drawings. As one lithographer in Philadelphia advertised in 1867: we sell "all subjects of fine arts executed in chromo."[1]

The most talented and most commercially successful of all American chromolithographers, Louis Prang, was unequivocal: "Chromolithography is in itself an art *to reproduce, to imitate, not to create*, [it is] . . . for the painter what the type is for the writer—it is the brush and the pallet of the nineteenth century."[2] Prang's reproductions of fine art enjoyed worldwide renown. His fifteen chromos after Thomas Moran's watercolors of Yellowstone National Park appeared in 1876 and were hailed "a just subject for national pride . . . equal . . . with anything of the kind ever undertaken in Europe, produced wholly on American soil."[3] Critics were convinced that these and other chromos were indeed faithful to the watercolors. Sometimes they were (compare, for example, figs. 1 and 2).[4] Prints of other American chromolithographers, generally not of Prang's grade of excellence, made up a bewildering array of reproductions. Typical is the *View on Esopus Creek*, after Casimir Clayton Griswold, by Colton, Zahm & Roberts of New York (fig. 3). Promoted as an accurate copy, it is one of a vast body of mediocre reproductions after unimportant artists. A label on the back presents particulars of the original painting and advertises additional chromos (fig. 4). Many other advertising labels survive, each testifying to the role of the chromo in the promotion of art in America.

The prime incentive of chromolithographers was profit, but their sales pitch aimed at the finer instincts. Appealing to the general spirit of art promotion that pervaded the minds of middle-class Americans, one chromo salesman wrote in 1868:

> It has often been asked, "How shall a democracy be educated in art?" We answer, "By art." It is idle to teach without example. And yet the art galleries in our country are few and far between. We have neither the treasures of the past nor a numerous class of painters, nor the means of supporting well-endowed academies of design. Without these agencies, we believe that, especially in a country of vast extent, but limited population, the only substitute for them, the only efficient educator of the people, is The Chromo.[5]

(text continues on p. 89)

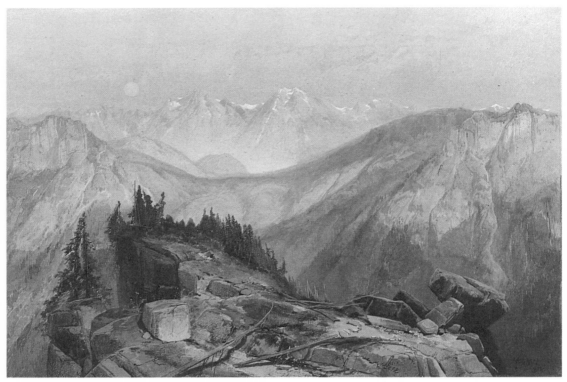

2. Thomas Moran, *The Lower Yellowstone Range*, 1874. Watercolor, 14 x 19¾ in.
Division of Graphic Arts, National Museum of History and Technology, Smithsonian Institution

4. Label on reverse side of fig. 3

View on Esopus Creek, N. Y.

PAINTED BY C. C. GRISWOLD.

Chromo-Lithographed and Published by

COLTON, ZAHM & ROBERTS,

No. 172 WILLIAM STREET, NEW-YORK.

Entered, according to Act of Congress, in the year 1869, by COLTON,
ZAHM & ROBERTS, in the Clerk's Office of the District Court of
the United States for the Southern District of New York.

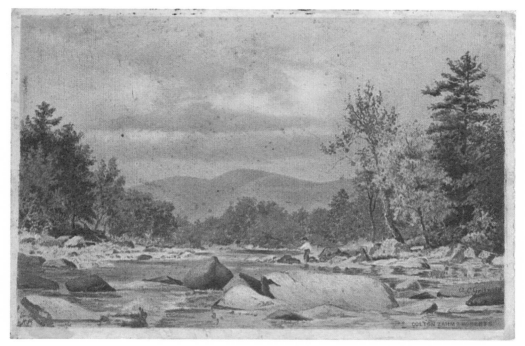

3. Colton, Zahm & Roberts. *View on Esopus Creek, N.Y.*, 1869. Chromolithograph after a painting by C.C. Griswold, 5⅛ x 7½ in.
Division of Graphic Arts, National Museum of History and Technology, Smithsonian Institution

5. Bass Otis. Lithograph (one-color), 1819, 3¾ x 5¼ in.
Division of Graphic Arts, National Museum of History and Technology, Smithsonian Institution

GRANDPAPA'S PET.

Drawn & Lithotinted by John H. Richards, expressly for Miss Leslie's Magazine the first specimen of this art ever produced in the United States.

Lith of P.S. Duval Philadelphia.

6. P.S. Duval and John H. Richards. *Grandpapa's Pet*, 1843. Lithotint with handcoloring, 6 x 4¾ in. Division of Graphic Arts, National Museum of History and Technology, Smithsonian Institution

7. C. J. Hullmandel. *Rue de la grosse horloge, Rouen.* Chromolithograph for Thomas Shotter Boys,
Picturesque Architecture in Paris, Ghent, Antwerp, Rouen (published in London, 1839),
21 ½ x 14 ⅜ in. Rare Book Room, Library of Congress

8. William Sharp. *Rev. F. W. P. Greenwood*, 1840. (See p. 50.)

9. P. S. Duval. Title page from *The Iris*, 1850–1851. Chromolithograph after a design
by Christian Schuessele, 9 x 6 in. Library of Congress

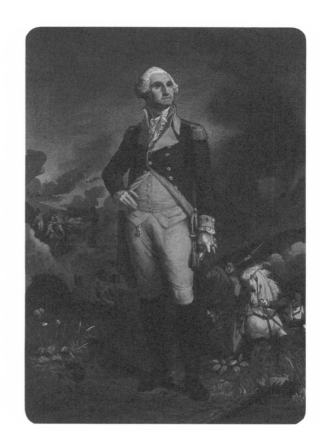

10. P.S. Duval. *Washington*, 1851.
Chromolithograph
after a painting by Christian Schuessele,
23½ x 18¾ in.
Library of Congress

11. P.S. Duval. *Lafayette*, 1851.
Chromolithograph
after a painting by Christian Schuessele,
22½ x 17¼ in.
Library of Congress

12. Julius Bien. *American Flamingo*, No. 8-1, plate 375, 1860. Chromolithograph after a watercolor by John James Audubon and a handcolored engraving by Robert Havell, Jr., 40 x 27 in.
Division of Graphic Arts, National Museum of History and Technology, Smithsonian Institution

13. F. Gleason. *Winter Sunday in Olden Times*, 1875. Chromolithograph, 14¾ x 20¾ in.
Division of Graphic Arts, National Museum of History and Technology, Smithsonian Institution

14. Label stamped on reverse of fig. 13

15a

15a–e. Louis Prang. *The Present*, 1873.
Chromolithograph after a painting by Meyer von Bremen, 12¾ x 14¼ in.
Key plate, three of thirty progressive proofs, and final state.
Division of Graphic Arts, National Museum of History and Technology, Smithsonian Institution

13. F. Gleason. *Winter Sunday in Olden Times*, 1875. Chromolithograph, 14¾ x 20¾ in.
Division of Graphic Arts, National Museum of History and Technology, Smithsonian Institution

14. Label stamped on reverse of fig. 13

15a

15a–e. Louis Prang. *The Present*, 1873.
Chromolithograph after a painting by Meyer von Bremen, 12¾ x 14¼ in.
Key plate, three of thirty progressive proofs, and final state.
Division of Graphic Arts, National Museum of History and Technology, Smithsonian Institution

15b

15c

15d

15e

The process of making a chromo was itself a topic of public enthusiasm. The technology was billed as something of a wonder, requiring both old craft skill and modern mechanical know-how. A classic description that appeared in the Boston *Daily Advertiser* shortly after the Civil War read in part:

Chromo-Lithography is the art of printing pictures from stone, in colors. The most difficult branch of it—which is now generally implied when chromos are spoken of—is the art of reproducing oil paintings. When a chromo is made by a competent hand, it represents an exact counterpart of the original painting, with the delicate gradations of tints and shades, and with much of the spirit and tone of a production of the brush and palette.

To understand how chromos are made, the art of lithography must first be briefly explained. The stone used in lithographing is a species of limestone found in Bavaria, and is wrought into thick slabs with finely polished surface. The drawing is made upon the slab with a sort of colored soap, which adheres to the stone, and enters into a chemical combination with it after the application of certain acids and gums. When the drawing is complete, the slab is put on the press, and carefully dampened with a sponge. The oil color (or ink) is then applied with a common printer's roller. Of course, the parts of the slab which contain no drawing, being wet, resist ink; while the drawing itself, being oily, repels the water, but retains the color applied. It is thus that, without a raised surface or incision—as in common printing, wood-cuts, and steel engravings—lithography produces printed drawings from a perfectly smooth stone.

In a chromo, the first proof is a light ground-tint, covering nearly all the surface. It has only a faint, shadowy resemblance to the completed picture. It is in fact rather a shadow than an outline. The next proof, from the second stone, contains all the shades of another color. This process is repeated again and again and again; occasionally, as often as thirty times. We saw one proof, in a visit to Mr. Prang's establishment,—a group of cattle,—that had passed through twelve times; and it still bore a greater resemblance to a spoiled color photograph than to the charming picture which it subsequently became. The number of impressions, however, does not necessarily indicate the number of colors in a painting, because the colors and tints are greatly multiplied by combinations created in the process of printing one over another. In twenty-five impressions, it is sometimes necessary and possible to produce a hundred distinct shades.

The last impression is made by an engraved stone, which produces that resemblance to canvas noticeable in all of Mr. Prang's finer specimens. English and German chromos, as a rule, do not attempt to give this delicate final touch, although it would seem to be essential in order to make a perfect imitation of a painting.

The paper used is white, heavy "plate paper" of the best quality, which has to pass through a heavy press, sheet by sheet, before its surface is fit to receive an impression.

The process thus briefly explained, we need hardly add, requires equally great skill and judgment at every stage. A single error is instantly detected by

the practised eye in the finished specimen. The production of a chromo, if it is at all complicated, requires several months—sometimes several years—of careful preparation. The mere drawing of the different and entirely detached parts on so many different stones is of itself a work that requires an amount of labor and a degree of skill, which, to a person unfamiliar with the process, would appear incredible. Still more difficult, and needing still greater skill, is the process of coloring. This demands a knowledge which artists have hitherto almost exclusively monopolized, and, in addition to it, the practical familiarity of a printer with mechanical details. "Drying" and "registering" are as important branches of the art of making chromos as drawing and coloring. On proper registering, for example, the entire possibility of producing a picture at every stage of its progress depends. "Registering" is that part of a pressman's work which consists in so arranging the paper in the press, that it shall receive the impression on exactly the same spot of every sheet. In book work, each page must be exactly opposite the page printed on the other side of the sheet, in order that the impression, if on thin paper, may not "show through." In newspaper work this is of less importance, and often is not attended to with any special care. But in chromolithography the difference of a hair's-breadth would spoil a picture; for it would hopelessly mix up the colors.

After the chromo has passed through the press, it is embossed and varnished, and then put up for the market. These final processes are for the purpose of breaking the glossy light, and of softening the hard outlines which the picture received from the stone, which imparts to it the resemblance of a painting on canvas.[6]

Although we now know some of the information and explanation to be incorrect, this awe of chromo-printing was far from unusual; similar essays made interesting copy for magazines and newspapers throughout the last three decades of the nineteenth century.

The chromo years have been relatively ignored by historians of printed pictures. The period from 1860 to 1900 is, in the history of American prints, a misty, unexplored twilight zone during which at least three important printing innovations were introduced into lithographic shops: machine-applied color, steam power, and photomechanical reproduction. The period marks the end of hand-powered printing presses for commercial use and the end of hand-colored prints such as those associated with Currier and Ives. Often viewed by historians as the era of the decline of significant American prints, the twilight zone is the genesis of modern picture-making.

For too long, the notion has persisted that the only prints worth looking at are handmade, that is, drawn on or cut into plates; printed on hand-operated presses; and colored by faceless women in the sweatshops of Endicott, Pendleton, or Currier and Ives. These are prints from the halcyon years in American history, that romantic age of printmaking that gave us the wholesome visions of Paul Revere's *Boston Massacre*, Nathaniel Currier's *Awful Conflagration of the Steam Boat* Lexington, and H. R. Robinson's ethnic stereotypes of blacks, Jews, and Irishmen. As long as the print precedes "modern" technology, it is considered legitimate for study, for classification, and for collecting—often regardless of

subject matter, aesthetics, or printing quality. But the minute a camera, power press, or automatic coloring technique is introduced the print begins to lose merit.

Harry T. Peters, whose avid collecting and energetic writing contributed so much to the study of American lithography (that "vast and absorbing jungle," as he called it),[7] wrote in *America on Stone* (1931): "Chromolithography, with multiple stones for one print . . . separated the artists from the craftsmen and turned popular picture making almost wholly over to the various journals and their advertisers."[8] In Peters's mind, the chromo technology divested the lithograph of individuality and personality. He continued:

. . . this quality of personality in the old lithographs may be almost as much a part of their appeal as their romantic American contents, and it may be very easily questioned whether a complete photographic record of the same subjects would have anywhere near the same appeal. It certainly is true that the best and most individual work is grouped near the beginning of the story. The only explanation I can offer is that the invention sprang up fully developed, in all its simplicity, eliminating any period of early technical crudity, and that good artists were naturally attracted to it in the early stages and drew away from it when technical over-development and increasing subservience to business began to make difficult or impossible the expression of personality.[9]

Although Harry T. Peters may be said to have idealized the early years of American lithography, his point is well taken. Even in the names of the printing firms themselves, one can see a growing tendency toward impersonalization. Trade cards of the 1830s and '40s carry names like P. S. Duval, William Pendleton, and Sarony, Major, and Knapp, while the post–Civil War cards bear the names American Lithographic Company, American Photo-Lithographic Co., Philadelphia Chromo Co., National Chromo Co., and New England Lithographic Co. Individuality, as expressed in a craftsman's name, definitely declined. The correspondence between companies and their consumers reflects this same trend. One handwritten letter mailed from the Endicott firm to the captain of a crew in the United States Navy in 1865 stated:

Dear Sir:

We wrote to you sometime [ago] . . . in reference to our Chromo Lithograph of the Bombardment of Fort Fisher and having received no reply presume you have not rec'd it.

We send you a sample copy by todays mail and as your vessel occupies quite a prominent place in it we think the officers and men would like to have some copies. If you will make out a list of those who want them and send the money to us with the addresses to which the copies are to be sent we will allow you an extra copy for every five names you obtain and will send them safely post paid by the following mail.[10]

Despite the obvious premium or gimmick in this specimen from the twilight zone, the letter takes a direct personal approach that connoisseurs of the early American lithograph (such as Harry T. Peters) would likely have favored. Twenty years later, business letters were written not by hand but on Remington #2 typewriters and on three-color stationery. In the romantics' view, the "personality" of American lithography had vanished by the 1880s.

Most of the collectors, curators, and historians of American prints have shared the conventional bias and, as a result, have cut themselves off from a turbulent era of immense importance. The twilight zone of American printmaking saw hundreds of different print techniques employing photography, chemistry, electricity, and mechanical innovations in a seemingly endless array of imaginative forms. Everyone seemed to be searching for the best way to produce the most pictures of the highest reproductive quality for the lowest cost. Many efficient techniques emerged, and for a part of the nineteenth century none was more visible than the American chromo.[11]

A Problem of Definition

The basic question is: What is a chromolithograph? How does it differ from other lithographs? There is no standard form or list of names that curators in this country follow;[12] as a result, lithographs are catalogued by a variety of systems. The result is chaos. The following list serves to sort out the terminology:

A. *Single-color lithograph*.
This is, of course, the simplest form, involving one lithographic stone and one printing-ink color. Bass Otis's landscape scene (fig. 5) is generally accepted as the first American lithograph.

B. *Hand-colored lithograph*.
This type first appeared in America in the 1820s and reigned as the major form until the early 1860s. Originally a black-and-white print colored freely by hand with crayons, chalks, and water paints, it became—under the direction of Nathaniel Currier and others—a mass-produced print colored often with stencils according to rigid color formulas.

C. *Tinted lithograph*.
Unlike the single-color and the hand-colored lithograph, which required one stone, the tinted lithograph involved two or three—seldom more. It is not known when they were first made in America, but tinted lithographs appeared in Germany from 1820 on, and are described in C. J. Hullmandel's *Art of Drawing upon Stone* (London, 1824) and in other European manuals of the period. Most have a colored ground such as lemon, gray, or light blue, from one stone, with the image delineated in a different color printed from a second stone. Many show a generous amount of hand-coloring. These should be labeled "lithograph—tinted and hand-colored."

D. *Lithotint*.
The term was coined by C. J. Hullmandel, its major promoter, in 1840. Often confused with "tinted lithograph" in cataloguing systems, the lithotint is a tonal lithograph printed from a single stone. Washes of different intensities were applied to the stone so that, after special preparation, the ink would print in varying degrees from light to dark, thus giving the lithograph the appearance of a wash drawing or a watercolor.

P. S. Duval and John H. Richards of Philadelphia are credited with producing the first lithotint in America. Entitled *Grandpapa's Pet*, it appeared in *Miss Leslie's Magazine* of April 1843 and boasted of being "the first specimen

of this art ever published in the United States" (fig. 6). The initial experiments were made by Richards, who, according to *Miss Leslie's Magazine*, first saw one of Hullmandel's lithotints in December 1841 and "although at that time ignorant of the composition of the chemical ink suitable for the purpose, and wholly unacquainted with the mode of application, he felt convinced that the discovery of these was worth his most strenuous efforts." The printing was probably done by P. S. Duval, who had come to the United States from France in 1831. The lithotint was new even in France in the early 1840s. Although the great French printer R. J. Lemercier was experimenting with it in 1841 and 1842, it was still in its infancy in 1843. The work of both Richards and Duval, then, was quite extraordinary.[13]

The lithotint never gained a foothold in America. It was difficult to make and required artistry and time. Duval, writing in 1871, noted that drawing by "*Lavis or Wash on Stone* . . . has never been fairly brought into practice as yet, but we will describe it, in the hope that some artist may be induced to try it."[14] Few did.

E. *Chromolithograph.*

In the broadest sense a chromo is a lithograph composed of at least three colors, each applied to the print from a separate stone. Moreover, unlike tinted lithographs, with a second or third color casting a hue across the print surface, the colors in a chromo compose the image itself. The earliest chromos were made by German printers in the 1820s. The inventor of lithography, Alois Senefelder, tried his hand at producing chromos and provided many guidelines that served later printers. Even his English patent of 1801 (no. 2518) for "Printing Textile Fabrics" included a section on the mechanical application of color. In his famous treatise of 1819, *A Complete Course of Lithography*, he wrote: "The manner of printing in different colours is peculiar to the stone, and capable of such a degree of perfection, that I have no doubt perfect paintings will one day be produced by it."[15]

German printers led the way in the development of color reproduction, but it was a French printer, Godefroy Engelmann, and his son who coined the term "chromolithographie" in a patent of 1837. Two years later Charles Hullmandel printed the color lithographs in Thomas Shotter Boys's *Picturesque Architecture in Paris, Ghent, Antwerp, Rouen* . . . , calling the process "chroma-lithography." This was probably the first use of the term in print.[16]

The earliest German, French, and American chromos juxtaposed blocks of color or solid tints, without attempting to suggest shades or tones. As lithographers gained experience, however, they aimed more and more at capturing the essence of original works of art by overlaying colors and by printing with a broad range of transparent and semitransparent inks. The London *Art-Journal* of April 1859 observed that "Chromo-Lithography . . . offers the means of repeating the work of the artist in the artist's own best style."[17] Among the earliest examples of high quality in Europe were the chromos produced by Hullmandel for Boys's *Picturesque Architecture* (see fig. 7). The preface made a point of differentiating between the old style and the new:

The whole of the drawings composing this volume are produced entirely by means of lithography: they are printed oil-colors, and come from the press precisely as they now appear. It was expressly stipulated . . . that not a touch should be added afterwards, and this injunction has been strictly adhered to. They are pictures drawn on stone, and reproduced by printing with colours: every touch is the work of the artist, and every impression the product of the press.

This is the first, and as yet, the only attempt to imitate pictorial efforts of landscape architecture in chroma-lithography; and in its application to this class of subjects, it has been carried so far beyond what was required in copying polychrome architecture, hieroglyphics, arabesques, etc., that it has become almost a new art . . . [As compared to] mere decorative subjects, [where] the colours are positive and opaque, the tints flat, and the several hues of equal intensity throughout . . . in these views the various effects of light and shade, of local colour and general tone, result from transparent and graduated tints.[18]

From this "new" beginning in 1839 the chromo, as a sophisticated reproduction of original art, grew in popularity, first in Germany, then England and France, and finally in the United States. By the time it reached America (1840), chromolithography meant any lithograph printed in color from at least three stones, and done in such a way that the colors were more than just tints overlying the entire surface. It also had a second, slightly narrower definition. By the late 1850s or early 1860s and for the rest of the century, it usually referred specifically to a printed color lithographic reproduction of an oil painting or watercolor—or at least a fine color lithograph of some religious, heroic, or landscape subject. Often, in the context of this second definition, a chromo was gaudy or heavy with varnish and glued to a painter's canvas and sometimes embossed with striations so that viewers could not see exactly where the print stopped and the canvas backing began. Or, chromos could also be reproductions of fine art incorporated into a calendar or some other commercial form.

In Europe, particularly Germany, the varnished and embossed chromos came to be called *oleographs*.[19] The term was not unknown in America; in fact, the American Oleograph Company (of Milwaukee) stayed in business for a number of years, and there is no consistent use of the term. Importers of foreign chromos occasionally used "oleography" for large, expensive chromos. In the *Phillips Business Directory* of New York City (1887–1888) the firm of Berger Bros. of 304 Broadway advertised "Main office for Germany . . . importers of chromos, Oleographs 15 x 20, 20 x 30,; sole agents for German factories; large stock at all times on hand; new designs daily. . . ." Several doors up on Broadway another firm, William Bruns, advertising in Wilson's New York *Business Directory* for 1883, was also explicit: "Publisher and manufacturer of standard chromos, classic and 10 x 14 Oleographs . . . fine chromo panels . . . art novelties . . . Catalogues mailed free." When the Cleveland firm of J. F. Ryder (best known for its chromo *Yankee Doodle 1776*) sent a batch of prints (produced by Clay, Cosack & Co.) to the *London Printing Times and Lithographer* (July 15, 1875) the British editor defined them as: "four oleographs, as they would be called in this

country—being printed in oil and embossed to imitate the irregularities of canvas." But somehow, "oleograph" was a term that failed in America. "Chromo" served to describe a variety of printed color lithographs, some used to disseminate works of fine art and others to advertise American industry. Mark Twain confirmed the broad and often imprecise American usage of the term chromolithography as he sat in the barren environment of a European castle in 1889. There were none of the little conveniences of life:

> . . . *no soap, no matches, no looking glass—except a metal one, about as powerful as a pail of water. And not a chromo. I had been used to chromos for years, and I saw now that without my suspecting it a passion for art had got worked into the fabric of my being, and was become a part of me. It made me homesick to look around over this proud and gaudy but heartless barrenness and remember that in our house in East Hartford, all unpretending as it was, you couldn't go into a room but you would find an insurance-chromo, or at least a three-color God-Bless-Our-Home over the door; and in the parlor we had nine.*[20]

Twain humorously defined the chromo to its full breadth: it was art, industry, sentimentality, and interior decoration all in one.

The quest for a definition is even more confusing when one realizes that the term "chromo" was used also to designate a number of trade items: "chromo greeting cards," "chromo novelties," "chromo show cards," "chromo ornaments," and "chromo blanks" are just a few examples sprinkled through the advertisements and the city directories.

For American museums and libraries, chromolithography is a useful term when it is qualified. For example, "chromolithographed reproduction of oil painting" or "chromolithographed trade card" or "chromolithographed reproduction of a watercolor used as a calendar illustration" seem suitable. The variety is endless. Nineteenth-century Americans used the word chromo several ways, and I believe that this spirit should be maintained. It is the contemporary use of chromolithography that should determine its present-day catalogue subclassification.

The American Chromo

In the 1840s and early 1850s the American chromo evolved from the work of Boston lithographer William Sharp; the Philadelphia firms organized by P. S. Duval, L. N. Rosenthal, and Thomas Sinclair; and the New York shop of Sarony and Major. Sharp's portrait of *Reverend Greenwood* (fig. 8), printed in 1840, reads: "Drawn from Nature and on Stone and Printed in Colours," and is probably the first American chromolithograph that conforms to the definition of a lithograph made of three or more colors each from a separate stone and together making up the composition of the figures. Success did not come speedily even after this historic first, for Sharp continued his pursuit of the elusive chromo technology throughout the 1840s. When his prints for the *Transactions of the Massachusetts Horticultural Society* were published in 1847, the editors emphasized in the "Preface to the Third Number," that chromos of the "highest artistic skill . . . involved . . . an amount of labor and

delay which could not have been forseen, and the same may be stated with re-
gard to the expense." At this early date, two of the chromolithographer's goals
were being set: exact reproduction and uniform quality. Within fifteen years,
chromolithographs were, ironically, to be condemned as mere reproductions
with a uniformity attributable to machines: the very dream of printers of the
1840s became anathema to some critics of the 1860s. The horns of the chromo-
lithographer's dilemma were evident from the start.

The American chromo followed several styles. Most of the works printed be-
fore the Civil War are characterized by broad areas of flat, opaque colors, juxta-
posed beside one another, a style that remained a part of the American chromo
tradition throughout the nineteenth century. Duval's illuminated title pages for
annuals such as *The Iris* in the early 1850s (fig. 9) are examples of this phenom-
enon, some productions requiring as many as ten colors. At the same time, how-
ever, Duval and his competitors were stepping in the direction of the "new-
style" chromo pioneered by Hullmandel in England more than ten years earlier.
Duval's chromos of Christian Schuessele's individual portraits of George Wash-
ington and the Marquis de Lafayette are among the most complex chromos that
had been produced in America. Although they did not blend colors felicitously
both aimed to create the illusion of watercolor or oil pigments (figs. 10 and 11).
The Philadelphia *Public Ledger* of March 4, 1852, remarking on the use of
thirteen separate stones, extolled: "The new style of chromolithography is
capable of the finest expressions of coloring, as well as of light and shade. They
appear like finished paintings and the cheapness of their production commends
the art to universal favor." The *Public Ledger* was paying the highest compli-
ment and imbuing the chromo with the noblest mission: Duval's new kind of
print was oil painting for the masses. It would bring art to everyone.

Technical mastery became the chromolithographer's trademark of the 1850s:
Sharp's *Victoria Regia* illustrations appeared in 1854 and Julius Bien's reproduc-
tions of Audubon's *Birds of America*, printed between 1858 and 1860, marked
the arrival of the sophisticated chromolithograph in America (see fig. 12). By
1871 Prang of Boston would stun the public eye with his landscapes after Benja-
min Champney.

As America's most famous chromo producer and popularizer Louis Prang's
position is unassailable. His self-promotion in advertising has made his name an
important historical word; it has also tended to blur the work of others. While
Prang went so far as to claim authorship of the word "chromo," a colloquial
shortening of chromolithograph, "as a sort of trademark for my best oil color
prints," his claim to originality is questionable. The *Oxford English Dictionary*
notes that the word "chromo" was in use "shortly after 1850," and in other
combinations, such as "chromo-facsimile," by the 1860s. As early as 1847 or
1848 William Sharp printed "chromo" on a chromolithograph entitled "The
Floral Year."

Some museum collections are loaded with Prang chromos, often because
Prang himself donated the works to the institutions. But several hundred chromo
makers who failed to entomb their work are simply names to us today. In less
than a century, the works of an army of printers and dealers have disappeared.

To cite one example the entry for F. Gleason in *America on Stone*, reads:

> *Unknown / 1½ Tremont Row / Publisher of a typical "Life and Age of Man,"
> n.d., small. . . . Also other small prints of this type, which were probably all
> copies.*[21]

Winter Sunday in Olden Times (fig. 13), which was printed by Strobridge and
Co. of Cincinnati, is a chromo copyrighted in 1875 by this "unknown." On the
back there is a suggestive blurb (fig. 14). The legible parts read:

> *The American and European CHROMO PUBLISHING CO. have on exhibi-
> tion, at their Picture Gallery, over a million of most elegant and costly Oil
> Chromos. They are all of large size, and embrace some of the most magnificent
> works of art ever produced either in Europe or America.*

After the next few sentences, which have been worn away, the text ends with an
interesting twist. The chromo was often used as a premium by newspapers and
magazines, but Gleason—who apparently was above all that—made the maga-
zine the premium for a chromo. "We will send you," he writes, "the Home
Circle ['the best illustrated family weekly paper in the United States'] with the
list of the Chromos, on receipt of a stamp for return postage."

Gleason was one of many chromo publishers who commissioned lithographers
to produce large runs of particular pictures. When Gleason's business apparently
failed in 1877, Strobridge had in stock at least two thousand copies of *Winter
Sunday in Olden Times*.[22]

Many of America's chromolithographers were foreign-born. Some, such as
Julius Bien and Louis Prang, brought in their heads the essence of European
lithography. They transferred the German craft to America, adapted it to
American practices, and raised the aesthetic and business standards to un-
paralleled heights. There were also chromolithographers from England, France,
Norway, Italy, Austria, and Russia who found their way to America.

A rough estimate based on business directories of America's eight largest cities
shows nearly five hundred firms producing, publishing, or selling chromolitho-
graphs in 1879. In New York alone, there were more than one hundred. The
competition was brutal, the combined sales pitches somewhat reminiscent of a
national convention of used-car salesmen. The production claims, even if in-
flated twofold, are staggering. Pelletreau and Raynor of New York City proudly
advertised in 1872: "Printing Fine Chromos with us forms a specialty, and we
need no stronger evidence of our success, than the Million and upwards of
Chromos we turned out during the last year from but six subjects. . . ."[23] And the
call for high-pressure salesmen was a din to the ear: "We want first class reliable
agents, male and female [wrote the New York *Independent*], in every town,
village, and city, in the whole country, to canvass for [chromos]. . . . We are
offering EXTRA inducements to good agents, and advise all such to send for our
descriptive circulars before engaging in any other business."[24] Other producers
may have been more modest, but the total volume of work—quality aside—
demands the attention of the historian.

Familiarity Breeds Contempt

From unbridled enthusiasm to pure disgust, the pros and cons of chromolithography have echoed for nearly a century. In the 1850s and 1860s stories of the chromo craft made dazzling copy. The progressive proofs exhibited by Louis Prang in his printshop and used by his salesmen to attract customers represented to some observers valid proof that modern technology was a key to the successful promotion of art in America (see fig. 15). By making possible accurate copies of master paintings, chromolithography was helping America to democratize fine art. C. W. Webber wrote in the introduction to his best-seller *The Hunter-Naturalist* (1852) that L. N. Rosenthal's chromos after Alfred Jacob Miller's paintings of the Plains Indians "brought to bear the latest discoveries of Science, in the application of mechanical forces to pictorial illustration, as to cheapen all their cost without any deterioration of artistic value; and bring the essential spirit of what have been heretofore as sealed books, from their excessive costliness, within the reach of the People."[25] The dream of a cultured citizenry seemed at hand. Chromolithography "promises to diffuse not a love of art merely among the people at large," wrote the *Boston Daily Advertiser* shortly after the Civil War, "but to disseminate the choicest masterpieces of art itself. It is art republicanized and naturalized in America."[26] Similar sentiments were repeated in the '80s and '90s and in the first two decades of this century.

In the 1880s there was a growing interest in what the editor of *Art Age* defined in 1884 as "Street Lithography." By contrast with Prang's traditional democratic idealism, which called for reproductions of fine art for the home, art for the street became a fad in the form of commercial advertising posters. "Every . . . lithographer who sends out well drawn, well colored, well composed theatrical posters to adorn the streets of a large American city is materially assisting in the art education of a nation. . . . For the average man or woman, it represents an innocent luxury of the eye which costs nothing and is free to all, and may therefore be enjoyed without compunctions of the purse's conscience."[27]

The ubiquity of the chromo, both as advertisement and as reproduction of fine art, spawned a host of hostile critics ranging from intellectuals to art historians to curbside philosophers. Clarence Cooke, self-proclaimed guardian of Victorian high culture, attacked in the New York *Tribune* the best of Louis Prang's chromos by insisting that they were counterfeits, mere illusions of art.[28] Cooke had many supporters. The English critic Philip Gilbert Hamerton stated his feelings in 1882:

> . . . *the employment of chromolithography to imitate the synthetic colour of painters is one of those pernicious mistakes by which well-meaning people do more harm than they imagine. The money spent upon a showy chromo-lithograph which coarsely misrepresents some great man's tender and thoughtful colouring might have purchased a good engraving or a good permanent photograph from an uncoloured drawing by the same artist. You will never meet with a cultivated painter who buys chromo-lithographs, the reason being that his eye is too well trained to endure them. Some of them, no doubt, are wonderful results of industry, but in a certain sense, the better they are the worse they are, for when visibly hideous they would deter even an ignorant*

purchaser who had a little natural taste, whereas when they are almost pretty they allure him.[29]

In the twentieth century Lewis Mumford carried on Hamerton's protest: "The cheaper chromo-lithograph only increased the amount of futile work in the field, helping printers to flourish whilst it encouraged the original artists to starve."[30] And in the late 1940s, Sigfried Giedion took the deadliest aim. In *Mechanization Takes Command* (1948) he condemned the second half of the nineteenth century for its lack of fresh vision, its mania for reproducing every kind of art object, and its dedication to confusing the human environment through mechanization.[31] The chromo publishers boasted that their works were "manufactured" in "factories." To Giedion and others this was reason not for praise but for condemnation. In Giedion's mind reproductions reduced paintings to anecdotes and, because of their massive numbers, led to a devaluation of art as a moral symbol.

The intellectual protest was only part of the negative response. Running through American culture from the 1890s until the present day is the use of the word chromo for "any person or object that is ugly or offensive."[32] Damon Runyon wrote in *Take It Easy* (1938): "[His sister] is the chromo sitting behind him. . . . She is older than he is, and has a big nose and a moustache."[33] In Australia, which imported American lithographs, "chromo" is a slang term for prostitute.[34] And during the final quarter of the nineteenth century, a phrase equivalent to "that takes the cake" was "that takes the chromo."[35]

This negativism was due to several factors: (1) the vast number of chromos simply got to be overwhelming and the fad fizzled; (2) overly sentimental or simply ugly reproduction characterized a great percentage of the chromos; and (3) the advertising blurbs, even the polite essays, bordered on the absurd. One notice of 1873 read:

> *It is a well-known fact that there are many things that cannot be done in a day, though, as the world grows older, the new and various combinations in the arts and sciences render short and easy some processes that have been slow and difficult. A few years ago an oil painting was so much of a rarity, by reason of the positive limitation of the supply, that only the very wealthy could afford to possess one. To-day the windows of our fancy stores are lined with pictures so nearly like oil paintings as to be hardly told from them, and at a cost which brings them within the reach of all. The fine chromo of to-day, for practical purposes, is as good as a painting in oil; indeed, it is oil painting, only the painting is quickly done, by a peculiar kind of printing process, instead of by the hand of the artist.*[36]

This, of course, is expected from an advertiser. But even review notices in art magazines of the 1880–1900 period cannot be taken seriously. One from *Art Age* of 1885 reads:

> *A nice bit of genre in lithographic advertising is the Kinney Bros.' colored plate, showing a pretty girl in a coquettish winter costume, tobogganing down an ice-slope, while Cupid, with large snowshoes on his small feet, hovers about her shoulder and pushes her along. It is soft and mellow in color, nicely drawn and poetic in idea.*[37]

And, finally, (4) the chromo lost its charm for Americans as magazines, news-papers, and other business enterprises promoted it incessantly as a giveaway or premium. The *Literary World* of December 1872 accurately predicted:

We believe in chromos; they do much to refine our homes, and to encourage a love for the beautiful, but under the present system of wholesale gratuitous distribution, their office will be degraded and they will rank as Sunday School picture cards.[38]

According to Frank Luther Mott's *History of American Magazines*, the premium system began before the Civil War and reached its peak in the 1870s. The classic story involves the promotion of a religious periodical, *Christian Union*, by John R. Howard. In 1870 he sent door-to-door salesmen around the country offering prospective subscribers the magazine and a steel engraving of Gilbert Stuart's *George Washington*. The agents gathered in 35,000 customers and the following year Howard offered two English chromos of children—one entitled *Fast Asleep*, the other *Wide Awake*—which doubled the circulation. In 1872 more chromos were offered and circulation doubled again. Success bred imitation and, year after year, throughout the 1880s and 1890s free chromos were mailed to new subscribers of many magazines. To be different, one magazine, *Braun's Iconoclast* of 1896, headlined: "No chromos, World's Fair Photos or A. H. Belo sewing machines go with the *Iconoclast*. We are running a magazine, not a plunder store."[39]

For almost half a century the chromo printing shops hummed with life, to be quieted and retooled at the beginning of the twentieth century when new processes for printing even more accurate reproductions appeared. By that time the chromo had enriched the language and the American experience in the business of promoting culture. There is much that is ugly and vulgar in the chromo story, but there is also a nucleus of important facts that deserve investigation. And the essential question of whether a "democratic" art (or a "counterfeit" art; one must choose according to his own conviction) serves to elevate or debase popular taste deserves intelligent debate.

1. Quoted in Nicholas B. Wainwright, *Philadelphia in the Romantic Age of Lithography* (Philadelphia: Historical Society of Pennsylvania, 1958), p. 70, footnote 13.

2. Louis Prang, "Chromo-Lithography the Handmaiden of Painting," New York *Daily Tribune*, December 1, 1866, p. 6.

3. F. V. Hayden, *The Yellowstone National Park* (Boston: L. Prang, 1876), preface.

4. See *The Printing Times and Lithographer*, January 15, 1878, pp. 13–14.

5. *Prang's Chromo: A Journal of Popular Art* (Boston), January 1868, p. 4.

6. Quoted in *Prang's Chromo*, January 1868, p. 1.

7. Harry T. Peters, *America on Stone* (Garden City, New York: Doubleday, Doran, 1931), p. 12.

8. Ibid., p. 24.

9. Ibid., p. 32.

10. Ibid., between pp. 16 and 17.

11. See, for example, the numerous processes described in Elizabeth Harris, "Experimental Graphic Processes in England: 1800–1859" (doctoral dissertation, University of Reading, 1965). I have not found a similar account for the experimental processes in America.

12. See chapter 15, "Pictures, Designs, and Other Two-Dimensional Representations," in *Anglo-American Cataloging Rules* (Chicago: American Library Association, 1967), pp. 329–342.

13. Michael Twyman, *Lithography 1800–1850: The Techniques of Drawing on Stone in England and France and Their Application in Works of Topography* (London: Oxford University Press, 1970), pp. 146–150, 214–215. In France an impressive number of paths were being explored: (1) the use of tint stones with the lights being scraped away, (2) the building up of several tints on one stone through cross-hatching, (3) the application of stumping chalk with dabbers to cover large spaces evenly with a tint, and (4) Lemercier's process of sprinkling powdered crayon onto a warm stone and working it with a tool to create a tone were only a few. I have found little evidence in American journals or in the prints themselves to suggest that much experimenting was being done to develop a thoroughly tonal process for lithography in the United States before 1845.

In "The New Art of Lithotint" (*Miss Leslie's Magazine* [April 1843], pp. 113–114) the author's enthusiasm overwhelmed whatever skills he may have had as a prognosticator. Lithotint, he wrote, is "destined at no very distant day to achieve a revolution in the pictorial world, such as centuries have not witnessed."

14. P. S. Duval, "Lithography," *American Encyclopaedia of Printing*, ed. John Luther Ringwalt (Philadelphia: Menamin & Ringwalt, J. B. Lippincott, 1871), p. 282.

15. Alois Senefelder, *A Complete Course of Lithography* (New York: Da Capo Press, 1968), pp. 272–273.

16. R. M. Burch, *Colour Printing and Colour Printers* (London: Sir Isaac Pitman and Sons, 1910), pp. 194–195. Burch saw Hullmandel as the real creator of "chromo-lithographic pictures in anything like the modern sense of the term."

17. *The Art-Journal* (London), April 1859, p. 101.

18. Thomas Shotter Boys, *Picturesque Architecture in Paris, Ghent, Antwerp, Rouen etc.* (London: T. Boys, 1839), preface.

19. R. M. Burch, *Colour Printing and Colour Printers*, p. 212: The German type of chromolithograph was known as "the 'oleograph' from the fact that the finished print was thickly coated with an oily varnish, and was passed, when dry, beneath a patterned roller, which imparted to the surface an embossed impression resembling the grain of canvas."

20. Samuel Langhorne Clemens, *A Connecticut Yankee in King Arthur's Court* (New York: Harper & Brothers, 1889), pp. 48–49.

21. *America on Stone* (see note 7), s.v.

22. Notice of Bankruptcy, F. Gleason to Strobridge & Co., May 31, 1877, Cincinnati Historical Society; Strobridge Account Book, July 1877, p. 96, Cincinnati Historical Society.

23. *Pocket Business Directory of New York City and Merchants' Memorandum Book* (New York: William J. Niles, 1872), pp. 48–51.

24. Frank Luther Mott, *A History of American Magazines: 1865–1885* (Cambridge: Harvard University Press, 1938), pp. 7, 191, 411, 425, 437, and 442; *A History of American Magazines: 1885–1905* (Cambridge: Harvard University Press, 1957), pp. 18, 29, 85.

25. C. W. Webber, *The Hunter-Naturalist: Romance of Sporting; or, Wild Scenes and Wild Hunters* (Philadelphia: Lippincott, Grambo, 1852), p. 3.

26. *Prang's Chromo*, January 1868, p. 1.

27. "Street Lithography," *Art Age* (New York), December 1884, p. 57. From the beginning, advertising sheets and novelty items were major ingredients in chromolithography. In 1852, the year after Duval's *Washington* and *Lafayette* pieces, his color presses were going full steam, producing printed color menus, tobacco labels, and trade cards. His major rivals—Thomas Sinclair, Wagner and McGuigan, and L. N. Rosenthal—appeared to cater to nearly every need: trade cards, book illustrations, and letterheads, often embellished by

reproductions of fine art or sentimental anecdotes. A business directory advertisement of 1856 by Wagner and McGuigan called attention to the

> *superior facilities at their extensive* lithographic *establishment.* . . . *Where the most efficient artistical skill is employed in the various branches of the Art, enabling them to produce the most elaborate drawings on stone of anatomy . . . portraits, landscapes . . . transferring from steel and copper plates, woodcuts, etc. This branch of their business is under their own* immediate supervision, *and having the assistance of the ablest workmen, enables them to produce work equal if not superior to any other establishment in the country in* Color Printing. *They produce the most chaste, unique, and magnificent illustrations for books, title pages, Certificates, Music titles, Show Cards, etc. Also a beautiful style in colors of Stores, Hotels, Businesses and Landscape views.* (McElroy's Philadelphia Directory [*Philadelphia: Edward C. & John Biddle, 1856*], *p. 9*).

Billheads, too, listed a phenomenal range of services.

28. New York *Daily Tribune*, November 20, 1866, p. 6; October 22, 1868, p. 4.

29. Philip Gilbert Hamerton, *The Graphic Arts* (London: Seeley, Jackson, and Halliday, 1882), p. 375.

30. Lewis Mumford, *The Brown Decades: A Study of the Arts in America 1865-1892*, 2d rev. ed. (New York: Dover Publications, 1955), pp. 35-36.

31. Sigfried Giedion, *Mechanization Takes Command* (New York: W. W. Norton, 1969), pp. 344-364.

32. Harold Wentworth and Stuart Berg Flexner (eds.), *The Directory of American Slang* (New York: Thomas Y. Crowell, 1960).

33. Damon Runyon, *Take It Easy* (New York: Frederick A. Stokes, 1938), p. 282.

34. *A Supplement to the Oxford English Dictionary* (Oxford: Clarendon Press, 1972), 1, p. 519.

35. Mitford M. Mathews (ed.), *A Dictionary of Americanisms* (Chicago: University of Chicago Press, 1951).

36. Anonymous advertisement from the Smithsonian Institution's Warshaw Collection of Business Americana (dated ca. 1873).

37. *Art Age*, April 1884, p. 93, and "Lithographs." See also September 1884, p. 14; January 1885, p. 84; April 1885, p. 146; June 1885, p. 179.

38. *Literary World*, 3, p. 104 (December 1872).

39. *A History of American Magazines: 1885-1905* (see note 24), p. 18.

"Fine Art Lithography" in Boston: Craftsmanship in Color, 1840-1900

SINCLAIR H. HITCHINGS
Keeper of Prints, Boston Public Library

Introduction

A few years ago, Carl Zigrosser pointed out that we know much about French and English and German prints of the nineteenth century but surprisingly little about nineteenth-century American printmaking.[1]

Recently, that situation has begun to change. Annual conferences on American prints reflect a rising interest and reveal a circle of younger scholars pursuing the history of American printmaking. From the first, these conferences have been planned as a series of papers that would be published. Exhibitions and visits to collections have enhanced the opportunities to learn.

The subject of American prints of the nineteenth century is vast, and the major reference works are not numerous—Groce and Wallace as a model dictionary of artists, Stauffer and Fielding, Peters, and Hamilton as comprehensive surveys, and a number of books about particular artists, places, or happenings.[2] One of these, Nicholas Wainwright's *Philadelphia in the Romantic Age of Lithography*, sets a good example for anyone exploring printmaking in an American city.[3] It defines that part of the Philadelphia story it seeks to tell, and then presents it in a clear and orderly way with a wealth of information and excellent illustrations. The catalogue of Charles Mason's collection of Boston and New England lithographs at the Boston Athenaeum will be comparable in the information and long-standing usefulness it offers. At this writing, work on the text is nearly completed.

The present notes on Boston color lithography before 1900 are offered as the findings of one explorer at a time when many explorations are taking place. Charles Mason, David Tatham, Bettina Norton, Carl Crossman, Roger Howlett, Georgia Bumgardner, Paul Swenson, myself, and others are accumulating information. Contributions to the present volume mark the first time a number of us have put our knowledge together.

Color Prints of the 1840s

Color lithography began in Boston on a note of excitement and intense competition. The year 1840, fifteen years after the Pendleton firm commenced work in black and white as the city's first business in lithography, is the first year of important achievements in color. William Sharp's portrait of the Rev. F. W. P. Greenwood has long been considered a lithotint, a confusing word intended to mean that Sharp used only one stone. On it was a design to be printed in black; additional colors were applied with a brush, by hand, before each impression. An early statement about Sharp's work in color appears in Morris Mattson's medical herbal *The American Vegetable Practice* (Boston: Daniel L. Hale, 1841).

There are twenty-four plates of botanical subjects lithographed in colors by Sharp, Michelin & Co., Tremont Street. On page xi, Mattson declares:

The colored illustrations in the materia medica, will, I presume, meet with the entire approbation of the public. They have been procured at great expense; and were executed by a new process, invented by Mr. Sharp, recently of London, being the first of the kind ever issued in the United States. The different tints were produced by a series of printed impressions, the brush not having been used in giving effect or uniformity to the coloring. Connoisseurs in the arts have spoken of them in terms of admiration, and Mr. Sharp will no doubt succeed in bringing his discovery to a still greater degree of perfection.

These attractive little prints in three, four, and five colors were based on drawings by Caroline Neagus. A few of the drawings were made by Anne Hill, by Sharp, and by Mattson.

Not more than a step behind Sharp was John Bufford. In May 1840, B. W. Thayer bought out Moore, successor to Pendleton. Bufford had begun work for Pendleton in 1829, and had gone into business on his own in New York in 1835; he returned to Boston in 1840 as chief artist and general manager of B. W. Thayer & Co. In the Boston Public Library are two folio lithographs, each titled *Locomotive Engine, Hinkley & Drury, Builders, Boston, Mass.* The first shows a locomotive with one set of large back wheels and two sets of smaller front wheels. Printed in black and green, the picture measures, to the edges of the sheet, $22\frac{7}{16}$ inches in height and $29\frac{13}{16}$ inches across. The imprint is as follows: "James Hinkley, del. / Thayer & Co.ˢ Lithography, Boston / Printed in Colors." The date 1835 has been noted in pen and ink at the bottom of the sheet, and on the back is written, in pen and ink: "Hinkley & Drury / Plan of [abo]ut 1835."

The second print shows a locomotive identical in most details but with two sets of large back wheels. In addition to black and green, a third color, yellow, is used to indicate shiny brass. The sheet measures $23\frac{1}{2}$ inches in height by $30\frac{3}{4}$ inches across. The imprint reads: "J. Hinkley, del / B. W. Thayer & Co'ˢ Lithography, Boston / Printed in Colors." Penciled on the print is the date 1837. The dates 1835 and 1837 might be the dates of Hinkley's designs, but as far as we know the firm of Thayer & Co. did not exist in those years. The prints seem to be ambitious but simple efforts at color lithography and might date between May 1840 and the end of the year, in the early months of the Thayer imprint. As manager of Thayer, Bufford would have supervised the work; probably he had a hand in it. The prints foreshadow similar prints with more colors and greater technical assurance that were issued by Bufford under the imprint of his own firm in the 1850s.

Bufford was a keen competitor and a hard worker. No later than 1841 he oversaw the production in the Thayer workshop of another big color print that was far more advanced in skills and techniques than the two prints of locomotives. Titled *Independent Boston Fusiliers* (fig. 1), it pictured some of the Fusiliers in uniform with the national capitol in Washington in the background. The imprint on the impression at the Boston Public Library reads: "composed and drawn on stone / by G. Dubois / Printed in Colors by B. W. Thayer, / Boston."

This is to Certify that
was admitted a member 18
Clerk

INDEPENDENT BOSTON FUSILIERS.

Instituted May 11th Chartered July 4th 1787
Attached to 1st Reg. 1st Brig. 1st Division
Commander

1. *Independent Boston Fusiliers*, 1841. Color lithograph composed and drawn on stone by G. Dubois, printed by the firm of B. W. Thayer, 18 x 22¼ in. Print Department, Boston Public Library

Printed colors are black, blue, dark brown, mustard or gold, red, green, and yellow. Since the print is a certificate of service, there are printed lines at the bottom with spaces to be filled in. The first two letters of the year, 18, are printed, and on the Boston Public Library copy the year has been completed in now-faded brown ink to read 1841. Sharp's portrait of Greenwood of 1840, the Sharp, Michelin & Co. plates of 1841 for Mattson's *The American Vegetable Practice*, the Thayer & Co. prints of two Hinkley & Drury locomotives, and the *Independent Boston Fusiliers* printed by the Thayer firm probably in 1841, all are early landmarks of Boston color lithography.

Sharp had brought advanced skills from England. He had worked in London for Hullmandel and knew of the developments which resulted in Thomas Shotter Boys's masterpiece of early color lithography, the *Picturesque Architecture* of 1839. When technical innovation is in the air, however, it stirs excitement and interest and spreads rapidly. There are suddenly many practitioners. So it was in the United States following Daguerre's success in France in obtaining photographic images. And so it was, at the same time, with color lithography, which received impetus from the extraordinary skills in the practice of lithography that had developed in Paris and London.

Sharp and Bufford led the way in Boston, it would seem, but others were at work very early in the printing of color lithographs. Of Francis Michelin, Peters says in *America on Stone*, "Sharp & Michelin produced a lithograph with a tint block in 1840. . . . A number of Michelin's prints were 'Printed in color' and he must have been first interested in this development by Sharp."[4]

E. W. Bouvé also, briefly, was Sharp's partner and went on to work in color lithography. Lithographs with tint stones are mentioned only in passing in this paper, which is concerned with lithographs in which a number of colors were printed in succession to build up a final effect. The three lithographs of 1843 of *The Streets of Boston* printed by Bouvé and Sharp, however, used a black stone and a tint stone to produce scenes and effects of great beauty. Based on paintings by Philip Harry, the prints were copyrighted by him. Two of them, *Summer Street* and *Tremont Street*, he drew on the stones, while *Tremont Street, South* was "On Stone by W. Sharp."

A miniature history of experiments in color lithography in America could be written with the help of American music sheet covers. The proud statement "Printed in Colors" appears repeatedly on Boston covers of the 1840s. An example of 1843 from the press of Thayer & Co. is "The Indians." In the same year Thayer issued the single-sheet print "View of the New Reservoir of the Albany Water Works Comp.y and the Albany Burgesses Corps, Taken from the Academy Park, Albany, N.Y.," with the same words (themselves printed in blue) "Printed in colors." Bright red and blue are used in a naive and cheerful way. Far more sophisticated are two music sheet covers of 1844, "Bluebeard" and "Quadrille de Punch," each "Printed in colours by Bouvé & Sharp, Boston." Black, red, blue, and gold, handled with a lively mastery of technique, give these prints an eye-catching gaiety and good humor. The drawing contributed to their success; "Quadrille de Punch" was on stone by Sharp, and he probably drew "Bluebeard," too.

Three music sheet covers of 1849 by Sharp are also important contributions. In "Stevens Quick Step" he uses black, green, and pink, but the colors that predominate are flat masses of red, blue, and gold in the "illuminated" manner. "National Lancers" was designed by Sharp. It shows a horse and rider, seems to have been intended for use as a cover, but may simply have been a single sheet print for purchase by members of the organization. Black is important in subtle modeling and shading of the horse; there is a buff tint stone, and some soft blue as background, but the flat red, blue, and gold of the rider's uniform dominate. "Fleurs d'Eté," a cover introducing three waltzes for piano, is "Drawn & Printed in Colors by W. Sharp, 228 Washington St. corner of Summer." He uses a range of colors delicately handled to produce an attractive feeling of the flowers themselves. The subtlety and skill of preparation and printing makes this a small triumph of color printing and a remembrancer of Sharp's love of horticulture.

Also from the late 1840s is another music sheet cover by Sharp, "The Battle Prayer," which is bold, bright, clumsy, and self-conscious. The stone that defines the design is printed in black; blue, red, and gold printed as flat colors offer a Victorian interpretation of the color effects of medieval illuminated manuscripts.

2. *View of the New Alms House for the City of Boston . . . on Deer Island*, 1849.
Color lithograph drawn by Joseph R. Richards, printed by J. H. Bufford & Co., 15 ¼ x 25 in.
Print Department, Boston Public Library

"The Battle Prayer" lacks the lightness of touch of other prints by Sharp in this manner, but the imprint ("W. Sharp Chromo Lith," printed in gold) suggests some difference of intent and technique. This was far from the first use of the term *chromolithograph*. On January 15, 1837, the great Parisian lithographic printer Engelmann was granted a patent for lithographic color printing, and by 1838 he was calling the process *chromolithographie*. David Tatham has discovered in an Albany magazine, *The Enquirer*, for 1842, four plates of medical subjects printed in "chromolithographie by J. H. Hall, Albany, N.Y." A charming use of the word *chromo*, also in these years of experiment, can be found on a little print titled *Delphinium Imperiale Flore Pleno* in the collection of the American Antiquarian Society. This becomes a modest bouquet to the new color printing process and carries the dim imprint *Chromolith by J H Bufford*. The firm of B. W. Thayer & Co. in Boston dissolved in 1844, and business continued at the same location, 204 Washington Street, in the name of J. H. Bufford & Co.; my guess is that Bufford's little flower print, "Chromolith" rather than "Printed in colors," dates from the beginnings of his own Boston business.

A landmark of this decade in color lithography, very different in color effect from the prints of 1840 and 1841, was the 1849 *View of the New Alms House for the City of Boston in the State of Massachusetts, Erecting on Deer Island in Boston Harbor* (fig. 2), drawn by Joseph R. Richards and printed by Bufford ("J. H. Bufford & Cos Lith., Boston"). A folio print, it uses four colors, black, gray, aquamarine, and a brick red, almost pink, which is dominant in effect.

Of the Boston lithographers who worked in color, Sharp was the pioneer and the man whose work consistently established new points of reference for his fellow workers. Bufford was for decades Boston's most prolific producer, and the Bufford firm under the management of his sons continued to be a major producer after his death in 1870. As part of his unflagging attention to business, Bufford kept up with new developments (see fig. 3). "I have had to try to define him," David Tatham wrote me in 1974, "not so much as an artist but as a manager whose long life in lithography makes him an important chronicler of the history of the medium through his firm's prints."

There were many other practitioners of color lithography in Boston in the nineteenth century—not only Michelin and Bouvé but Tappan & Bradford, whose *Locomotive for Passengers with Outside Cylinders*, a handsome folio printed in colors in 1852, can serve as an example; J. Mayer, F. Gleason, C. Frank King; Charles Crosby, who printed eyefilling chromolithographed

3. *John H. Bufford, Advertising Card, 1867.*
Lithograph printed by the firm of John H. Bufford, 8¼ x 10⅜ in.
Print Department, Boston Public Library

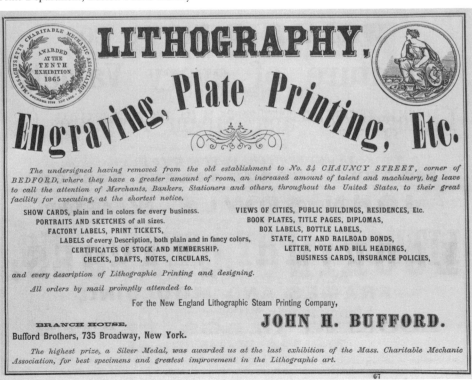

advertisements—the list could be much longer. To me, however, the history of color lithography in Boston centers on four people—Sharp, Bufford, Prang, and Armstrong—and I ask the tolerance of anyone who feels that my survey emphasizes these four at the expense of others.

Technical Accomplishments: 1850–1890

Sharp's greatest achievements in color printing were reached in the 1850s. His folio chromos illustrating John Fisk Allen's *Victoria Regia; or The Great Water Lily of America* ("Boston: Printed and Published for the Author, By Dutton and Wentworth, 37 Congress Street. 1854") are numbered among the important American color lithographs of the nineteenth century. John Fisk Allen based his publication on the typography and folio format of Walter Fitch's *Victoria Regia; or, Illustrations of the Royal Water-Lily*, published in London in 1851. He reprinted segments of Fitch's text but built his book in part upon observations of specimens of the water lily grown by him at Salem, Massachusetts. Allen acknowledged his debt to Fitch, but nowhere in the publication is there a similar acknowledgement that in his chromos Sharp owed much to the chromos in the London treatise. These bear the proud imprint "W. Fitch, Del et Lith / Frederick Reeve Imp." With the exception of one chromo based on a sketch by Allen, Sharp's illustrations have the imprint "Wm Sharp delt / Sharp & Son Chromo Lithd / Dorchester Mass." This, too, is a proud imprint, for both the London and the Boston prints are ambitious undertakings carried out with great skill and mastery. One of Sharp's illustrations follows the design of the English treatise's plate 3, *Victoria Regia. Expanded Flower*; within the design he makes a number of changes in detail, most notably in the color of the blossom, which shows much more red and much less yellow. A second of Sharp's illustrations is closely related to the English plate 2, *Victoria Regia. Opening Flower*, but here he has made greater changes in design. In several other illustrations, he derives his scale, his basic colors, and his format from the illustrations of the English publication. In most of the illustrations the viewer is brought close to the plant, which with its serrations and points becomes sometimes almost ferocious in aspect. Sharp's art accentuated this quality; there is nothing primitive about his technique or his knowledge of color lithography, but the plants as he depicts them look as though they might reach out of the printed page and devour the viewer.

Very different are the chromos of fruit Sharp made over a period of years as illustrations to C. M. Hovey's *The Fruits of America* (issued in two volumes in 1856). These are wonderfully decorative and completely convincing, and deserve an honored place in the crowded record of artists' depictions of fruit. The Boston Public Library owns a number that were once in the possession of Louis Prang. Sharp's masterful work was closely scrutinized by the man who later established himself as the leading American producer of chromos.

In the fifties, the decade of his highest achievements, Sharp produced a chromolithographed portrait of Daniel Webster. Even with our present limited knowledge of this print, it appears to be of major importance in the progress of color lithography in Boston. It has been dated as early as 1852 and as late as

1860; if it falls within these years, it is the first Boston print to show a convincing illusion of an oil painting achieved through lithography, and it is years ahead of Louis Prang's adoption of the style that we equate today with the word chromo-lithography. It is a small print, and the remarkable effect of an oil is achieved without imitation of the texture of brush strokes. Granular patterns on the stone, created with many small black dots, give a texture comparable to that of aquatint. Color is sometimes very rich and dark, as in Webster's black velvet collar, and sometimes partially transparent, revealing one color laid over another. The print makes use of a master lithographer's technical secrets and deserves continued and more detailed study.

A series of Bufford prints of this period, comparable to Sharp's folio chromos of *Victoria Regia* in the place of distinction they occupy in American print-making of the nineteenth century, are the five lithographs showing the excavations of 1811 and 1812 that turned the top of Beacon Hill into fill for building operations along Boston's shores (see fig. 4). Issued in 1857 and 1858, with the general title *Old Boston*, the series is based on drawings by J. R. Smith, which are owned today by the Boston Public Library. Bufford did not imitate the pale watercolor washes of Smith's eyewitness drawings of almost fifty years earlier; his more solid and more lifelike color is attractive in a different way, and con-

4. *Beacon Hill, from the Present Site of the Reservoir between Hancock & Temple Sts.*, 1858. Color lithograph (after a J. R. Smith drawing of 1811) printed by the firm of J. H. Bufford, 12⅛ x 14½ in. Print Department, Boston Public Library

5. *Old Warehouse—Dock Square, Boston*, 1860. Color lithograph (after a painting by A.K. Kipps) printed by L. Prang & Co., 11⅞ x 14¾ in.
Print Department, Boston Public Library

tributes to pictures that are highly decorative as well as interesting for their subject matter. They have long enjoyed the attention of collectors.

There is still some transparency in the color of the Beacon Hill series, and this gentle clarity of color is even more evident in another landmark of Boston lithography, Prang's intimate glimpse of a "city interior" showing streets and buildings, people, horse-drawn vehicles, and business signs. The focus of attention is the Old Feather Store, an ancient building whose demolition was the occasion for the print. Based on a painting by A. K. Kipps and titled *Old Warehouse—Dock Square, Boston. Built 1680. Taken down 1860*, the lithograph is a small folio and carries the imprint: L. Prang & Co. Lith. 34 Merchants Row, Boston (fig. 5). Colors are black, red, gray, pink, light brown, and light green. The red of the wagon in right center provides the spark of color that enlivens the picture and makes it successful.

Prang's view of the Old Feather Store and its environs was a clear signal that he could meet and excel the established Boston lithographers in the art and craft of printing in colors. In years to come, he was to tower over his competitors. He linked his name for all time to come with the word chromolithography, and gradually established himself as the country's leading promoter and purveyor of chromos.

Prang was born in Breslau in 1823 and died in Los Angeles in 1909. When still a very young man he worked in his father's calico-printing establishment, where he learned principles of color mixing, designing, engraving, and printing. Later he shared in the revolutionary movement of 1848 and because of his liberal politics was forced to leave his native Prussia.

He went first to Switzerland and in 1850 sailed for the United States. During his first years here, he worked for a short time for *Gleason's Pictorial* and also worked in the lithography business in Philadelphia, where he briefly added his name to those of two well-known Philadelphia practitioners in the firm of Rosenthal, Duval & Prang. In 1856 he went into partnership with Julius Mayer in Boston. Among the early prints they produced are *The Chauncy Hall School and First Congregational Church, Boston*, dated 1857, in which color is stenciled onto the surface of the print; *A Birds' Eye View Map of Harvard*, a folio which uses a black stone and a tint stone; and the 1860 print of the Old Feather Store.

In the late eighteen sixties Prang set out to reproduce oil paintings in full color and with surface effects that simulated the surface texture of an oil painting in which brush strokes and the pattern of the canvas itself can be seen. Among the most notable of the first chromolithographs produced in this way were two prints of 1866 after landscapes by the American artist Alfred T. Bricher (1837–1908). They were titled *Early Autumn on Esopus Creek, N.Y.*, and *Late Autumn in the White Mountains*. These prints required a lengthy preliminary interval of planning the color sequence in order to achieve perfect registration as well as brilliant color and tonal values. Bricher watched with great interest the progress of preparation and printing. Later, Prang was to publish a number of chromolithographs after other landscapes by Bricher. It was not unusual to print from twenty-five to thirty stones to build up the illusion of a painter's oil colors on canvas. After the final color stone had been printed, the print was embossed and varnished to heighten the illusion of an oil. The prints were framed with or without glass in walnut or heavily gilded frames of the period and hung in the parlors of countless American homes. Editions were large, and the prints were sold in great numbers.

In 1867 the Prang Company moved to a new brick building with a mansard roof that still stands at 286 Roxbury Street, Roxbury, Massachusetts. Here the business continued to expand, and color prints in a wide range of subjects were produced in great quantity. Greeting cards became popular (Prang claimed to be the founder of the greeting card business in America) and some were made from designs by leading American artists of the day. Landscapes, sporting subjects, portraits, still lifes, historical scenes (including Civil War battles), and marine views provided themes for color prints of quality, which achieved an international reputation for the firm (see fig. 6). Many of Prang's most notable single prints and series in this wide reach of subject matter came later, but by 1868 he possessed a full repertoire of chromos printed from many stones. He issued an elaborate list of his chromo stock in that year (see fig. 7).

Like the prints of Currier & Ives, Prang's chromos appealed to a large number of Americans. The Currier & Ives lithographs, however, were printed for the most part with one stone, and color was added by hand. Prang's prints, in con-

6. *Sunset in California*, 1867. Chromolithograph (after a painting by Albert Bierstadt) printed by L. Prang & Co., 12 x 18 in. Print Department, Boston Public Library

7. *Prang's Chromos* (advertisement; undated). Chromolithograph printed by Louis Prang & Co., 9½ x 15½ in. Print Department, Boston Public Library

trast, achieved a level of technical perfection in the field of printed color seldom equaled before or since.

Among the most spectacular color prints by the Prang Company are the series of fifteen chromos of 1874–1876 after watercolors by Thomas Moran depicting the natural wonders of Yellowstone Park (see fig. 8). These sparkle with color, and every effort was made to reproduce the Moran watercolors in a completely convincing way, even to the use of a lithographic stone from which was printed the illusion of the lines or ribs of the artist's laid watercolor paper. A western landscape that equals and perhaps excels these Moran views of Yellowstone is the folio chromo *Yosemite Valley* of about 1871 (fig. 9), based on a painting by Thomas Hill. The illusion of distance and of light coming down through the clouds is remarkable. There are many Prang landmarks, still another being the series of ten folio sheets of 1874–1876 titled *Parallel of Historical Ornament* (see fig. 10). Using published archaeological works, Prang and his staff were able to bring together on each sheet numerous architectural and decorative details. Printed in colors, these have the visual attractiveness, in smaller scale, of a patchwork quilt, and the architecture of earlier eras is given a distinctly Victorian expression.

Prang's production of chromos grew out of his instinct for new fashions and his organizational genius. He brought together a circle of craftsmen that no other Boston lithographer could rival. Indispensable in this group were German lithographers including Heinzen and Gehring, who had attained an expert understanding of the ways in which color from single stones could be built up, with color printed over color in what lithographers call glazes, to arrive at the desired effect. The density and depth of color, the order of printing, and the use of various grays, neutral or partially transparent, to make late adjustments in the effect of the chromo, were matters they dealt with from long experience.

While Prang established "oil colors" as his firm's style, other Boston lithographers continued to print in the simpler color of Bufford's Beacon Hill prints of 1857 and 1858 and Prang's *Old Feather Store* of 1860. Bufford's folio lithograph of 1865, *The New Masonic Temple, Boston*, is very much in this style of clear, partially transparent color. The colors are black, a soft or brick red, yellow, gray, brown, a second (neutral) shade of gray, and possibly a third, lighter shade of gray. Less sophisticated is a small print that, like the view of the Masonic Temple, is frequently seen on the market and in collections. Titled *Yankee Volunteers Marching into Dixie*, it was printed in Bufford's establishment in 1862 and uses five colors: black, red, blue, buff, and yellow. The dome of the Boston State House can be seen in the background, and the foreground is filled with ranks of marching volunteers in dress combining the most exuberant elements of the costume of a circus barker and of Brother Jonathan (Uncle Sam).

Continuing the tradition of few colors and of color effects far simpler than those Prang invoked in his own chromos are many Boston color lithographs of the 1870s. *Rockingham House*, a folio portrait of a Portsmouth, New Hampshire, hotel, was lithographed about 1870 by Charles H. Crosby & Co., 159 Dorchester Avenue, Boston. The colors are black, a soft red, green, yellow, brown, dark gray, and light gray, along with the white of the paper. Also in this tradition are

8. *Yellowstone Lake*, 1875. Chromolithograph (after a watercolor by Thomas Moran) printed by L. Prang & Co., 9¾ x 14¼ in.
Print Department, Boston Public Library

9. *Yosemite Valley*, ca. 1871. Chromolithograph (after a painting by Thomas Hill) printed by L. Prang & Co., 15⅞ x 26 in.
Print Department, Boston Public Library

10. *Examples of Historical Ornament* (Egyptian), 1874. Chromolithograph printed by
L. Prang & Co., 19⅛ x 13 in. Print Department, Boston Public Library

11. *Patent / Steel Barb Fencing / Manufactured by Washburn & Moen M'f'g. Co. / Worcester, Mass.,*
ca. 1875–1880. Chromolithograph printed by J. H. Bufford's Sons, 18½ x 25 in.
Print Department, Boston Public Library

two music sheets commemorating the great Boston fire of November 1872. They
attempt to be lurid; to our eyes they are high-spirited and eye-catching. Red,
naturally, is accented. The titles are "Fire Fiend Grand March" and "Homeless
Tonight or Boston in Ashes," and both were printed in the Bufford plant, which
his sons carried on after his death in 1870. A striking print probably dating from
the late 1870s is an advertisement in folio, *Patent Steel Barb Fencing Manu-
factured by Washburn & Moen M'f'g. Co. Worcester, Mass.* (fig. 11). Its scenes
illustrate the use of barbed wire, and the design includes depiction of a strand of
barbed wire as border at the four sides of the print. Colors are black, red, blue,
green, yellow, orange, buff, gray, and several shades of brown. The imprint is
"J. H. Bufford's Sons Lith. 141 Franklin St. Boston." As late as 1878, a Forbes
Co. lithograph, *The First Hotel Erected by the Oak Bluffs Land & Wharf Co.
1867*, in small format, made expert use of only three colors, black, light green,
and red, each varying in color according to the openness or solidity of crayon
work on the stone, and with additional color effects obtained by printing one
color over another. With a vivid sunset flush behind the hotel building, the print
suggests chromo color with notable economy of means. C. W. Field, who signed
the stone with the date 1878, knew his craft.

The effect of skilled practitioners from England, France, and Germany on
color lithography in Boston can be seen throughout this account. German
immigrants influenced American life in many ways and in the graphic arts in-
cluded Thomas Nast, Joseph Keppler (who founded *Puck*), and Louis Prang. The
Germans brought to Boston, among other gifts from their homeland, a boom in

12. *Munich Lager Beer Brewery / Suffolk Brewing Co., Incorporated 1875*, ca. 1875.
Chromolithograph printed by the firm of C. Frank King, 20⅝ x 25¼ in.
Print Department, Boston Public Library

brewing. The 1870s were a great decade for Boston beer drinkers, as folio and elephant folio beer posters attest. A handsome example, in the tradition of transparent color rather than Prang's oil colors, is *Munich Lager Beer Brewery. Suffolk Brewing Co. Incorporated 1875. 423 to 433 Eighth St, Boston*, with the imprint "C. Frank King. Lith, 32 Winter St, Boston" (fig. 12). The colors are black, strong brick red, soft red or pink for the horizon flush in the sky beyond the brewery, blue, green, and the white of the paper. In addition, although gold is not used, the effect of gold in lettering is given through three different colors: yellow, mustard, and blue on mustard producing a neutral, darker, brownish color.

"Artistic" Lithographers, 1875–1900

The 1870s saw the emergence in Boston of Armstrong & Co., "artistic lithographers," as they named themselves on a trade card. Specializing in the printing of chromos for scientific works as well as sporting subjects, Charles Armstrong developed his own distinctive color style, often a chromo interpretation of watercolors. He belonged very much in the realm of color dominated by Prang. Not really a rival—Prang continued to turn out chromos on a vastly greater scale—he might instead be described as a colleague. He was a master craftsman with superb background and knowledge.

Armstrong was born in London in 1836. His father was an artist; his uncle,

who lived next door, a surgeon. When he was fourteen, he began apprenticeship with Leighton Brothers, London, specialists in color printing from wood and metal (color wood engravings and color mezzotints) and stone (chromolithography). At the same time, he studied art at the Marlborough House School. He completed his apprenticeship in 1857 and the next year went to work for Vincent Brooks, the London lithographic firm. In the years that followed Armstrong became their leading lithographic artist and acquired a reputation as a practitioner of the craft of chromolithography. He came to America in 1866 and worked for several years in New York before joining Prang's firm. There he worked under the head artist, William Harring von Ammon, who signed prints W. Harring.

Armstrong's grandson, the late Leeds Wheeler, spent many years compiling a history of the Armstrong firm. Mrs. Wheeler has kindly given me the use of a copy of the unpublished typescript, one of the most detailed studies in existence of a business in lithography and chromolithography. Of Prang's plant, Wheeler writes, "German and English were used indiscriminately both in conversation in the artists' room and in instructions on proofs so that Armstrong, no master of languages, welcomed the gift of a German-English Dictionary inscribed in the formal language of the day: 'Mr. C. Armstrong from his Mother with her kindest love to her dear son Augt. 31st 1869.'"

Armstrong worked for Prang in 1869, 1870, and 1871. Among the chromos he drew on stone were *Summer* (1869) after a painting by Bricher; *The Joy of Autumn* (1870) after a painting by William Hart; *Mt. Chocorua* (1870) after a painting by Benjamin Champney; *Henry Ward Beecher* (1871) after a painting not yet identified; and *Dessert No. 3*, a still life after a painting by Carducius P. Ream.

The firm of Armstrong, McLellan and Green (John E. Green and Daniel M. McLellan), Armstrong's first independent venture, was established in Boston after he left Prang. In 1872 he founded Armstrong & Company, which was briefly located in Boston, then in Daye Court in Cambridge, next to the Riverside Press, in 1873. A downtown Boston office was maintained at various addresses. For the most part the firm was producing black and white lithographs in these early years.

The sporting prints issued by Armstrong & Co. continue to be sought after today. In 1877 and 1878 the firm prepared and printed *Upland Game Birds and Water Fowl of the United States*, twenty chromos after watercolors by the Boston artist Alexander Pope, Jr. Scribner's in New York successfully published the portfolio. Later ventures included *The Celebrated Dogs of America*, twenty chromos after watercolors by Pope, published by Armstrong in 1880 and sold through agents to subscribers; *The Celebrated Horses of America*, twenty chromos after paintings by Maurice Scanlon, Edwin Forbes, Henry Stull, and Scott Leighton, published by E. K. Dunbar & Co., Boston, 1881; *American Yachts*, twenty-six chromos after watercolors by Frederic S. Cozzens, published by Scribner's in 1884; and a number of chromos for the Scribner's set of 1895, *Shooting Pictures of A. B. Frost*. Of Cozzens's *American Yachts*, Wheeler says: "Considering the interest of the subject matter, the quality of Cozzens' sketches,

and the skill of the lithographic artists in the reproductions, this set is perhaps the outstanding one by Armstrong & Co."

One of Armstrong's first ventures in scientific illustration was the preparation and printing of thirty-three color plates, from drawings by Isaac Sprague, illustrating *The Trees and Shrubs Growing Naturally in the Forests of Massachusetts* (2 vols., Boston: Little, Brown and Company, 1875). The firm produced fifty-one chromos after drawings by Sprague to illustrate Dr. George L. Goodale's *The Wild Flowers of America* (Boston: S. E. Cassino, 1879; republished by Bradlee, Whidden, 1894). In 1881, with backing from Harvard University, Scribner's published a set of fifteen enormous chromolithographs made at the Armstrong plant. Titled *Trouvelot's Astronomical Drawings*, they were based on large pastels that Professor Trouvelot had prepared from observations with the naked eye and through telescopes. The pictures are very abstract and decorative and would be completely at home in an exhibition of American paintings of the 1960s. Unfortunately the great size and bulk of the portfolio has consigned it to storage in the remotest reaches of large libraries.

For a work by Dr. George McClellan, *Regional Anatomy in its Relation to Medicine and Surgery* (Philadelphia: J. B. Lippincott Company, 1891–1892), the craftsmen at Armstrong's made drawings on stone based on photographs by the doctor. He then colored proofs of the black-and-white prints, and the colored proofs served as models for roughly one hundred full-page chromolithographs. Armstrong also furnished chromos (after watercolors by William J. Kaula) for Dr. John Collins Warren's *Surgical Pathology and Therapeutics* (1895).

Two of the most charming productions of the chromo era are books printed by letterpress that went through the lithographic press a number of times, as well, to receive the colors for small and delicate decorations. *An Island Garden* by Celia Thaxter (Boston: Houghton Mifflin, 1894) has twelve full-page illustrations and eight headpieces, all Armstrong chromolithographs after watercolors by Childe Hassam. A number of the original watercolors are owned by the Boston Public Library. *Cape Cod* by Henry David Thoreau (2 vols., Boston: Houghton Mifflin Company, 1896) has many small marginal chromolithographs. These were prepared at the Armstrong plant from a unique copy of an earlier edition of the book in which Amelia M. Watson had made many small, informal watercolor vignettes in the margins.

The Armstrong firm had moved from Daye Court a short distance to the new Lithographic Building at the Riverside Press in 1887. The 1890s were a time of economic troubles that killed many of Boston's lithographic firms. Bufford closed in 1890. Armstrong became Armstrong-Moore in 1897 and was bought in 1901 by George H. Walker & Company, printers of maps and music covers. Charles Armstrong retired from Armstrong-Moore about 1904 and died in 1906.

Louis Prang sold out in 1897, and the firm was carried on in Springfield, Massachusetts, under the name Prang-Taber. He continued for a few more years his venture in art education, the Prang Educational Company, and his name survives today in the trade name Prang's Artists' Colors.

Chromolithography and Art Nouveau
Before his departure from the graphic arts, Prang adapted his many-faceted

13. Ethel Reed. *Pierre Puvis de Chavannes*, 1895 (poster for a book by Lily Lewis Rood).
Color lithograph printed by L. Prang & Co., 22 x 15½ in.
Print Department, Boston Public Library

mastery of color printing to the presentation of Art Nouveau designs in flat color patterns by poster artists of the nineties. His last years in business brought him into the era of halftone reproduction at the end of the century. A double-folio weather chart of about 1895 presents many scenes (large card size) of sky and clouds; it combines the use of halftone with the color skills developed over many years by the firm's chromolithographers. The results are exceptionally handsome.

Prang was one of the great entrepreneurs in the graphic arts. Like Nathaniel Currier in the previous generation, he had an exceptional sense of American taste and an equally remarkable ability to capitalize on it. He was continually on the lookout for new artists and new approaches. He kept scrapbooks (several are in the Boston Public Library) as sources of ideas. Josiah Wedgwood, a century earlier, had been an avid collector of visual ideas in the same way.

At the urging of Foxcroft Cole, Prang in 1870 tried a portfolio of lithographs in the Parisian manner, with a tint stone to add warmth, depth, and shadow in Cole's Barbizon designs of sheep and shepherds. Apparently it didn't sell. Americans liked a full range of color, and Prang gave it to them. He belabored the word *art*, using it relentlessly in his advertising and making it credible by his patronage of leading American artists of the day. The craftsmanship that went into his chromos reproducing their work also helped to make clear his dedication to the cause of art, a commitment equaled by his dedication to the cause of sales.

Prang was still learning, still changing, and very much the skilled entrepreneur and patron in the 1890s. He welcomed the new ideas of the decade, hired Bruce Rogers of Chicago to edit his journal, *Modern Art*, and encouraged Art Nouveau design by providing superb printing for posters by Louis Rhead and others. Ethel Reed's poster of 1895 advertising a Prang publication, *Pierre Puvis de Chavannes* by Lily Lewis Rood (fig. 13), uses only three printed colors, black, mustard yellow, and gray, along with the white of the paper, to achieve one of the masterpieces of the American poster movement. Louis Rhead's calendar of 1897, heavily influenced by the work of Eugene Grasset in Paris, is a success in its own right and a landmark of American Art Nouveau; Prang printed and published it. Another Prang calendar, for 1896, possessing wonderful freshness and simplicity of color presents designs by F. Schuyler Matthews (see fig. 14); Prang printed it in 1895. Louis Rhead's posters advertising *L. Prang & Co.'s Holiday Publications* and *Prang's Easter Publications* (1896) are other American landmarks of the nineties from Prang's plant.

Other Boston lithographers applied their craftsmanship to the vogue for posters with striking results. Ethel Reed worked with a number of firms. Armstrong & Co. printed her *Behind the Arras*; the Heliotype Printing Co. her *Fairy Tales*; George H. Walker & Company her *Arabella and Araminta* and *In Childhood's Country*. The titles are those of books by Boston publishers who advertised by means of her posters. The Forbes Company printed E. B. Bird's *The Red Letter*. Bird and Charles Woodbury were M.I.T. graduates who became successful artists; both were active in Boston in the nineties and made highly successful poster designs (see fig. 15). The Boston contribution to Art Nouveau design and color in graphic art, however, is dominated by Ethel Reed and Louis Rhead, and Prang holds an honored place as printer and patron.

14. F. Schuyler Matthews. *March* (page from Prang's calendar for 1896), 1895.
Color lithograph printed by L. Prang & Co., 15 ⅛ x 10¾ in.
Print Department, Boston Public Library

15. Charles Woodbury. *Trolley Trips on a Bay State Triangle*, 1897. Color lithograph printed by Heliotype Printing Co., Boston, 11¼ x 16½ in. Print Department, Boston Public Library

The Art Nouveau chromos do not fit our use of that word to imply sometimes garish oil colors. Perhaps the popular meaning of the word chromo is so strong we should refer to the posters and poster calendars of the nineties as color lithographs instead. They were evolutionary rather than reproductive. Often the guide used by the lithographic craftsmen was a watercolor, but with the artist's advice and approval stronger colors were evolved—flat printed colors in contrast to the suggestive washes of watercolor.

Prang continued to operate on a number of different levels, turning out greeting cards in vast quantities, purveying single-sheet prints to the American public, and operating the Prang Educational Company, which beat the drum for certain teaching techniques and which offered printed example and inspiration, not always in full color. To the Educational Company we owe many of the large lithographic facsimiles that were hung in schoolrooms all over the United States. Some reproduced European master paintings; others were after photographs of architectural monuments like the Colosseum, the Pantheon, and the ruins of Greek temples. These big brown reproductions became a part of American life.

At the other extreme of size were Prang's "chromo gems," card-size chromos that sparkled with color. Into their albums and scrapbooks American children of the late nineteenth century lovingly pasted these little cards and many other similar products of the presses of the day.

To the end, Prang continued to produce ambitious single-sheet chromos that would symbolize his skills. Chromos of 1893 after Winslow Homer's watercolors *The North Woods* and *The Eastern Shore* were among the last. Homer inspected proofs, and in a letter to Prang, now in the Metropolitan Museum of Art, he described the prints as perfect.

When the Grolier Club planned an exhibition in 1895 celebrating the centenary of lithography, Prang was asked to write the introduction to the catalogue. He had belonged to the club in its early years, had once served on a special Lithography Committee (with Edward H. Bierstadt and Franklin H. Tinker), and was clearly the man to turn to. If you peer with great concentration into the past, you may see his bearded Victorian visage in his roles as paterfamilias of the exhibition and the grand old man of American lithography. In the Boston Public Library is a lithographic portrait of Senefelder published in 1834. It is inscribed, in a spidery hand: "To Mr. Louis Prang, the most distinguished follower of Senefelder in the new world. Congratulations on his 75th birthday, March 12th, '99 from his old friend Samuel P. Avery, New York."

Books about Prang's memorable achievements have appeared in recent years, but writers to date have not been able to encompass the multiplicity and excellence of the Prang chromos. Harry T. Peters, Frederic Conningham, and Harry Shaw Newman described, listed, and catalogued Currier & Ives prints so thoroughly that they established a permanently thriving demand by collectors.[5] For Prang's chromos, the job is still to be done.[6] Incidentally, as noted earlier, Prang's prints were varnished to heighten the effect of oil paintings. Discoloration of the original varnish may be a reason that the chromos are not traded in large quantities on the market.

The Forbes and Walker lithographic firms survived the nineties in Boston. To the story of that decade of color lithography in Boston there is an epilogue, in which chromo craftsmanship survived to some extent, and was applied to a considerable amount of advertising lithographically printed in color up to the First World War and beyond. Lithography in Boston was not again to see figures who combined technical knowledge and business ability on the scale possessed by Sharp, Bufford, Armstrong, and Prang. Three of the four brought with them from overseas an expert knowledge of superior skills. As late as 1860, the European centers continued to be more advanced in technique, but by 1870 Prang could challenge the skills of any European producer. All four of the leading Boston entrepreneurs made intense and sustained contributions to this local story of progress in color lithography, progress which eventually helped set the international standards.

NOTES
1. In his introduction to Karen Beall, *American Prints in the Library of Congress* (Baltimore: Johns Hopkins Press, 1970).

2. George Groce and David Wallace, *The New-York Historical Society's Dictionary of Artists in America 1564–1860* (New Haven: Yale University Press, 1957); David Stauffer, *American Engravers Upon Copper and Steel* (New York: The Grolier Club, 1907) and supplement by Mantle Fielding (Philadelphia: privately printed, 1917); Harry T. Peters, *America on Stone* (New York: Doubleday, Doran, 1931); and Sinclair Hamilton, *Early American Book Illustrators and Wood Engravers, 1670–1870* (Princeton: University Press, 1950).

3. Nicholas B. Wainwright, *Philadelphia in the Romantic Age of Lithography* (Philadelphia: Historical Society of Pennsylvania, 1958).

4. Peters, *America on Stone*, p. 282.

5. Harry T. Peters, *Currier & Ives, Printmakers to the American People* (New York: Doubleday, Doran, 1929–1931); Frederic Conningham, *Currier & Ives Prints* (New York: Crown Publishers, 1949; updated by Colin Simkin, 1970); Harry Shaw Newman, *The Old Print Shop Portfolio* (New York), *passim*.

6. I have the good fortune to work at the Boston Public Library with Paul Swenson, who in the past decade has become one of the few real authorities on the Prang firm; I acknowledge my debt to him in many of my comments here.

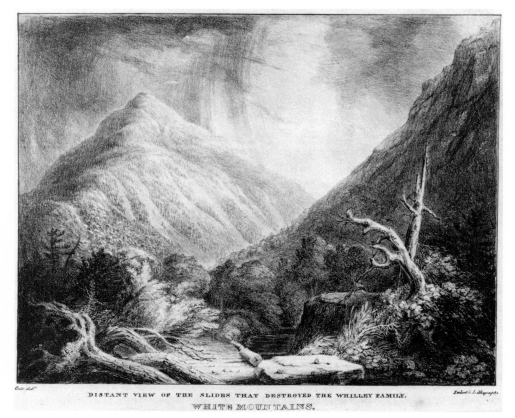

DISTANT VIEW OF THE SLIDES THAT DESTROYED THE WHILLEY FAMILY.
WHITE MOUNTAINS.

1. Thomas Cole. *Distant View of the Slides That Destroyed the Whilley Family. White Mountains*, ca. 1828–1829. Lithograph, 8⅝ x 11 in. Printed by Anthony Imbert, New York. Albany Institute of History and Art

The American Painter-Lithographer

JANET FLINT

Curator of Prints and Drawings, National Collection of Fine Arts,
Smithsonian Institution, Washington, D.C.

The earliest lithographs to be published in the United States in the nineteenth century—dating from the years of the second decade—are pale suggestions of the rich potential of the medium. Since Senefelder had made his first successful essay, some twenty-four years earlier, artists such as Vernet, Charlet, Guerin, Gros, and others in Germany and France had achieved much in the development of lithography as an art form equal to engraving and etching. Painter-lithography could not hope to receive the same attention and encouragement in the United States, however, where political, social, and commercial concerns took precedence over the conception of art as an end in itself.

Yet lithography was first undertaken in the United States with interest and optimism. There are several instances of early writings on lithography that introduced the hope that the new art would be given adequate patronage. In the *American Journal of Science and Arts* for October 1821, a spokesman for lithography states that Barnet and Doolittle, who printed the lithographs in the current issue, have "in their possession, a great variety of lithographic prints, which sufficiently evince the adaptiveness of the art to an elegant as well as common style of execution. The finest things done in this way are really very beautiful; and they possess a softness which is peculiarly their own."[1] It must be added, however, that the writer goes on to say in the following sentence: "Still lithography is not a rival, it is merely an auxiliary to copper plate engraving, which especially in the higher branches of the art, must still retain the pre-eminence which it possesses."

The critic John Neal wrote in 1828, after a visit to the Pendleton's shop in Boston: ". . . the day is not far off when the best of them [lithographers] will be astonished—whatever they may believe now—at the vigor and beauty of lithographic prints, and amazed at the hidden capacities of the art. Already we are beginning to see the spirit, liveliness and strength of admirable chalk-drawings in the every-day workmanship of mere apprentices; and to hope for the fine, bold, sketchy manner, and glorious freedom of the old masters—of the men who used to throw off an historical picture, as people now-adays are in the habit of throwing off advertisements, or letters, and to flash forth their divinest and most astonishing inspiration with the facility of unpremeditated eloquence."[2]

This interest in the development of lithography as a fine art was shared, at least in the early years, by some artists and publishers. In Philadelphia, Cephas Childs certainly saw lithography as a painter's medium. He succeeded in persuading Thomas Sully to do at least one lithograph, the small but lovely and sensitively drawn study of R. Walsh, Jr. The unusual introduction of Childs's name on the stone (as director of the work), however, seems to indicate that

Sully received at least some assistance from Childs. Henry Inman, in partnership briefly with Childs, created several lively, original lithographs that he himself had drawn on stone, but all too often he appears to have simply turned over his drawings or paintings to Albert Newsam, the staff artist for Childs, or to others to be copied.

We know from the *Boston Monthly Magazine* for December of 1825 that Pendleton tried to interest a number of artists in lithography, furnishing them with stones, chalk, and pencils.[3] Rembrandt Peale was one of the earliest painters to respond. His *Lord Byron*, printed by Pendleton around 1825 or 1826, is one of the most fully realized, accomplished prints of this early period, but much of his later work is uninspired and not very original. M. E. D. Brown's study of William P. Dewees, M.D. (1833) is generally considered to be one of the finest portraits done in lithography during this early period. Printed by Lehman and Duval, it is outstanding in its mastery of tone and form, yet credit for its mood and atmospheric enveloping shadows must go in part to the original painting by John Neagle that it reproduces.

By the 1840s much of the early interest in lithography as a fine art disappears from published writings, and several firms that had ambitions toward a finer use of the art had ceased to exist. The firms that survived were often able to do so only because of their willingness to print what was most marketable. The early impetus for creative, original works—never very strong—was considerably diminished. Albert Newsam, Fitz Hugh Lane, Napoleon Sarony, Winslow Homer, and others continued to produce excellent works within the commercial establishment, but instances of artists who chose to engage in lithography through interest in the medium, rather than employment, were few. Of these, Thomas Cole, William Rimmer, William Morris Hunt, and Thomas Moran made significant contributions to American painter-lithography in the nineteenth century. Their work can only be surveyed at this point, however, for many questions remain unanswered. Signatures, dates, or inscriptions giving printing and publishing information, usually present at least in some form on the lithographs of the more active commercial publishers, are often missing. Famous as painters or sculptors, these artists produced lithographs with little fanfare, in few impressions, and have received scant attention.

Shortly after Rembrandt Peale was introduced to lithography by the Pendletons in Boston, Thomas Cole (1801–1848) was initiated by the early New York pioneer Anthony Imbert. Certainly Cole's early experiences as an apprentice to a calico printer and as an engraver's assistant would have done little to leave him with a taste for a career in the graphic arts, yet, as an inveterate draftsman, he may well have been attracted to lithography as an extension of drawing that offered greater autographic freedom than other printing techniques. When Cole left Philadelphia for New York in 1825, he arrived in the midst of great civic excitement and the celebration surrounding the opening of the Erie Canal. It seems likely that Cole, from what we know of his great love of illustrated books, would have been intrigued by Anthony Imbert's lithographs for Colden's landmark publication of 1825 *Memoirs of the Celebration of the Completion of the New York Canals* and by the notes on lithography that appeared in the book. In the next few years, Cole and Imbert were to produce the *Distant View of the*

Slides that Destroyed the Willey Family, White Mountains (fig. 1). This impression, now owned by the Albany Institute of Art and History, but until a few years ago in the possession of the Cole descendants, is very rare, possibly unique.

The scene is derived from Cole's experiences in the White Mountains, where he traveled with William Pratt during October of 1828. In his journal of that trip Cole vividly described his impressions of the Willey house and its surroundings.

> *The sight of that deserted dwelling (the Willee House) standing with a little patch of green in the midst of that dread wilderness of desolation called to mind the horrors of that night (the 28th of August, 1826) when these mountains were deluged and rocks and trees were hurled from their high places down the steep channelled sides of the mountains—the whole family perished and yet had they remained in the house they would have been saved—though the slides rushed on either side they avoided it as though it had been a sacred place. A strange mystery hangs over the events of that night. . . . We looked up at the pinnacles above us and measured ourselves and found ourselves as nothing . . . it is impossible for description to give an adequate idea of this scene of desolation.[4]*

Much of Cole's romantic response to the majestic but threatening wilderness comes through in this dramatic, atmospheric view through the mountain pass. Rising cliffs, gnarled trees, and windswept skies are conceived with the excitement and exuberance of the discoverer's first experience. The lithograph was at one time tentatively dated between 1830 and 1835, but circumstances of the artist's career argue for an earlier date, probably 1828 or 1829, just before he went to Europe. In spite of the fact that Cole, with the patronage and sponsorship of people like William Dunlap, John Trumbull, and Asher B. Durand, had found a market for his paintings in New York, his financial situation was not as sound as he could wish. In efforts to put together enough money to finance his trip, he may very well have augmented his income by the sale of lithographs. He was in Europe between June 1829 and November 1832, and it is unlikely that on his return, with new visions of great paintings in mind and with his first major allegorical series, "The Course of Empire," in the offing, he would occupy himself with a lithograph based on the White Mountains trip of four years earlier.

The Falls at Catskill (fig. 2) probably dates from the same period as the White Mountains lithograph and, from its appearance, was probably printed by Imbert. Again, it is an extremely rare print; only two impressions are known. Although the lithograph is unsigned and bears no inscription, it was included in a scrapbook acquired from the estate of Florence H. Cole Vincent and is closely related to a signed drawing now in a private collection. Cole obviously approached lithography without preconceived ideas of technique or the conventional clichés that characterize so many later American lithographs. Directed only by his own vision, the lithographs are as remarkably fresh and free as his drawings.

Fortunately, Cole's only other known lithograph, *The Good Shepherd* (fig. 3), exists in a number of impressions. It was published posthumously in 1849 by John P. Ridner, printed by Sarony and Major, and dedicated to the artists of

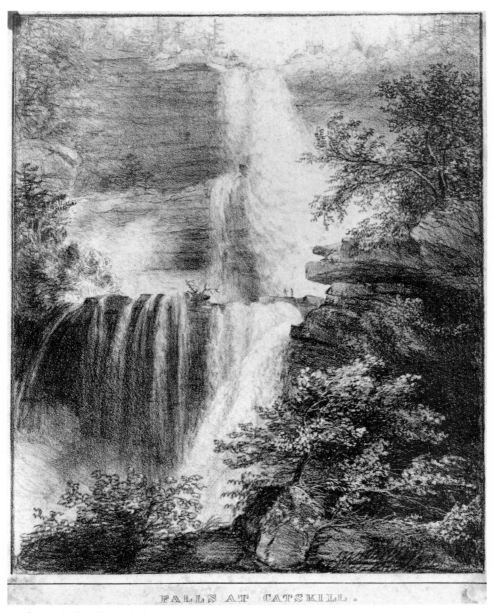

FALLS AT CATSKILL.

2. Thomas Cole. *The Falls At Catskill*, ca. 1828–1829.
Lithograph, 10½ x 8⅜ in.
Albany Institute of History and Art

"The Good Shepherd."

To the Artists of America this print is respectfully dedicated by
Maria Cole

Published by John P. Ridner 397 Broadway New York.

3. Thomas Cole. *The Good Shepherd*, ca. 1847. Published in 1849 by John P. Ridner.
Color lithograph, printed in tints by Sarony and Major, 11⅜ x 16½ in.
Museum of Fine Arts, Boston. M. and M. Karolik Fund. 1978.191

America by Maria Cole, the artist's widow. The print is signed in the black
stone, lower edge of center, "T. Cole," and printed with four stones, black and
three tints of beige, tan, and gray. It was apparently based on Cole's last
finished painting (present whereabouts unknown); a similar drawing in pencil,
heightened with white, signed and dated 1847, exists in a private collection.

The Good Shepherd is, in all likelihood, the lithograph referred to in a letter
from John M. Falconer, the painter and etcher, dated December 20, 1847, from
New York.[5] Falconer acknowledged having received that morning a stone from
Cole by packet boat and having taken it to the Michelin lithography firm at 111
Nassau Street. We know from the letter that Cole intended from the first to
draw at least one tint stone for the lithograph. It is also revealed that Cole, in
spite of his preeminence among American painters, had to bear, at least in part,
the costs of printing. Michelin felt the drawing would not yield a strong im-
pression; Falconer, therefore, urged Cole to come to New York to put the
finishing touches on the stone. (The black stone is somewhat weak, and this
may explain why the lithograph was eventually printed with three tints rather
than one.)

Falconer erroneously assumed in the letter that this was Cole's first experiment in lithography. This may be explainable by the fact that Falconer had only recently come to the United States and was unaware of the two lithographs done twenty years before.

Falconer went on to say that a lithograph "got up in superior style" and published by the American Art Union would be splendid, citing as precedent the publication of a lithograph by the London Art Union the year before. One realizes from this that in the hierarchy of fine prints, lithography was still regarded as inferior to engraving. It also underlines an American sense of artistic inferiority to Europe and the artists' need for reassurance in such seemingly groundbreaking endeavors. In a subsequent letter, Falconer spoke again of this scheme and of the great necessity for secrecy. Apparently the publication of a lithograph by a painter of rank seemed such a novel idea that Falconer was afraid someone else, learning of the plan, might preempt him.

Cole had not been well for some time and became quite ill after Christmas of that year. He died on February 8th of 1848, less than two months after Falconer's letter. It is not known why it was decided after Cole's death to place the stone with Sarony and Major rather than Michelin, who had a considerable reputation for his lithographs in tints. It is possible that Ridner, assuming the costs of publication for Maria Cole, simply preferred to work with Sarony and Major.

The mystery that surrounds much of William Rimmer's life (1816–1879) extends to his work as a printmaker. Most impressions appear to be unique and little is known about the circumstances of their production. Rimmer was one of the most remarkable figures in nineteenth-century American art. Although self-taught, he was probably the most learned anatomist of his time, a powerful and imaginative draftsman and painter, and a gifted sculptor. His career included, in addition, brief periods spent as an apprentice lithographer, soap maker and sign painter, and, for longer periods, cobbler and practicing physician—again self-taught. He was also a highly respected teacher in both Boston and New York, where he lived much outside the mainstream of the artistic communities. A strangely troubled man, he was dogged throughout his life by misfortune and personal and artistic tragedies. Although the circumstances of his family life are too complex to be dealt with here, it seems certain that he believed himself to be the son of the lost dauphin, by rights King of France, a circumstance that might explain much of the eccentric and secretive arrogance described in contemporary accounts of his personality. Even in 1890 Truman Bartlett was denied access to family documents and papers when writing his book about Rimmer.[6]

It is known that Rimmer served a brief apprenticeship in Thomas Moore's lithography shop for about a year around 1837, along with the painters Fitz Hugh Lane, Benjamin Champney, and Robert Cooke. "The Fireman's Call," a sheet music cover from this period, scarcely hints at the quality of his later work, except in the unusually dramatic blacks and the billows of smoke. Some doubts are raised about the amount of freedom given to a young artist in a lithographic establishment, for according to one of Rimmer's fellow apprentices at Moore's shop, Rimmer also produced, during this same period, a striking and unusually accomplished lithograph called *The Hunter's Dog* or *The Dead Hunter and His*

4. William Rimmer. *The Entombment*, undated. Lithograph, 4¾ x 5¾ in. Worcester Art Museum

Dog. The expert handling of foreshortening and complex anatomical forms as well as the dramatic force of the work set it outside the commonplace; it hardly seems to be by the same hand as "The Fireman's Call." The work is reproduced in Bartlett's monograph on Rimmer, but its present whereabouts are unknown.

"The Roarers," a sheet music cover of 1837, was probably drawn for Daniel Jenkins shortly after Rimmer left Moore's shop. In this work Rimmer was given the opportunity to depict a lion, one of his favorite and often repeated subjects. Inspired by Rimmer's lifelong obsession with the animalistic nature of man, lions would later take on greater ferocity and violence. In this early work, the delightfully animated beast is used to express "those qualities of courage, strength and forcefulness" that the "Roarers," the Rifle Rangers of the City Guards, identified in themselves.[7]

The Worcester Art Museum owns four lithographs attributed to Rimmer, all undated and untitled. *Landscape With Rider*, a small scene of an English-garbed horseman taking a fence, is typical of certain vignettes commonly used for sheet music covers of the period. The other three are more unusual. An *Entombment* (fig. 4), a *Head of Christ*, and a *Portrait of a Man* (possibly a prophet; fig. 5) are much more dramatic, bolder, and freer in the use of the lithographic crayon than the music covers of 1837, and must date sometime in the late forties or early fifties.

Rimmer's finest lithograph, fortunately preserved in the collection of the Boston Museum of Fine Arts, is a reclining nude (fig. 6). The print was given to the Museum by Caroline Hunt Rimmer, the artist's daughter, with the notation that "it was done some time in the last of the fifties, not later than 1860." Again, it was evidently never published and is extremely rare, possibly unique. It has been suggested that the figure represents an allegory of luxury, but the imagery is very similar to several drawings of Venus reclining done later in the sixties. Rimmer's lifelong obsession with the nude as an artistic form was highly controversial and often created difficulties for him in his role as teacher and in exhibitions. Here, the eccentric exaggeration of form and the highly personal imagination that characterize Rimmer's best work have been combined with soft and misty tonalities to produce a strangely lovely and haunting image.

In contrast to his Boston colleague, William Morris Hunt (1824–1879) was blessed from youth with family fortune and social advantages. He enjoyed a devoted following in Boston and as many portrait commissions as he wished. Actually, Hunt and Rimmer were friends of sorts, although their strong personalities and divergent views on art kept them professionally apart. Forced to leave Harvard during his senior year because of ill health, Hunt, with his mother and her four other children, went to Rome in 1843 seeking the benefits of a warmer climate. It was there that Hunt decided to become an artist. He was encouraged by Emmanuel Leutze to study in Dusseldorf, which he did for a brief time, but, finding the curriculum too restrictive, left for Paris. There he studied briefly with Thomas Couture, and then became a devoted follower of

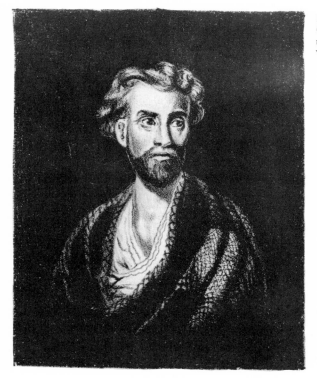

5. William Rimmer. *Portrait of a Man* (a prophet?),
undated. Lithograph, 6¼ x 4¾ in.
Worcester Art Museum

6. William Rimmer. *Reclining Nude Woman*, 1855–1860. Lithograph, 10⅜ x 11¼ in. Museum of Fine Arts, Boston. Gift of Miss Caroline Hunt Rimmer. M7393

Millet, actually living for two years at Barbizon, along with several other American disciples of Millet. During the years 1850 to 1855, Hunt and Millet developed a very warm and close friendship. The lithograph *Marguerite*, dated 1853 on the verso is an unidentified hand, is after a painting of these years. It was certainly influenced by the French lithograph movement that included Millet's own works as well as those of another close friend, Antoine Louis Barye, the sculptor of animals and a gifted lithographer.[8] We also know from an account by Henry James, whose brother William studied with Hunt, that Hunt greatly admired the lithographs of Delacroix. As James said in *A Small Boy and Others*, "I remember his [Hunt] repeatedly laying his hand on Delacroix, whom he had found always and everywhere interesting—to the point of trying effects, with charcoal and crayon, in his manner."[9] The delightful verve, the assurance, and the competence of the *Marguerite* (not to be confused with the later version of 1863 by Fabronius) would seem to indicate that it might well be one of several studies in lithography undertaken while Hunt was still in France and, if so, would explain how he was able to create shortly after returning to the United States a splendid and fully realized series of lithographs.

7. William Morris Hunt. *The Violet Girl*,
undated (published in 1857).
Lithograph with tint stone, 9¾ x 7¾ in.
National Collection of Fine Arts, Washington, D.C.

8. William Morris Hunt. *Hurdy-Gurdy Boy*,
undated (published in 1857).
Lithograph with tint stone, 7½ x 5¾ in.
National Collection of Fine Arts, Washington, D.C.

Hunt married and settled in Newport, Rhode Island, in 1856. It was here
during that year and early 1857 that he drew a series of lithographs on stone
after his own paintings. A resident of Newport in the latter part of the century
recalled: "Many of our old houses still contain Hunt's own lithographs of some
of his most famous pictures," mentioning *Street Musician*, *Girl at the Fountain*,
and *Child Selling Violets* as having been made at Newport.[10] We know from a
notice in *The Crayon* that Hunt had completed at least two of the lithographs,
The Violet Girl (fig. 7) and the *Hurdy-Gurdy Boy* (fig. 8), by May of 1857.[11] The
full set of six lithographs (which includes, in addition to those already mentioned,
Stag in the Moonlight [fig. 9], *The Fortune Teller*, and probably *Boy with a
Goose*) was published in 1857 by Phillips and Sampson, Boston book dealers and
publishers, at $3 per set, according to the information given on the wrapper of
the portfolio.[12] The cover sheet describes the series as painted and lithographed
by Wm. M. Hunt and a number of the prints repeat this information. They are
drawn in very rich blacks, probably with soft crayons on a not too finely grained
stone. The full tonality of soft grays to deep blacks is achieved by the gradual
building up of layers rather than by single strokes of the crayon. There is even
the suggestion, as in *The Violet Girl*, that some areas have been masked out,
spattered with tusche, and then built up with the addition of more crayon. Other
areas have been lightly touched with a scraper. The lithographs are a high point
in painter-lithography in America. Hunt has gone far beyond merely copying his
own paintings in his exploration of the medium, restating the rich tonalities of
his paintings in new ways. All six are beautifully printed, each with a tone stone.

9. William Morris Hunt. *Stag in the Moonlight*, undated (published in 1857). Lithograph, 9¾ x 6⅛ in. Museum of Fine Arts, Boston. Gift of R. Clipston Sturgis. M32917

The printer is not known, but by the late fifties there were any number of printers in Boston capable of holding the delicate nuances of Hunt's lithographs for a full edition. Sophisticated in technique and finish, the lithographs look much more European than American. This may explain in part why, in spite of Hunt's popularity, the publishing venture was not, apparently, a success. Certainly, the picturesque subject matter, with a hint of sentimentality, should have given them a broad appeal. Engraving, however, was still too firmly established as the appropriate medium for fine prints and these small black-and-white works could not compete in a wider market with the sprightly, brightly colored popular lithographs.[13]

Thomas Moran (1837–1926) was by far the most prolific of these four painter-lithographers. Between the years 1859 and 1869 he produced over forty lithographs; unfortunately, only a few impressions are known.

Moran's career began in Philadelphia in the engraving shop of Scattergood and Telfer, where he spent seven years as an apprentice woodengraver. Once his talent in drawing had been established, however, he appears to have done little engraving; most of his time was spent drawing sketches on engraving blocks. Encouraged in his independent studies and following the precedent set by his older brother Edward, who had been painting for several years, Thomas left the shop in 1856 to share Edward's studio and devote his time to painting and, in time, the graphic arts.[14] He seems to have always been curious about the possibilities of many media, and always searching for each medium's own special effects. His work in etching is well known and, at various times in his career, he also tried engraving, mezzotint, and even *cliché-verre*. In all of these, one seldom has the feeling of unsure experimentation or faltering approach, for Moran seems to have been gifted with an easy and confident graphic touch. Many of his lithographs are among the most beautiful produced by American artists in the nineteenth century.

Moran's earliest dated lithograph is a small marine reminiscent of the work of Eugène Isabey; his next dated work, the *Return to Port* of 1862, clearly acknowledged his debt to the French lithographer. When Isabey's famous "Cahiers de Marine," lithographs of coastal scenes and ports, was issued by Morlot in Paris in 1833, it was also published simultaneously in London by McLean and in New York by Bailly and would have been available to Moran in this country. Over the next few years, Moran worked only sporadically in lithography, much of his time being spent in painting, traveling, and, with a wife and family to support, increased activity as an illustrator. A few landscapes, beach scenes, and, curiously, a few studies of fish fossils appear between 1863 and 1865. The most concentrated period of work, resulting in his most significant lithographs, was between 1867 and 1869, with the production of at least 15 lithographs, all landscapes, mainly American views around Philadelphia or Lake Superior created in 1869. These works are larger in scale and much more ambitious and innovative in execution than earlier efforts. *In the Forest, Wissahickon* (fig. 10), dated 1868, was printed by James McGuigan of Philadelphia, active in various partnerships there from the mid-forties. (The lithograph is printed in an appliqué process and, as several of Moran's earlier lithographs were also printed appliqué, it is pos-

10. Thomas Moran. *In the Forest, Wissahickon*, 1868, from "Studies and Pictures By Thomas Moran." Printed by James McGuigan, Philadelphia. Lithograph, 12⅛ x 8¾ in.
Cooper-Hewitt Museum of Decorative Arts and Design, New York

sible that McGuigan had worked with Moran from the very beginning.) Moran employed a full scale of tones, ranging from soft grays to very deep blacks. The surface is further enlivened with scratchwork and flicks with a scraper to produce an illusion of dappled sunlight falling through dense trees. *In the Forest* was evidently intended for a portfolio of lithographs titled "Studies and Pictures by Thomas Moran," as were several of the stones produced in the 1868–1869 period. With so few impressions extant, however, it seems likely that only proofs for the portfolio were pulled. According to Frank Weitenkampf, Moran's favorite lithograph, *Solitude*, was printed in only ten to twelve impressions before an accident ruined the stone.[15]

Solitude, also intended for the series, is one of the most beautiful of Moran's lithographs, one in which he brings to life, in a very dramatic way, a sense of the desolate wildness of the Lake Superior country he had visited with Isaac Williams in the summer of 1860. Textures, form, light, and shadow are modeled with a refined sophistication and inventiveness absent from most American lithographs of this period.

View of Baiae of 1869 (fig. 11) was intended as number three of the "Studies and Pictures." One of the few romantic interpretations of the European landscape in this American series, it would have resulted from Moran's travels there earlier in the sixties.

11. Thomas Moran. *View of Baiae*, 1869, from "Studies and Pictures By Thomas Moran."
Printed by James McGuigan, Philadelphia. Lithograph, 7⅛ x 12¼ in.
Thomas Moran Biographical Art Collection, Long Island Collection, East Hampton Free Library

12. Thomas Moran. *On the Susquehanna*, 1869. Lithograph, 8¼ x 11¼ in. (trimmed).
Thomas Moran Biographical Art Collection, Long Island Collection, East Hampton Free Library

On the Susquehanna, also of 1869 (fig. 12), is typical of several quiet, lyrical views of the Pennsylvania landscape. Appropriately, Moran chose to work in a lower key, with softer values rather than the more dramatic contrasts of black and white in *Solitude* and *In the Forest*. Though the work is more subdued, there is still a remarkable variety of tone, resulting in, essentially, a painting in black and white on stone. By the late sixties Moran was obviously in full command of his medium. It appears that having mastered the technique of lithography his interest turned elsewhere, for the lithographs seem to have ceased abruptly in 1869.

It is unfortunate that Moran's lithographs were not more widely distributed. Had they been, he might have been able to evoke the kind of interest he helped achieve for American etching between 1878 and 1888. American taste, however, continued to dictate the production of increasingly larger "framing prints"—either engraved reproductions or hand-colored and color-printed lithographs—to which the commercial houses responded. With the strengthening of the commercial aspects of lithography and the rise of the more specialized professional lithographic artist, instances of real artistic individuality and force became fewer and fewer.

Near the end of the century, in the wake of renewed interest and achievement in Europe, several artists and publishers again turned their attention to painter-lithography. Montague Marks, editor of the magazine *Art Amateur*, attempted to stimulate a comparable revival of artistic lithography in America, but his am-

bitions met with little success. It was not until the second and third decades of the twentieth century that America developed a strong and original school of painter-lithographers.

NOTES

1. Quoted in Charles Henry Taylor, "Some Notes on Early American Lithography," *Proceedings of The American Antiquarian Society* 32, Part 1 (April 12, 1922), pp. 68–69.

2. *Observations On American Art. Selections from the Writings of John Neal (1793–1876)*. Edited with notes by Harold Edward Dickson. The Pennsylvania State College Studies, no. 12, 1943, p. 40.

3. Quoted by David Tatham, "The Pendleton-Moore Shop—Lithographic Artists In Boston, 1825–1840," *Old Time New England* 62, no. 2 (October–December 1971), p. 36.

4. Thomas Cole, "Sketch of my Tour to the White Mountains with Wm. Pratt—October, 1828," pp. 7–8. Collection of Thomas Cole Notebooks and Sketchbooks, Detroit Institute of Arts.

5. Thomas Cole Correspondence and Papers, Manuscript and History Division of the New York State Library, Albany, New York.

6. Truman Howe Bartlett, *The Art Life of William Rimmer*. Boston and New York: Houghton, Mifflin and Company, 1890. See also *William Rimmer, 1816–1879*. Catalogue of an exhibition prepared by Lincoln Kirstein, Whitney Museum of American Art, New York, 1946.

7. David Tatham, *The Lure of the Striped Pig: The Illustration of Popular Music in America, 1820–1870*. Barre, Massachusetts: Imprint Society, 1973.

8. The question of dating is further complicated by a note in a sale catalogue of Hunt's work, held in Boston on February 23 and 24, 1898, by Paul Hunt. It mentions, among other prints, "The Marguerite of 1859. D. C. Fabronius' lithograph after Hunt's painting Marguerite, dates from the early 1860s."

9. Quoted in Gibson Danes, "William Morris Hunt and His Newport Circle." *Magazine of Art*, April 1950, p. 148.

10. Mrs. Maud Howe Elliott, "Some Recollections of Newport Artists," a paper read before the Newport Historical Society, quoted by Martha A. S. Shannon, *Boston Days of William Morris Hunt*. Boston: Marshall Jones Company, 1923, p. 46.

11. *The Crayon: A Journal Devoted to the Graphic Arts* (Stillman and Durand, New York), May 1857, p. 157.

12. The *Boy with a Goose*, which has been generally accepted as a part of the set (a complete set with an original wrapper has not been located), is dated 1858 in the stone. It is possible that, although intended for publication in 1857, the full and completed portfolio was not released until the addition of *Boy with a Goose* in 1858.

13. Although published by Phillips and Sampson, the project appears to have originated with Hunt. The fact that he retained the stones would seem to indicate that he funded at least part of the publication. In a catalogue for an auction of Hunt's work, held in February of 1898 by Paul Hunt, is a note stating that the stones were lost in the great Boston fire of 1872, when Hunt's studio in the Mercantile Building on Summer Street was totally destroyed.

14. During these years Edward often supplemented his income as a marine painter by doing small jobs for lithographers. Thomas, however, probably needed little contact with lithographers or incentive to experiment with lithography.

15. Frank Weitenkampf, "Painter-Lithography in the United States." *Scribner's Magazine* 33 (June 1903), p. 544.

Sylvester Rosa Koehler and the American Etching Revival

CLIFFORD S. ACKLEY

*Associate Curator, Department of Prints, Drawings, and Photographs,
Museum of Fine Arts, Boston*

In 1882, responding to the prospect of a curatorial position at the Museum of Fine Arts, Sylvester R. Koehler pointed out modestly and wryly that although he did not have a conventional print connoisseur's knowledge of the history of printmaking he did, unlike many print authorities, have a firm grounding in the graphic techniques and could distinguish one medium from another.[1] The Boston Print Department's first curator,[2] a position he occupied from 1887 until his death in 1900, Koehler was in fact a critic and scholar of the graphic arts (or, as he would have preferred, of the reproductive or multiplying arts) of international reputation.[3] He was a key figure in the late-blooming American version of the international etching movement, or "revival," that flourished in France and England in the 1860s. The movement is best represented in those countries by the publisher-promoter Alfred Cadart and his *Société des Aquafortistes* (Society of Etchers) and the critic Philip Gilbert Hamerton, who championed the work of the gifted amateur etcher Seymour Haden. The movement's arrival in America is signaled by the founding in 1877 of the New York Etching Club, the first of many such organizations. Cadart had visited New York a decade earlier armed with all the paraphernalia required to produce an etching, and a few Americans had taken lessons at that time but, as Koehler (who was a kind of American Cadart himself) noted, the visit did not have lasting consequences for the growth of the American etching movement.[4]

Walter Shirlaw's portrait of Koehler (fig. 1) embodies many of the qualities that Koehler believed a modern etching should have. Freely sketched on a plate of modest dimensions, the evocation of the sitter is suggestive rather than explicit. Furthermore, the plate was "artificially" inked with a generous amount of warm brown ink and printed on a warm-toned, translucent Japanese paper. Appropriately, the plate was made while Koehler, that indefatigable promoter of the multiplying arts, was delivering a lecture on etching.[5] He believed in teaching by showing or doing, as may be seen in an etching that he executed before a Boston women's club in 1887 during a lecture-demonstration (fig. 2). Koehler, who had no illusions about his own artistic gifts, scrupulously noted on the reverse of this example that it was an "unsound impression" and, with characteristic meticulousness, that the plate was executed in pure etching with three different needles and four bitings of the plate.

Koehler's habit of teaching by getting his hands dirty is probably a consequence of the background he brought to the history and criticism of printmaking. Born in Leipzig in 1837, the son of an artist, he emigrated to America at the age of 12. In 1868 he moved to Boston, where he was for ten years technical manager for the lithographic firm of Louis Prang and Co. before becoming managing

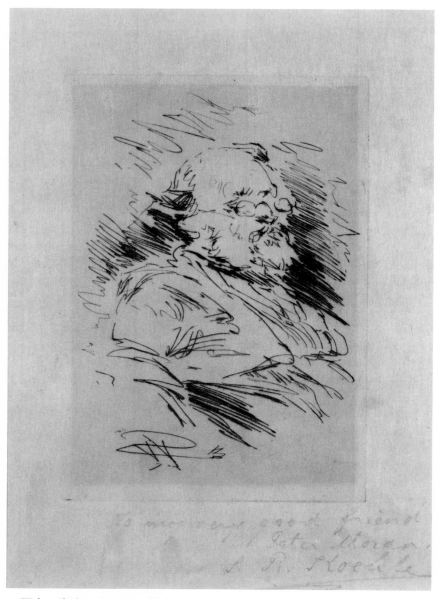

1. Walter Shirlaw. *Portrait of Sylvester Rosa Koehler*, 1885. Etching, 5⅛ x 3⅝ in. Museum of Fine Arts, Boston. Gift of M. Knoedler and Company. 37.216

2. Sylvester Rosa Koehler. *Landscape*, 1887. Etching, 4 x 6 in.
Museum of Fine Arts, Boston. Sylvester R. Koehler Collection. K1437

editor of the *American Art Review*. The latter position gave Koehler the opportunity to promote publicly etchings by American painters. The prospectus of the *American Art Review*, which was published from 1880 to 1881 by the Boston firm of Estes and Lauriat, makes it clear that the special feature of the magazine was to be the publication of a series of "Original Painter-Etchings by American Artists." It states that the European etching revival is largely attributable to the efforts of well-known European art journals and that it was hoped that the *American Art Review* would perform a similar service for etching in America. The "Valedictory" of the magazine states: "The pride of its projectors will ever be that it was the first organ which made known to the world at large the works of the American etchers, who were laboring in comparative obscurity at the time of its inception, but who have since emerged into the broad light of public recognition."

The editions of hundreds or thousands of impressions printed for these journals were possible only after a method of steel-facing the soft, malleable copper plates by means of electrolysis was introduced in the mid-nineteenth century.[6] Koehler, who was intensely interested in fine distinctions between early and late impressions when studying old master prints, reveals a good sound nineteenth-century faith in technology when he observes that, when dealing with steel-faced plates, questions of "early" and "late" become irrelevant and that the *10,000th* impression of an edition could conceivably be the finest of all.[7]

Koehler succeeded in publishing plates by 26 American etchers in the magazine during its two-year run, and he accompanied their publication with a series of articles called "Works of the American Etchers," which are not only biographies and appreciations but catalogues-in-progress of each artist's work as complete as he could make them. Catalogues of particularly prolific or significant etchers such as Thomas and Peter Moran were followed by second installments recording new work. In Koehler's own words these ongoing catalogues constitute the "*Peintre-Graveur Américain* for which I am trying to lay the foundation in *The Works of the American Etchers*." The concept of the painter-engraver or painter-etcher, the notion that the most creative prints are those produced by painters, is a belief Koehler shared with other prominent figures of the international etching revival; it motivated men like Cadart and Koehler to actively encourage painters to try their hand at etching. When the painter George Inness was making his first and only etching, *On the Hudson*, in 1879, he corresponded with Koehler about problems with the plate and sent him proofs for his opinion.[8]

Another instance of Koehler's active participation in the etching process is an impression from a small plate by another German immigrant, the painter Ignaz Marcel Gaugengigl (fig. 3). It comes from Koehler's own collection and has an inscription by Koehler on the reverse indicating that he himself printed this first working proof after it was etched at his house on June 28, 1881. It could very well have been this plate that Koehler referred to at the time of the closing of the first major exhibition of American etchings, which he had organized in 1881 for the Museum of Fine Arts. At that time Koehler wrote to Charles G. Loring requesting the return of his press and tools, which had served as a technical display, because "I have a plate to bite and proof for an artist friend."[9] It is characteristic of Koehler's direct, pragmatic approach to the promotion of the etching medium that when, in 1880, he published his American translation of the

3. Ignaz Marcel Gaugengigl. *Head of a Woman*, 1881. Etching, 3¾ x 2⅜ in. Museum of Fine Arts, Boston. Sylvester R. Koehler Collection. κ1141

treatise on etching by the French etcher Maxime Lalanne, he appended his own introductory chapter listing homemade or improvised etching equipment (including monkey wrenches, rattail files, and knitting needles) that could be procured from the corner drugstore or hardware store if the artist did not have access to the art supply stores of the major cities.[10] He commissioned the Boston marine painter Walter Lansil to execute his first etching using such homemade equipment and inserted an impression from the plate at the end of this chapter in order to prove to the skeptical reader that it really could be done.

Koehler believed that the printing of etchings, the most personal of the "multiplying arts," required a greater degree of artistic sensibility than was required for the other intaglio processes and his ideas about how an etching should be inked and printed undoubtedly exerted an influence on the look of American etchings in this period. As his printing of the Gaugengigl plate reveals, he had a decided preference for richly inked impressions (in this instance a tint or film of ink was left on the unworked areas of the plate) and for warm-toned or brownish inks. He felt that it was a shame to deny oneself the extra dimension that the modern etching printer could bring to the printing of a plate, particularly through the technique of *retroussage* or "bringing up," as Koehler translated the French printer's term. In *retroussage*, after the ink is worked into the grooves of the printing plate, some of it is gently dragged out of the grooves with a cloth, giving a softer, fuller, and more painterly effect to the etched line. The fashion for printing with a "tint" of ink left on the plate surface or with *retroussage*, combined with Koehler's preference for warm-toned or brownish inks, reinforced his conception of etching as a medium with an unusually wide range of tone and coloristic effect.

The notion of the "artistic" etching printer who actively collaborates in or completes the artistic act brings to mind the most influential of such figures in the nineteenth century, the man who printed Whistler's "French Set" in the 1850s and who printed many of the editions published by Cadart: Auguste Delâtre. It should be noted, however, that some writers, such as the English critic Hamerton, complained that Delâtre's manner of printing with a "tint" and with *retroussage* had simply become another sterile formula, a means of covering up the defects in a plate.[11]

Koehler's taste in the printing of etchings may be clearly illustrated by comparing two impressions of George Loring Brown's *Cascades at Tivoli* of 1854. One, printed for the edition of 1860, is a light, delicate clean-wiped impression printed in black ink on white paper (fig. 4); another, an impression from Koehler's own collection, a trial printing for one of his publications of the 1880s (fig. 5), is charged with brownish ink and printed on a warm-toned, vellum-weight Japanese paper.[12] This proof is printed in the same manner as the impressions on white paper published in Koehler's book *Etching* in 1885. Correspondence with Brown (whose etchings Koehler seems to have rediscovered and whose etchings of Italian subjects, along with those of John Gadsby Chapman of the same era, are among the earliest instances of American painter-etchings of genuine artistic interest) indicates that Koehler cleaned the plates for Brown and may even have had them rebitten, perhaps in an effort to update or modernize the tonality of the prints.[13]

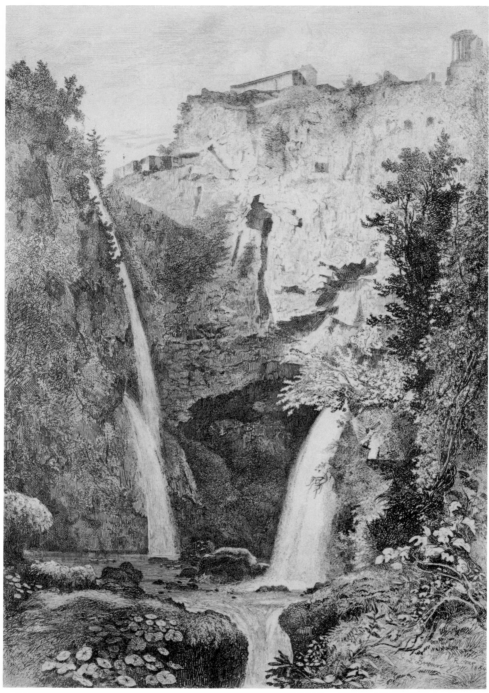

4. George Loring Brown. *Cascades at Tivoli*, 1854. Etching, 7¾ x 5¼ in.
Museum of Fine Arts, Boston. Harvey D. Parker Collection. P12262

5. George Loring Brown. *Cascades at Tivoli*, 1854. Etching, 7¾ x 5¼ in.
Museum of Fine Arts, Boston. Sylvester R. Koehler Collection. K804

An example of a plate printed "clean" and one of the same plate printed with *retroussage* was included in both the original French and in Koehler's American edition of Lalanne's treatise. Amusingly enough, Koehler noted that the *retroussage* plate in the American edition, which was printed in France and "shows what the art of the printer can do for an etching," is not printed as well as it might be.[14] Koehler included examples of impressions printed "clean" and printed with *retroussage* in the 1881 exhibition of American etching as well as in other books and exhibitions. In fact, he showed great originality for his time in his exhibitions of both old and modern masters by frequently showing more than one impression of a print, whether a Rembrandt or a Seymour Haden, in order to illustrate points about quality or character of impression.

The efforts of Koehler and others to promote the medium of etching in America succeeded all too well, and soon he and writers such as Mrs. Schuyler van Rensselaer and Ripley Hitchcock were to be heard complaining of fad and fashion and crass commercialism: an etching was no longer an intimate, spontaneous sketch to be treasured in a portfolio, but was now a large-scale, decorative picture, labored and mechanical in execution, intended to be framed and hung on the wall in a dishonest attempt to emulate paintings.

An obituary notice that appeared in the *International Studio* would surely have pleased Koehler. After praising the general sophistication of the *American Art Review*, "the first dignified art journal published in America," the writer referred to the original etchings published in those pages: "These were printed with *retroussage* by Kimmel and Voigt in a manner superior to the printing of plates in such foreign periodicals as the *Gazette des Beaux Arts*."[15]

NOTES

1. Letter to Charles G. Loring, April 20, 1882; Archives, Museum of Fine Arts, Boston.

2. He also served simultaneously as the first curator of the graphic arts section of the Smithsonian Institution, Washington, D.C.

3. A collector as well, in 1898 Koehler gave the Museum of Fine Arts his collection of over 6,000 prints, many of them works by contemporary American etchers.

4. S. R. Koehler, *Etching* (New York, London, Paris and Melbourne: Cassell & Company Ltd., 1885), p. 157.

5. Before the Gotham Art Students (register of the Koehler collection, Museum of Fine Arts, Boston).

6. See the description of the steel-facing of etching plates in Maxime Lalanne, *Traité de la gravure a l'eau forte* (Paris, 1866), pp. 92–94.

7. S. R. Koehler, Introduction, catalogue of the "Exhibition of American Etchings," Museum of Fine Arts (Boston, 1881), p. 7.

8. Correspondence filed with prints, Museum of Fine Arts, Boston.

9. Letter to Charles Loring, May 31, 1881; Archives, Museum of Fine Arts, Boston.

10. Maxime Lalanne, *A Treatise on Etching*, translated by S. R. Koehler (Boston: Estes and Lauriat, 1885), pp. xiii–xxii.

11. Philip Gilbert Hamerton, *Etching & Etchers* (New York: Macmillan & Co., 1868), pp. 349–354.

12. Koehler's interest in the coloristic properties of Japanese paper was a taste he shared with other advocates of the etching movement such as Delâtre and Hamerton. He admired not only its warmth of color and satiny texture but also its translucency, comparing it poetically to the effect of light shining through a stained-glass window. Japanese paper was not, however, commercially viable for large editions like those of the *American Art Review*. Among white printing papers Koehler admired the sparkle of handmade Dutch etching paper. When it was not available in sufficient quantities for the large *American Art Review* editions, Koehler had a comparable machine-made paper manufactured to his specifications and noted with pride that it surpassed in certain respects the handmade paper.

13. Correspondence on microfilm, Archives of American Art.

14. Lalanne, p. xxiv.

15. "American Studio Talk," supplement to vol. 12, *The International Studio*, 1900–1901, pp. i–ii.

American Monotypes

DAVID KIEHL

*Curatorial Assistant, Department of Prints, Drawings, and Photographs,
Metropolitan Museum of Art*

The monotype, a synthesis of the print and the drawing, is probably the least understood of the processes available to the printmaker. Frequently in the past, museum curators and private collectors have betrayed a certain degree of ignorance when dealing with monotypes, the former having mistakenly included them among drawings, while the latter have refrained from purchasing something that was not exclusively one medium or the other. Pioneering studies in the last decade on the work of Castiglione, Degas, Gauguin, Pissarro, and Prendergast have compelled scholars and collectors to reevaluate their former attitudes and begin a reinvestigation of this vital printmaking process.

Scholarly study of the monotype has justly been concentrated on those of French artists of the late nineteenth and early twentieth century whose output was known and readily accessible, for example, a large group of monotypes by Degas. Although they were well known, it took the consummate skill and organization of Eugenia Parry Janis to recognize their importance and place them in proper context with Degas's work in other media.

American monotypes have not received the same degree of attention as those of impressionist and post-impressionist artists. The earliest American examples appeared in 1879 and 1880, and the turn of the century saw the monotype as a part of the artistic output of a number of artists. Art magazines of the day published articles describing the process and small exhibitions of monotypes were held in museums and galleries, but even so, the study of the American experience with the monotype has been limited. The research requires a surviving body of work from which to make stylistic analysis, and only now have monotypes from this period begun to surface in public and private collections. Also, while contemporary articles and catalogues recorded the method of making monotypes, they rarely discussed the role the process played in the artist's career. Artists seemed reluctant to record their opinions of and experiments with the process in their letters, diaries, or studio journals.

Before examining what is known of American monotypes of the late nineteenth and early twentieth century, it would be useful to define this process that has been called both a print and a drawing and to examine briefly its historical background in Europe. As its name implies, the monotype refers to a process whose end product is a single printed impression.[1] To achieve this impression, the artist creates an image directly on the surface of the plate with printing ink. The image is not fixed onto the surface permanently as in the intaglio and lithographic processes, and in most cases it can be printed only once. If, however, enough ink remains on the plate after pulling the impression, and the artist is sufficiently skilled, a second and much lighter impression can be printed.

Even with its limitations on edition, certain technical advantages can be cited

for the monotype as compared with the etching or lithograph. The monotype can be directly applied to a variety of available surfaces including traditional copper or zinc plates, lithographer's stones, panes of glass, heavy artist's boards, and even wooden planks. The only real limitations for the printmaker are his own artistic abilities and the drying time of the type of ink used. The degree of ability to handle etching needles or engraving tools, different grounds, and acid baths does not affect the making of monotypes. Broad painterly effects and a variety of textures not possible in etching can be achieved. (The etching plate can be specially inked for each printing to produce a more painterly tone, but the linear quality of the etched lines remains a dominant factor in the image when printed.)

It has been suggested that artists turned to the monotype instead of the lithograph because of the disrepute of commercial lithography, exemplified by such firms as Currier and Ives, in the nineteenth century. While there is some degree of truth to this statement, it oversimplifies the situation. A lithograph can be drawn freely on the stone with crayon or with washlike lithotint, but the grainy character of the medium tends to detract from whatever painterly character is achieved. To bring out a variety of tonal effects, the lithographer depends on his skill to manipulate the density of crayon or lithotint on the surface, manifested in the print as different intensities of the same tone. The monotype, on the other hand, derives its rich and varied tonal gradations from the initial layerings of printing ink, as well as the wipings and additions to that surface when the drawing is made. The first practitioners of the monotype process in America were more interested in the effects the process could achieve than in the distribution of multiple impressions. When the latter question arose, the artists then frequently turned to lithography.

There are two basic methods for working on the surface of the plate. With the first, known as the dark-field manner, the image is created as the artist wipes away parts of the layer of ink covering the surface, often using his fingers along with brushes and rags. Details of the image appear as highlights, and the surface layer of ink frequently appears in the background. The origin of this monotype method is most likely to be found in the careful wiping of excess surface ink from the etched or engraved plate.

The image in the light-field manner is applied to the surface as in a painting or watercolor. This method requires some skill, as the impression must be taken before the inks (especially if multiple colors are used) become too dry for printing. The two methods are sometimes combined, creating a rich and varied printed surface.

Flexibility in materials as well as in working methods is characteristic of the monotype process. Although a slightly dampened japan or india paper is preferred, almost any paper, dampened or dry, or even fabric, can be used. Also, whereas the printing of intaglio plates and of lithographic stones requires an evenly pressured journey through a printing press, almost any kind of press can be used with the monotype. Frank Duveneck and his students used Otto Bacher's etching press in Venice, and William Merritt Chase wrote of using the wringer of a washing machine in California during the second decade of this century. The rich and velvety texture of the printer's ink could be enhanced even by a selective

degree of pressure from a spoon, which Maurice Prendergast is said to have found effective. Too much ink with too much pressure could result in what Joseph Pennell derisively called a "squashed oil painting."[2]

Several American artists who made monotypes in the late nineteenth century issued claims to the discovery of a new printmaking process. This was certainly not the case, for as early as the 1640s Giovanni Benedetto Castiglione was experimenting with the monotype as a means to achieve the velvety tonal effects found in Rembrandt's etchings and drypoints. Whether Castiglione invented the process is not known, but his masterful impressions in both the light and dark manner are highly prized. It would be safe to say that the monotype process was forgotten, if not lost, until the mid-nineteenth century, when Adolphe Appian made a number of landscape monotypes.[3] There were other attempts as well, but it is with Degas that the monotype gained stature as a printmaking technique. Working with his good friend Vicomte Ludovic Napoléon Lépic, he experimented with the use of printing ink to tone etched plates and, advancing to the next logical step, by 1875, monotypes were an active part of his artistic output.[4] Some of them were reworked with pastels and played as great a role in Degas's exploration of subjects as his work in other media. Always the teacher, he encouraged Camille Pissarro, among other artists, to try out the process. Whether a connection can be made between Degas and his circle and the American artistic contingent in Germany discussed below remains to be found.

Between 1800, the traditional date for the introduction of the monotype to the American art world, and the early 1900s, a large number of monotypes were made. The process was popular with many artists, both for its novelty and for the opportunity to flatter their own particular bravura style. Many of these artists remain in obscurity today, some because of the change in scholarly and public taste, and others for basic lack of technical skill. The American experience with the monotype prior to World War I can best be characterized by the work of four artists: Frank Duveneck, William Merritt Chase, Charles A. Walker, and Maurice Prendergast. The first three, all of whom were among the earliest American proponents of the process, used it for different reasons. The fourth artist was the only American painter to fully integrate the monotype into his total artistic production, something not achieved by the others.

An early link between the European and American experience with the monotype is most likely to be found in the art schools of Munich and, a few years later, in Florence and Venice, where Frank Duveneck and "his boys," a group studying with him, worked between 1878 and the early 1880s. This frolicsome group of artists was a welcome addition to the Anglo-American communities in these two cities. Otto Bacher, one of the "boys," was also a printmaker and he brought his press with him.[5] Bacher did not record how or when the first monotypes or, in this case, Bachertypes were made by the group. He simply noted that they were made "as a means of entertainment" during social evenings at the homes in the Anglo-American communities. The monotypes would be raffled off among the guests or given to the hosts. Bacher indicated that Whistler reported seeing a number of the group's prints at the house of a woman in England.[6] The Museum of Fine Arts in Boston has a monotype by Duveneck, *Indian Encampment* (fig. 1), that documents their practice of distributing the prints at the end

1. Frank Duveneck. *Indian Encampment*, undated. Monotype, 12¼ x 17⅛ in.
Museum of Fine Arts, Boston. 50.3232

of the evening.[7] It would be simplifying the situation to label the monotypes
from the Duveneck circle as only a more artistic variant of the parlor game.
Rather, it was a "fun" version of printmaking that could teach these future
painters much about composition by light and shade. While etchings were also
attempted, the monotype permitted the inexperienced painter-etcher the freedom
of using a process that did not require a great degree of technical skill. One such
student was Charles A. Corwin, who made at least one etching and one mono-
type.[8] The latter (fig. 2), pulled about 1881, is one of the great portraits of
Whistler, a frequent visitor and friend of the Duveneck circle. Bacher believed
that Whistler changed his attitude toward tonal wiping of the etching plate as a
result of the monotypes that he saw on his visits to Venice.[9] It seems entirely
possible that he tried the process himself but, as yet, no documented or attributed
impression has surfaced.

Duveneck and William Merritt Chase were close friends during their Munich
years. It is likely that before returning to New York in 1878, having spent time
with Duveneck in Venice painting and studying the old masters, Chase either
saw monotypes being made there or was told about the process in letters from
Duveneck. He exhibited his own monotypes publicly in 1881,[10] and again in 1882

2. Charles A. Corwin. *Portrait of Whistler*, 1880. Monotype, 18⅛ x 6⅛ in.
Metropolitan Museum of Art. Elisha Whittelsey Collection. 60.611.134

3. William Merritt Chase. *Reverie: Portrait of a Woman*, 1890–1895. Monotype, 19½ x 15¾ in. Metropolitan Museum of Art. Purchase: Louis V. Bell, William E. Dodge and Fletcher Funds. Murray Rafsky Gift and funds from various donors. 1974.544

at the Fifth Annual Black-and-White Exhibition at the Salmagundi Sketch Club.[11] While not the first to show monotypes in America, Chase, as a fashionable painter and as an art teacher, was influential in the popularity of the process.

Chase's bravura style of painting was not easily adaptable to the linear nature of the more conventional intaglio processes. The dark-field method, with its dependence on both brushwork and the wiping action of rags, swabs, and fingers, was a fortunate discovery. Only one of Chase's monotypes, however, can justly be considered a masterpiece to rival his work in oil. This large study of a woman (fig. 3) is noteworthy not only for its unusual size but also for the

rich and velvety effect of the printer's ink. The subject of this sensitive study is probably the artist's wife, who served as a model for numerous paintings in the 1890s. Chase's monotypes included a number of other subjects: a few nudes, a series of male heads in "period" dress, a group of landscapes supposedly printed in California with a washing machine wringer, and several very sensitive self-portraits. Since most of the surviving examples come from his heirs, Chase's monotypes, except for those exhibited in the early 1880s, were probably meant for his own use. Some of them may have been done as classroom projects; one example of a landscape in colors has survived with a listing of the names of some of Chase's students on the reverse.[12] More than a demonstration of a practical process, the monotype was probably presented as an artistic toy that could produce some interesting pictures, a painterly print from one color of ink.

In contrast to this lighthearted approach was the serious attitude of Charles A. Walker of Boston, who treated the final print as a painting, rather than as a print (see fig. 4). According to Koehler, he discovered the monotype process in 1881, independent of European travel or contact with the Duveneck circle[13] and his enthusiasm for the technique was soon put to the public test with exhibitions

4. Charles A. Walker. *Trees*, 1881. Monotype, 12½ x 16¾ in. Museum of Fine Arts, Boston. Bequest of Frank C. Doble. 1973.543

in Boston in November and at Knoedler & Co. in New York in December 1881. The review of the latter show in the *Art Journal* of December 1881 noted that Walker had successfully tried the process with a variety of subject matter. While his monotypes, both in black and white and in color, display a great dexterity, they reveal a rather limited artistic vision, lacking the spontaneity and invention to be found in the work of Duveneck and Chase.

It is with Maurice Prendergast that we find the first thorough integration of this technique into an American artist's total production. The monotype as a medium of expression clearly suited his artistic needs; he worked as easily in monotype as in oil or watercolor during the fifteen years he used it.[14] Prendergast had at least one distinct advantage: his visits to Paris in the late 1880s and early 1890s would have brought him in contact with the work of the "avant-garde" French artists and especially with the artistic production of the multi-talented Degas.

Over 300 monotypes survive to show Prendergast's use of a limited repertoire of subject matter to explore the possibilities of the medium. Like the watercolors and paintings from the same period, the monotypes have their own distinctive character even though imagery is often identical. With the monotype, Prendergast could get a silvery Whistlerian effect that he had trouble achieving with the more traditional methods of watercolors and oils. The transfer of oily ink onto dampened paper under the evenly applied pressure of the printing press, or the selective pressure of a utensil such as a spoon, accounted for much of this effect. Prendergast's monotype images are frequently blurred, as areas of color are emphasized over the delineation of details. In particular, his monotypes of young girls strolling in parks or fields (see fig. 5) or on the seashore, usually become a play of pattern, their white dresses indicated with quick wipings of the ink across the surface of the plate. Many of them have a surface softness that may be attributed to a second pull from the inked plate.[15] While some images do exist in two pulls, another explanation may also be possible. Prendergast could have let the inked surface get slightly dry before completing the printing process. Small creases and other tension signs so often found in his monotypes would result from the overly wet paper necessary to attract the partially dried ink.

Prendergast's monotypes were exhibited by museums, dealers, and art societies during his lifetime and, more important, while they were being produced. During the late 1890s and the first years of the next decade, Prendergast frequently included monotypes among the watercolors and oils sent to various exhibitions, identifying them only by title and not by medium. It would have been unlikely for an artist at the turn of the century who was interested in making monotypes to be unaware of this impressive body of material. Yet, there is no significant evidence of monotypes derivative of his work by other artists. The utter charm of these images of women and young girls in the park or at the shore, women hurrying through wind and rain, and street scenes in cities like Boston and Paris (and their relative availability) has kept the monotypes of Prendergast popular among American collectors.

Some of the most delightful monotypes by early twentieth-century American artists came from members of the Ashcan School (see figs. 6 and 7). Sketching

5. Maurice Prendergast. *Lady with a Muff*, ca. 1895.
Monotype, 8⅞ x 3⅞ in. Metropolitan Museum of Art.
A. Hyatt Mayor Purchase Fund; Bequest of Marjorie P. Starr.
1976.529

6. John Sloan. *Woman Brushing her Hair*, undated.
Monotype printed in purple ink. 5⅞ x 4¼ in.
Museum of Fine Arts, Boston. Mary L. Smith Fund. 62.1172

was a constant activity of many evenings spent during the first decades of this
century by Robert Henri and John Sloan with their wives, frequently in company
with other artists of the group or with students from the Art Students League.[16]
If a printing press was available, etchings were made. In the entry in his diary
for August 7, 1907, Sloan noted one such evening: "Henri came to dinner in the
evening and we had a little monotype fun with the etching press."[17] This
particular evening session is documented by two surviving monotypes by Henri
and, though Sloan made no mention of their presence, several examples by
League students. The latter betray the natural stiffness of the beginner in the

hesitant and heavy-handed manner in which the ink is wiped from the plate. In contrast, the monotypes by Henri and Sloan impart effectively the spontaneous fun of these evenings as the images emerge from the inked surface in a virtual shorthand of quick wipings.

Arthur B. Davies, also associated with members of the Ashcan School, produced several monotypes, of which two are in the collection of the Metropolitan Museum of Art and one in the collection of the Museum of Fine Arts, Boston (fig. 8). One at the Metropolitan is similar in style to Maurice Prendergast's work, while the other, resembling a Japanese study of a male figure, is conceived with an almost calligraphic use of brushwork on a cleanly wiped plate. These monotypes predate Davies's work with other printmaking processes.

Of greater importance, possibly, is the work of Albert Sterner, which was discussed and reproduced in contemporary periodicals.[18] Sterner's monotypes in one or more colors show a technical dexterity as well as a familiarity with a variety of stylistic influences not evident in his etchings and lithographs. His *Nude in a Landscape* of 1911 (fig. 9) is a haunting and monumental image richly brushed onto the plate. A number of monotypes have been made available recently by his estate and will require further scrutiny as more examples of his work become known.

7. Robert Henri. *New York Street Scene*, undated. Monotype, 5 ¾ x 6 ¾ in. Museum of Fine Arts, Boston. 63.445

8. Arthur B. Davies. *Study of a Male Figure*, 1895–1900. Monotype, 15⅞ x 10⅛ in.
Metropolitan Museum of Art. Gift of A. W. Bahr. 58.21.23

9. Albert Sterner. *Nude in a Landscape*, 1911. Monotype, 19¾ x 11¾ in.
Metropolitan Museum of Art. Purchase: Anne Stern Gift. 1977.524.1

10. William F. Hopson. *Tree in Landscape*, undated. Monotype, 4½ x 6½ in. Museum of Fine Arts, Boston. Horatio Greenough Curtis Fund. 1973.158

While this initial study has concentrated on a limited number of examples, many American artists made use of the monotype technique at some time in their careers. Among them are Peter Moran, Charles F. W. Mielatz,[19] Ernest Haskell, Edward Ertz, William Fowler Hopson (see fig. 10), Albion Bicknell, L. H. Meakin, F. Luis Mora, and the actor Joseph Jefferson. The "Duveneck boys" must have produced a considerable body of material in their evening sessions, but only a few images have surfaced to date. A number of them may survive in the albums and souvenirs collected by English and American tourists in Venice.

To American artists of the turn of the century, monotypes presented an attractive addition to their artistic production. They were commonly included in annual exhibitions of work by the painter-etchers.[20] The immediacy of the printed image and the ease of production enhanced the rich, painterly qualities of the process. It is hoped that as further investigation progresses into the artists and the literature of the period, a clearer statement as to the role of the monotype will emerge. Even without a total understanding of the contemporary intellectual thoughts on the process, we have been left with a distinctive body of material that demands our consideration.

NOTES

1. There is some confusion as to whether the process should be called monotype or monoprint. Some contemporary printmakers have purposefully taken only one pull from their engraved or etched plates. The latter term seems more descriptive of the deliberate limitation of edition, which has nothing to do with the process by which the print is made.

2. Joseph Pennell, *Etchers and Etchings* (New York: Macmillan, 1919), p. 309.

3. Michel Melot, "Les Monotypes d'Adolphe Appian," *Nouvelles de l'estampe* no. 25 (Jan.–Feb. 1976), pp. 13–16.

4. Eugenia Parry Janis, *Degas Monotypes* (Cambridge, Mass.: Harvard University Press, 1968), pp. vii, viii.

5. Otto Bacher, *With Whistler in Venice* (New York: Century Co., 1908), pp. 116–121.

Hugh Patton, *Etching, Drypoint, Mezzotint* (London, 1895), pp. 104, 106. Patton related his initial experience with the monotype and the Duveneck circle in Florence: "I came across this method of working on copper in Florence, in the year 1882, where it was practiced by some young American etchers, Munich students (by the little group, in fact, known as the 'Duveneck Boys', Mr. Frank Duveneck being the leading spirit). It was practised by them however, rather by way of pastime, than as a serious form of art. . . ."

While critical of the method, Patton saw some merit in it, as he goes on to say: "As I have hinted, the practice of 'monotype' is rather to be regarded as a pastime, than as a serious form of art; but to the etcher who has a press beside him it will prove a very fascinating method of trying broad strong effects in an impressionistic way. When carried out in too much detail, much of the effect is lost."

6. Bacher (see note 5 above).

7. Note accompanying the Duveneck monotype: "Villa Ball Florence Winter 1883–1884. On copper plate in oil paint with then fingers, a stick and a rag—Every Monday Evening printed one copy on an old press set up in the hall. These were given to Kanes and myself. They are by Frank Duveneck / all the others were given to Mrs. Thomas Ball."

8. S. R. Koehler, *Etching* (New York, 1885), p. 163. Koehler refers to a "Whistlerian" etching by Charles A. Corwin. Corwin did not return to etching or even the monotype after he left Venice.

9. Bacher (see note 5 above).

10. Frank Weitenkampf, *American Graphic Art* (New York: Macmillan, 1924), p. 109.

11. Salmagundi Sketch Club, *Catalogue of the Fifth Annual Black and White Exhibition* (New York, 1882), p. 23. Chase's entry in the exhibition, no. 491, was untitled. He did not indicate what resale value he placed on the print. Monotypes by Charles A. Walker (no. 222, *Surf at Nahant*) and A. H. Bicknell (nos. 259 and 342, both untitled) were also in the exhibition.

12. Offered for sale by Kennedy Galleries in 1976.

13. S. R. Koehler, "Das Monotype," *Chronik für vervielfältigende Kunst* 4, no. 3 (1891), p. 3. Koehler described a visit to Walker's studio in 1881 soon after Walker developed the monotype process. He also included an account of the conversation between the critic and the artist.

14. The earliest monotypes by Prendergast seem to date about 1891 and the latest about 1905. After this time he exhibited paintings almost exclusively.

15. Hedley Howell Rhys, *Maurice Prendergast 1859–1924* (Boston: Museum of Fine Arts, 1960), p. 34. "He (Degas) rather cryptically outlined his method of producing them in instructions that he gave to his only pupil, Mrs. Oliver Williams, in 1905: 'Paint on copper in oils, wiping parts to be white. When picture suits you, place on it Japanese paper and either press in a press or rub with a spoon till it pleases you. Sometimes the second or third plate is best.'"

If the surviving monotypes are second or third pulls, the images on the first pulls must have been obscured under a heavy film of ink to account for the rich and complete images that have survived. The second pulls of Degas needed much additional work in pastel or other materials to complete images that had lost much of their ink in the earlier pulls. Most of Prendergast's monotypes do not have this additional work. Where it does occur, it tends to be the addition of facial features to foreground figures.

16. Henri and Sloan were not the only practitioners in their circle. William Glackens made several monotypes of which a circus scene is by far one of the largest American examples known. Everett Shinn, according to Frank Weitenkampf, made several colored "pastel" monotypes (*American Graphic Art* [New York: Macmillan, 1924], p. 109). The considerable output of monotypes by Abraham Walkowitz, George "Pop" Hart, and Eugene Higgins, while worthy of further study, are part of the next chapter in a study of the monotype in America.

17. Bruce St. John, ed., *John Sloan's New York: 1906–1913* (New York: Harper & Row, 1965), p. 120.

18. Christian Brinton, "Apropos of Albert Sterner," *International Studio* 52, no. 207 (May 1914), pp. lxxi–lxxviii.

19. In 1908, The Society of Iconophiles published *Twelve Reproductions in Colored Photogravure of Monotypes by C. F. Mielatz* as Series X for their subscribers.

20. Philadelphia Society of Etchers, *Catalogue of the First Annual Exhibition* (Philadelphia, 1882), p. 4. Koehler noted in his introduction to this catalogue that the inclusion of monotypes in the exhibition was "defensible only on the ground that they grew out of etching, and are produced, for the present at least, by painter-etchers only."

George Inness. *On the Hudson*, 1879. Etching on mounted Japanese tissue, 7⅛ x 5⅜ in.
Museum of Fine Arts, Boston. Sylvester R. Koehler Collection. K1344

CHECKLIST OF THE EXHIBITION
American Prints 1813–1913,
Department of Prints and Drawings,
Museum of Fine Arts, Boston

April 12 – June 15, 1975

Prints are listed in chronological order.
Height precedes width; measurements
correspond to the image size exclusive of
inscriptions or titles unless otherwise
indicated.
All prints not credited to the American
Antiquarian Society, the Boston Public
Library, or the Metropolitan Museum
are from the collection of the Museum
of Fine Arts.

Thomas Gimbrede, born France, 1781–1832
For the firm of Bowyer, New York
Portrait of Oliver Hazard Perry
Engraving and etching in the stipple manner,
about 1813–1820
12 x 8½ in. (Stauffer 1076)
M. and M. Karolik Collection. 39.254

Rembrandt Peale, 1778–1860
For Pendleton's Lithography, Boston
George Washington, Patriae Pater
Lithograph, 1827
19⅛ x 15¼ in.
Gift of W. G. Russell Allen. 38.547

Alexander Jackson Davis, 1803–1892
For Imbert's Lithography, New York
Second Congregational Church, New York
(J. R. Brady, architect)
Lithograph on mounted China paper
about 1826–29
9¾ x 11⅞ in.
Harvey D. Parker Collection. P18146

Cephas G. Childs, 1793–1871
For his lithographic firm, Philadelphia
The White Plume
Lithograph on mounted China paper, 1830
About 11 x 9 in.
Gift of W. S. Dexter. M12087

John Gadsby Chapman, designer, 1808–1889
For the firm of Edward S. Mesier, New York
The Knight with a Snowy Plume, illustration
for a sheet music cover
Lithograph, about 1827–33
Sheet: 13¼ x 10 in.
Gift of Dr. Charles E. Clark. M9914 3/2

Anonymous
For the firm of Pendleton, Boston
The Mellow Horn, sheet music cover
Lithograph, about 1831
Sheet: 12⅞ x 9⅝ in.
Gift of J. Francis Driscoll. 47.213

Anonymous
For Pendleton's Lithography, Boston
Portrait of John Sheridan, professional
gymnast
Lithograph, 1830–35
About 12½ x 9¾ in.
Anonymous Gift. M8594

James Eddy, 1806–1888
For the firm of Pendleton, Boston
Certificate of the Boston Fire Department
Etching and engraving, after a painting by
Robert Salmon, 1833
8½ x 10⅞ in.
Bequest of Charles Hitchcock Tyler. 33.808

George Lehman, about 1800–1870
For the firm of Childs and Inman, Philadelphia
View of Charleston, South Carolina
Lithograph, hand-colored, about 1833
8¼ x 13 in.
Gift of Dr. Charles E. Clark. M9906

Asher Brown Durand, 1796–1886
Ariadne, after the painting by John Vanderlyn
First state, etching only, 1835
14¼ x 17⅞ in. (Stauffer 682)
Gift of John Durand. M6249

Asher Brown Durand, 1796–1886
Ariadne, after the painting by John Vanderlyn
Etching and engraving, intermediate state,
before additional graver work and letters, 1835
14¼ x 17⅞ in. (Stauffer 682)
Gift of John Durand. M6250

Asher Brown Durand, 1796–1886
Ariadne, after the painting by John Vanderlyn
Etching and engraving, completed image,
before title, printed by A. King, published by
the artist, 1835
14¼ x 17⅞ in. (Stauffer 682)
Harvey D. Parker Collection. P12793

William James Bennett, born England,
1777–1844
View of Troy, New York
Etching and aquatint, hand-colored, 1838

$15^{1/2}$ x $25^{1/4}$ in. (Fielding 152)
M. and M. Karolik Collection. 39.251

E. Bookhout, active 1840s
After a design by John Gadsby Chapman
Exotic Birds, illustration for a poster
advertising Isaac van Amburgh's Menagerie
Woodcut in color, about 1840
$27^{1/2}$ x $19^{3/4}$ in.
Museum Purchase. M10657

John Sartain, born England, 1808–1897
The Artist's Dream
Mezzotint and etching after a painting by
George Comegys, published by the Apollo
Association, 1841
$16^{7/8}$ x $20^{5/8}$ in.
Sylvester R. Koehler Collection. K2104

Charles Fenderich, born Germany, ca. 1810–
after 1870
Portrait of Charles S. Todd
Lithograph on mounted China paper, printed
by the firm of P. S. Duval, Philadelphia,
published in Washington, D.C., by the artist,
1841
About $10^{3/4}$ x $10^{7/8}$ in.
Sylvester R. Koehler Collection. K3179

Nathaniel Currier, 1813–1888
For his lithographic firm, New York
*Portrait of Marcus Morton, Governor of
Massachusetts*
Lithograph, about 1843
$11^{1/8}$ x $8^{1/2}$ in.
Bequest of Charles Hitchcock Tyler. 33.807

David Claypoole Johnston, 1797–1865
Portrait of the Painter, Washington Allston
Etching, published in "The New Mirror," 1843
7 x $5^{1/4}$ in.
Gift of the Friends of the Museum. M3031

A. de Vaudricourt, active 1835–1851
For the firm of Bouvé and Sharp, Boston
*Royal Mail Steam Ship Britannia Leaving East
Boston for Liverpool*
Lithograph, printed in black and gray-green,
after a sketch by the sculptor, J. C. King, 1844
$15^{1/8}$ x $24^{3/4}$ in.
Bequest of Charles Hitchcock Tyler. 33.968

Fitz Hugh Lane, 1804–1865
For his firm, Lane and Scott's Lithography,
Boston

Steam Packet Ship Massachusetts in a Squall
Lithograph, printed in black and gray, 1845
$9^{3/4}$ x $14^{3/4}$ in.
Gift of Miss Sarah Sullivan Perkins and Mrs.
Charles Mills Cabot in memory of Miss
Elizabeth Welles Perkins

William Morris Hunt, 1824–1879
The Marguerite
Lithograph on mounted China paper, after
his 1852 painting, 1853
$5^{5/8}$ x $4^{1/2}$ in.
William P. Babcock Bequest. B1880

Napoleon Sarony, born Canada, 1821–1896
Self-Portrait
Lithograph, about 1850–60
$8^{1/4}$ x $7^{3/4}$ in.
Lent by the American Antiquarian Society,
Worcester

George Loring Brown, 1814–1889
Cascades at Tivoli
Etching, 1854, published in New York in 1860
as part of the set of nine "Etchings of the
Campagna, Rome"
$7^{3/4}$ x $5^{1/4}$ in.
Harvey D. Parker Collection. P12262

William Sharp, born England, ca. 1803–1875
For his firm, Sharp and Son Chromo
Lithographers, Dorchester, Mass.
The Expanding Flower, plate 2 from the
portfolio "Victoria Regia," or "The Great
Water Lily of America," text by John Fisk
Allen, published by Dutton and Wentworth,
Boston
Color lithograph, 1854
$15^{1/8}$ x 21 in.
Gift of Charles D. Childs. 48.57

Frances (Fanny) Palmer, born England,
ca. 1812–1876
For the firm of Currier, New York
May Morning from a set of four prints (the
four seasons) entitled "American Country Life"
Lithograph, hand-colored, 1855
$16^{3/4}$ x $23^{7/8}$ in.
Lee M. Friedman Fund. 69.81

John Gadsby Chapman, 1808–1889
Italian Peasant Girl with a Sheaf of Wheat
Etching on mounted China paper, 1857
$7^{1/4}$ x $4^{3/4}$ in.
Sylvester R. Koehler Collection. K859

Eastman Johnson, 1824–1906
The Wigwam, in "Autograph Etchings by
American Artists illustrated by selections from
American Poets," produced under the super-
vision of John W. Ehninger, W. A. Townsend
and Company, New York, 1859
Photographic "etching" or *cliché verre* made
by scratching the opaque collodion coating
from a glass plate, producing a hand-made
negative; photographic printing by P. C.
Duchochois
$5\frac{1}{2}$ x 5 in.
M. and M. Karolik Collection. 62.79

William Rimmer, 1816–1879
Reclining Nude Woman
Lithograph, about 1855–60
About $10\frac{3}{8}$ x $11\frac{1}{4}$ in.
Gift of Miss C. H. Rimmer. M7393

A. R. Kipps, active mid-nineteenth century
For Louis Prang & Co., Lithographers, Boston
Old Warehouse—Dock Square, Boston
Lithograph in color, 1860
$10\frac{1}{2}$ x $14\frac{3}{4}$ in.
M. and M. Karolik Collection. 62.93

James A. McNeill Whistler, 1834–1903
Rotherhithe
Etching and drypoint, 1860, one of the set of
"Sixteen Etchings" ("The Thames Set"),
published in 1871
$10\frac{3}{4}$ x $7\frac{3}{4}$ in. (Kennedy 66)
Harvey D. Parker Collection. P11784

Frances (Fanny) Palmer, born England,
ca. 1812–1876
For the firm of Currier and Ives, New York
"Wooding Up" on the Mississippi
Lithograph, hand-colored, 1863
18 x $27\frac{3}{4}$ in.
M. and M. Karolik Collection. 62.98

Felix Octavius Darley, designer, 1822–1888
For the firm of John Filmer, wood engraver,
New York
Illustrations in *A Selection of War Lyrics*
by various authors, James G. Gregory,
publisher, New York, 1864
Electrotypes of wood engravings, printed in
black and buff
Page: 9 x $6\frac{1}{2}$ in.
Purchase. 1921

Winslow Homer, 1836–1910
For the Eno Lithography Company,
New York
Skating on Union Pond
Lithograph, printed in black, light blue,
and light orange, about 1868
$16\frac{1}{2}$ x 27 in.
Lee M. Friedman Fund. 67.1019

Thomas Moran, born England, 1837–1926
Solitude
Lithograph, 1869
$20\frac{5}{8}$ x 16 in.
Sylvester R. Koehler Collection. K3235

George Loring Brown, 1814–1889
For the firm of George Ward Nichols,
New York
Bay of Naples
Lithograph, printed in black and buff,
about 1860–70
$6\frac{7}{8}$ x $10\frac{1}{2}$ in.
Sylvester R. Koehler Collection. K3170

Eastman Johnson, 1824–1906
For the firm of George Ward Nichols,
New York
Marguerite
Lithograph, printed in black and buff,
about 1860–70
$10\frac{7}{8}$ x $8\frac{3}{4}$ in.
Lent by the American Antiquarian Society,
Worcester

Winslow Homer, designer, 1836–1910
Silhouette illustrations in "The Courtin',"
narrative in verse by James Russell Lowell,
James R. Osgood and Company, Boston, 1874
Photogravures from drawings, printed in
black and cream
Page: $9\frac{3}{4}$ x $7\frac{1}{2}$ in.
Purchase. 1921

Samuel Colman, 1832–1920
Barn Yard at East Hampton, Long Island
Etching and drypoint on Japanese tissue,
about 1877
$2\frac{1}{2}$ x $6\frac{5}{8}$ in.
Gift of the etcher. M2535

George Inness, 1825–1894
On the Hudson
Etching on mounted Japanese tissue, 1879
$7\frac{1}{8}$ x $5\frac{3}{8}$ in. (Ireland 920)
Sylvester R. Koehler Collection. K1344

R. Swain Gifford. *Landscape*, 1880. Etching, 3 ½ x 6 ⅞ in.
Museum of Fine Arts, Boston. Gift of R. Swain Gifford. M4165

James A. McNeill Whistler, 1834–1903
Nocturne: Palaces
Etching and drypoint, printed in brown,
with a heavy film of ink left on the plate,
1879
From the "26 Etchings" (The Second
Venice Set)
11½ x 7⅞ in. (Kennedy 202)
Bequest of Mrs. Horatio G. Curtis.
27.1404

Otto Henry Bacher, 1856–1909
Distant Venice
Etching, printed in brown, 1880
4½ x 7¼ in.
Sylvester R. Koehler Collection. K755

R. Swain Gifford, 1840–1905
Landscape
Etching, 1880
An inscription by the artist indicates that this
is a unique impression of a plate drawn
directly from nature.
3½ x 6⅞ in.
Gift of R. Swain Gifford. M4165

Stephen Parrish, 1846–1885
Sunset, Gloucester Harbor
Etching printed in brown on Japanese
tissue, 1880
4⅞ x 8¾ in. (Parrish 40)
Sylvester R. Koehler Collection. K1690

Thomas Moran, born in England, 1837–1926
East Hampton Beach, Long Island
Etching, etched sandpaper tone and drypoint,
printed in brown, about 1880
6 x 11⅞ in.
Everett Statue Fund. M436

Mary Nimmo Moran, born Scotland,
1842–1899
*Vegetable Garden in Shantytown,
New York*
Etching and abraded tone, 1881
6 x 10 in.
Sylvester R. Koehler Collection. K1490

Peter Moran, born England, 1841–1914
A Corner in Spanish Taos
Etching, 1881
5 x 7 in.
Sylvester R. Koehler Collection. K1557

Ignaz Marcel Gaugengigl, born Germany,
1855–1932
Head of a Woman
Etching, printed in brown by S. R. Koehler,
1881
3¾ x 2⅜ in.
Sylvester R. Koehler Collection. K1141

Thomas Moran. *East Hampton Beach, Long Island*, about 1880. Etching
(etched sandpaper tone and drypoint), printed in brown, 6 x 11⅞ in.
Museum of Fine Arts, Boston. Everett Statue Fund. M436

Mary Nimmo Moran. *Vegetable Garden in Shantytown, New York*, 1881.
Etching (with abraded tone), 6 x 10 in.
Museum of Fine Arts, Boston. Sylvester R. Koehler Collection. K1490

Peter Moran. *A Corner in Spanish Taos*, 1881. Etching, 5 x 7 in.
Museum of Fine Arts, Boston. Sylvester R. Koehler Collection. K1557

Wyatt Eaton, born Canada, 1849–1896
Head of a Woman
Etching on Japanese tissue, 1881
5³⁄₈ x 8 in.
William P. Babcock Bequest. B1406

Mary Cassatt, 1855–1926
Woman Seated in a Loge
Lithograph on mounted China paper,
about 1881
11¹⁄₈ x 8⁵⁄₈ in. (Breeskin 23)
Bequest of W. G. Russell Allen. 63.309

John Henry Twachtman, 1853–1902
Willows and Footbridge, near Cincinnati
Etching printed in black from a plate wiped
clean of excess ink, about 1879–82
3¹⁄₄ x 5 in.
Sylvester R. Koehler Collection. K1813

John Henry Twachtman, 1853–1902
Willows and Footbridge, near Cincinnati

Etching printed in brown with a carefully
manipulated film of ink left on the plate
to evoke a particular effect of light and
atmosphere, about 1879–82
3¹⁄₄ x 5 in.
Sylvester R. Koehler Collection. K1816

Charles H. Woodbury, 1864–1940
Gloucester (beached sailboat)
Etching printed in brown, 1882
3 x 4³⁄₄ in.
Lent by the Boston Public Library, Print
Department

Timothy Cole, born England, 1852–1931
Sansone (Samson)
Wood engraving, after a design by Elihu
Vedder, in the 1882 Christmas supplement
to *Harper's* magazine
About 16¹⁄₄ x 18³⁄₄ in.
Sylvester R. Koehler Collection. K3670

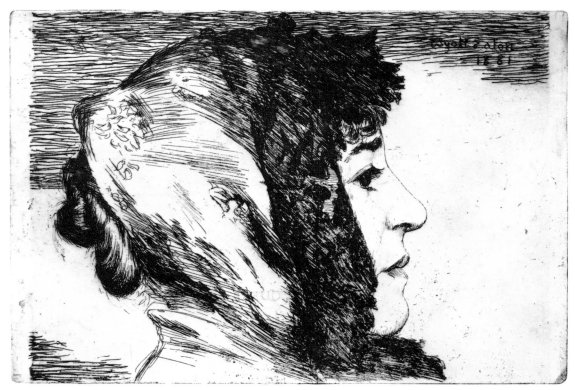

Wyatt Eaton. *Head of a Woman*, 1881. Etching on Japanese tissue, 5 3/8 x 8 in.
Museum of Fine Arts, Boston. William P. Babcock Bequest. B1406

John Henry Twachtman, 1853–1902
Woman on the Quay, Honfleur
Etching printed in brown, about 1883–84
4 1/8 x 5 1/2 in.
Sylvester R. Koehler Collection. K1825

Frank Duveneck, 1848–1919
Fishing Boats, Italy
Monotype in brown, 1884
12 1/4 x 17 in.
George R. Nutter Fund. 50.3231

John Henry Twachtman, 1853–1902
Street with Shanties, Bridgeport
Drypoint printed in brown, 1885
2 3/8 x 3 3/4 in.
Sylvester R. Koehler Collection. K1818

Walter Shirlaw, born Scotland, 1838–1910
Portrait of Sylvester R. Koehler
Etching printed in brown on Japanese tissue,
1885

5 1/8 x 3 5/8 in.
Gift of Knoedler and Company. 37.216

Joseph Pennell, 1857–1926
Palace Theatre, London
Etching on Japanese tissue, 1886
8 7/8 x 7 in. (Wuerth 118)
Lent by the Boston Public Library,
Print Department

Charles A. Platt, 1861–1933
Honfleur
Etching on rose paper, 1887
5 1/2 x 7 7/8 in. (Rice 79)
Josiah Bradley Collection.
Gift of Mrs. Josiah Bradley. M19333

Julian Alden Weir, 1852–1919
The Hillside
Etching, about 1888–89
4 5/8 x 6 1/2 in. (Zimmerman 94)
The Metropolitan Museum of Art,
Rogers Fund, 1918

Charles H. Woodbury, 1864–1940
Farm
Etching printed in brown, unique
impression, 1889
6⅞ x 8⅞ in.
Lent by the Boston Public Library,
Print Department

Anonymous
Poster for Gold Coin Tobacco
Lithograph in color, about 1880–90
20⅞ x 13 in.
Anonymous Gift. 68.430

William Merritt Chase, 1849–1916
Reverie: Portrait of a Woman
Monotype in brown, about 1890
About 18⅞ x 15½ in.
The Metropolitan Museum of Art, purchase,
Louis V. Bell, William E. Dodge and Fletcher
Funds, Murray Rafsky gift, and funds from
various donors, 1974

Mary Cassatt, 1855–1926
Woman Bathing (The Toilette)
Drypoint and aquatint printed in color, 1891
14⅜ x 10½ in. (Breeskin 148)
Gift of William Emerson and the Charles
Henry Hayden Fund. 41.810

Arthur Wesley Dow, 1857–1922
View in Ipswich
Woodcut in color on Japanese tissue, 1895
5 x 2⅜ in.
Gift of Mrs. Ethelyn H. Putnam. 41.710

Arthur Wesley Dow, 1857–1922
View in Ipswich: Sunset
Woodcut in color on Japanese tissue, 1895
5 x 2⅜ in.
Gift of Mrs. Ethelyn H. Putnam. 41.711

Arthur B. Davies, 1862–1928
Figure in a Landscape
Monotype in color on Japanese paper,
about 1895–1900
5 x 8¾ in.
The Metropolitan Museum of Art, gift of
A. W. Bahr, 1958

Will Bradley, designer, 1868–1962
Poster advertising *The Modern Poster* by
Arsène Alexandre and others, Charles
Scribner's Sons, publishers
Photomechanical metal relief in color,

published in a numbered edition of 1000, 1895
18 x 10⅝ in.
Anonymous gift in memory of John G.
Pierce, Sr. 65.223

Gelett Burgess, designer, 1866–1951
The Purple Cow, a nonsense pamphlet issued
by *The Lark* magazine, William Doxey,
publisher, San Francisco, 1895
Photomechanical metal relief on rough-
textured yellow paper
Double page: 7⅝ x 10¼ in.
William A. Sargent Collection. 37.2264

John Singer Sargent, 1856–1925
Study of a Seated Draped Model
Lithograph on Japanese vellum, 1895
11¾ x 8⅝ in. (Dodgson 1)
Bequest of W. G. Russell Allen. 63.397

James A. McNeill Whistler, 1834–1903
Study—Mr. Thomas Way, No. 1
Lithograph, 1896
7½ x 4⅞ in. (Way 107)
Lee M. Friedman Fund. 72.52

Will Bradley, designer, 1868–1962
Advertisement (The Twin Comet Lawn
Sprinkler) and *cover design* for the May and
June 1896 issues of *Bradley, His Book*,
published by the artist, the Wayside Press,
Springfield, Mass.
Photomechanical metal relief
Page: 10¼ x 5 in.
Gift of William A. Sargent. 37.1958

Edward Penfield, designer, 1866–1925
Poster for Harper's July
Photomechanical metal relief in color, 1896
18⅝ x 13¾ in.
Gift of Wheaton Holden. 1971.122

Ethel Reed, designer, 1876–after 1910
Time and the Hour
Photomechanical metal relief on gray
oatmeal paper, 1896
18⅜ x 13⅜ in.
Lent by the Boston Public Library,
Print Department

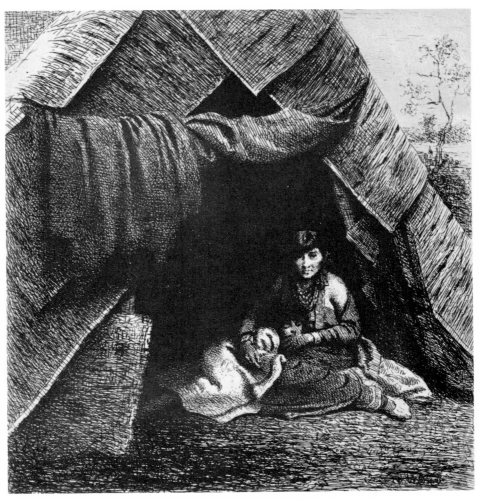

Eastman Johnson. *The Wigwam*, 1859. Photographic "etching" or *cliché verre*, 5½ x 5 in. Museum of Fine Arts, Boston. M. and M. Karolik Collection. 62.79

Charles H. Woodbury, designer, 1864–1940
Poster Advertising Trolley Trips on a Bay State Triangle
Photomechanical metal relief in color, printed by the Heliotype Printing Company, Boston, 1897
11¼ x 16⅝ in.
Anonymous gift in memory of John G. Pierce, Sr. 65.228

Robert Henri, 1865–1929
Street Scene
Monotype printed in brown on buff paper, about 1897
6⅛ x 7 in.
Lee M. Friedman Fund. 63.445

Will Bradley, designer, 1868–1962
Illustrations to "War is Kind," verses by Stephen Crane, Frederick A. Stokes Company, New York, 1899
Photomechanical metal relief on blue-gray paper
Page: 8½ x 5 in.
William A. Sargent Collection. 37.1978

Maurice Brazil Prendergast, born Canada 1859–1924
Central Park
Monotype in color on Japanese mica paper, about 1901
11¼ x 9¼ in.
Abraham Shuman Fund. 60.965

John Marin, 1870–1953
Cathedral, Laon, I
Etching on Japanese vellum, 1906
8½ x 5¼ in. (Zigrosser 20)
Lent by the Boston Public Library, Print Department

John Marin, 1870–1953
San Marco, Venice
Etching on Japanese vellum, 1907
6½ x 8¾ in. (Zigrosser 65)
Gift of L. Aaron Lebowich. 50.3262

Joseph Pennell, 1857–1926
From Cortlandt Street Ferry
Sandpaper mezzotint, 1908
13 x 9¾ in. (Wuerth 502)
The Metropolitan Museum of Art, Harris Brisbane Dick Fund, 1917

Alfred Stieglitz, 1864–1946
The City of Ambition
Photogravure on Japanese tissue, 1910
13⅜ x 10¼ in.
Gift of Miss Georgia O'Keeffe. 50.834

Alvin Langdon Coburn, 1882–1966
Broadway at Night
Photogravure printed in greenish-black, from *New York*, 1910
8½ x 6⅛ in.
Gift of David J. McAlpin. 1972.333

John Sloan, 1871–1951
Night Windows
Etching, 1910
5¼ x 6⅞ in. (Morse 152)
Gift of William Emerson. 31.1385

Frank Benson, 1862–1951
Mother and Child
Etching printed in brown, 1913
6¾ x 5½ in. (Paff 23)
Lent by the Boston Public Library, Print Department

John Marin, 1870–1953
Woolworth Building, New York, No. 2
Etching, 1913
11 x 8½ in. (Zigrosser 114)
Gift of W. G. Russell Allen. 54.890

Childe Hassam, 1859–1935
Union Square
Etching on blue paper, 1916*
14¼ x 5¾ in. (Clayton 89)
The Metropolitan Museum of Art, Gift of Mrs. Childe Hassam, 1940

* Erroneously described in the original checklist of the exhibition as an etching of 1896.

Index